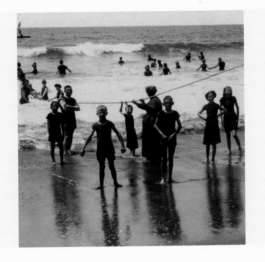

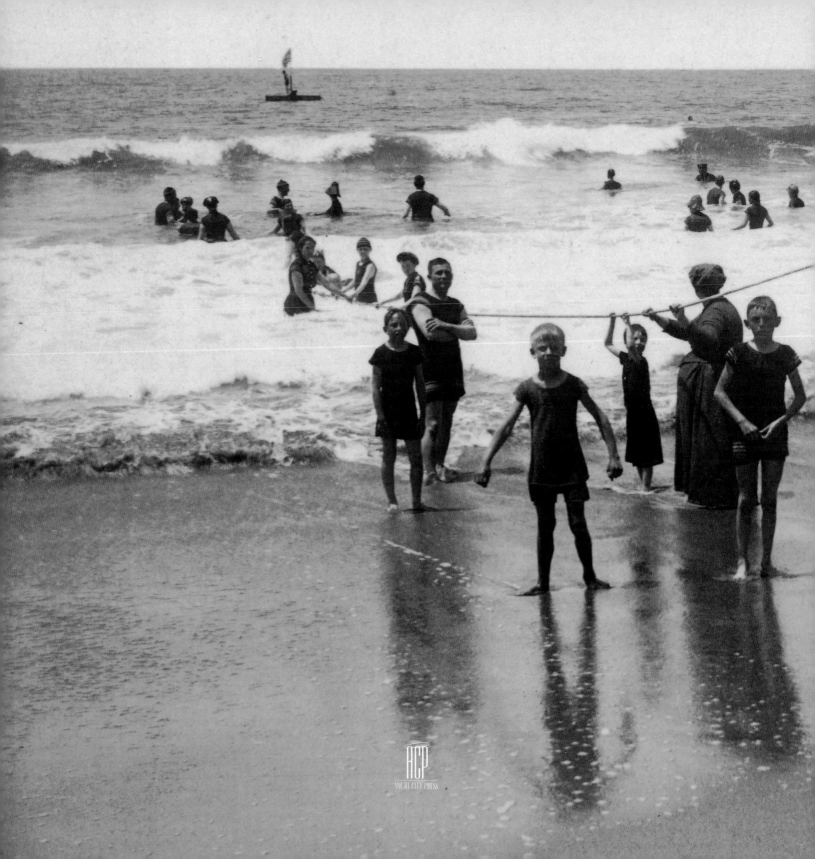

SANTA MONICA BEACH

A COLLECTOR'S PICTORIAL HISTORY

ERNEST MARQUEZ

Jacket and title pages:

BATHERS ON THE SANTA MONICA BEACH, 1890s

Some of the children playing in the water in this H.F. Rile photograph hold a safety rope that extended from the beach to a raft anchored offshore. Notice the fully clothed woman who is either enjoying the surf as well, or simply trying to keep her eye on the rowdy crew.

Santa Monica Beach: A Collector's Pictorial History
Copyright © 2004 by Ernest Marquez
Designed by Amy Inouye, www.futurestudio.com

First edition
10 9 8 7 6 5 4 3
ISBN 978-1-883318-36-9 (hardcover edition)
ISBN 978-1-883318-95-6 (paperbound edition)

Library of Congress Cataloging-in-Publication Data
Marquez, Ernest, 1924–
Santa Monica Beach : a collector's pictorial history / Ernest Marquez.--
1st ed.
p. cm.
Includes bibliographical references and index.
ISBN 1-883318-36-X (hardcover : alk. paper)
1. Santa Monica Region (Calif.)--History--Pictorial works. 2. Beaches--
California--Santa Monica Region--History--Pictorial works. 3. Santa
Monica Bay Region (Calif.)--History--Pictorial works. 4. Santa Monica
Region (Calif.)--History. 5. Beaches--California--Santa Monica Region--
History. 6. Santa Monica Bay Region (Calif.)--History. I. Title.

F869.S51M37 2004
979.4'93--dc22
2004015351

Printed in China

ANGEL CITY PRESS
2118 Wilshire Boulevard #880
Santa Monica, California 90403
310.395.9982
www.angelcitypress.com ANGEL CITY PRESS

TO MY PRECIOUS CHILDREN
EILEEN, MONICA AND ERNESTO

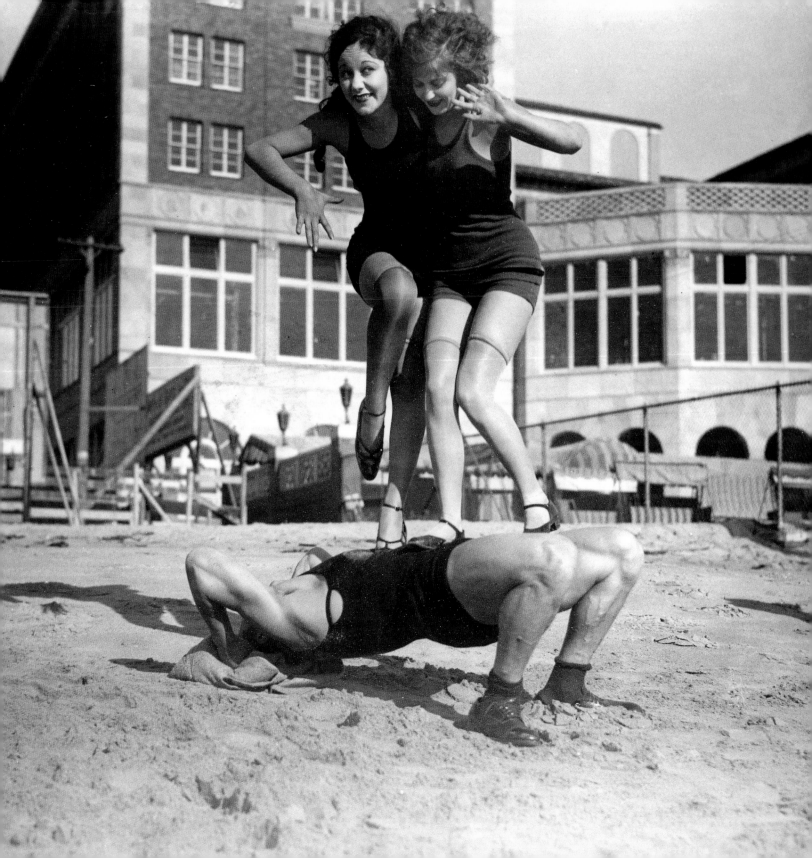

CONTENTS

CASA DEL MAR BEACH CLUB, EARLY 1930s

Young women dance on a strongman's stomach in front of the
Casa Del Mar Beach Club.

INTRODUCTION

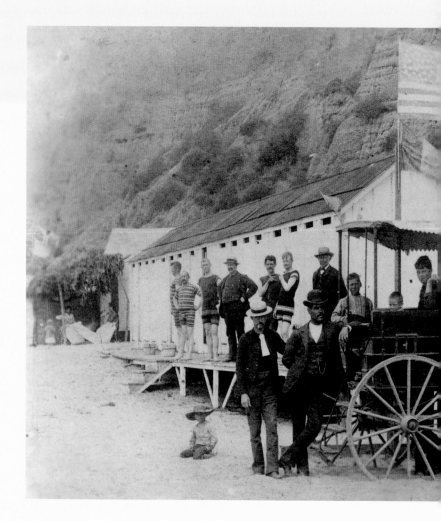

There is no other beach in California that has been photographed more than Santa Monica. From the day Santa Monica was registered as a township in 1875, photographers found the place to be an irresistible subject. No doubt the unmatched beauty of the area, its mild climate, and the ever-changing development led professional photographers, as well as tourists and locals alike, to log many hours on the Santa Monica shore. Even when Santa Monica was in its infancy, photographer E.G. Morrison recognized the potential for a prosperous business making photographs. In 1875 he moved to Santa Monica to set up a photography studio called Seaside Gallery in a canvas tent next to the Santa Monica Bath House. There he sold tintypes and photographs to visitors and tourists.

The town of Santa Monica is situated on the shore of what is called Santa Monica Bay. (A controversy erupted in the 1930s as to whether it was actually a bay or a bight, but that is another story.) The headlands of the bay are Point Dume at the north end and Rocky Point on the south, near the entrance to the Los Angeles Harbor at San Pedro. Though other beach towns came into existence along the bay, none have achieved the world renown Santa Monica has. The town was special from the beginning.

In 1839 the Mexican government granted the land that eventually became the City of Santa Monica to three Mexican citizens, Francisco Marquez, Ysidro Reyes and Francisco Sepulveda. These men had no idea at the time that their home would become a major city known throughout the world. Initially, this land was issued as two separate Mexican land grants: the 33,000-acre *Rancho San*

Pascual Marquez Bath House, 1887

A special horse-drawn wagon (with "Santa Monica Canyon" painted on its awning) brought visitors to the Pascual Marquez Bath House, the first bathhouse north of town. Though Michael Duffy built and owned the bathhouse, he named it in honor of Pascual Marquez, who owned the land.

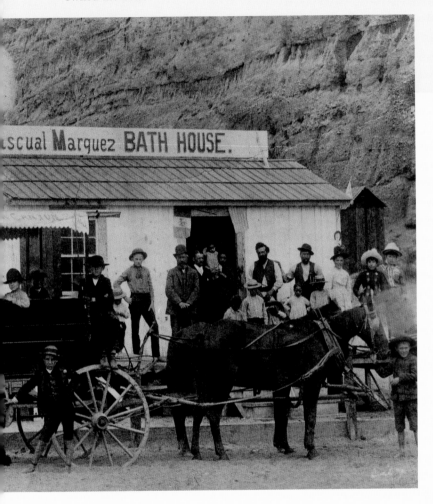

Canyon, people from the hot, dusty town of Los Angeles were welcome to camp there to enjoy the scenery and cool ocean breezes.

My interest in exploring the history of Santa Monica Beach has much to do with two men, the owners of *Rancho Boca de Santa Monica*. Francisco Marquez and Ysidro Reyes were my great-grandfathers and, like my father and grandfather before me, I was born in Santa Monica. It was the same time movie stars were building magnificent homes on the beach. I grew up in Santa Monica Canyon, where my friends and I caught polliwogs and frogs in the creek and munched on the tangy watercress that grew wild in the water. I often wondered then, as I do now, if my grandfather and my father played in this same creek as boys.

As I grew older, my friends and I spent summer days at the beach, which was walking distance from my home. We went swimming and body surfed on the south side of the groin that jutted out to sea in front of actor Nat Pendleton's home. To maintain our frantic energy and feed the hunger that went along with it, we collected discarded soda bottles on the beach and then claimed the deposit at Mr. Edwards's small grocery at the mouth of the canyon. With our few coins, we'd walk over to Ted's Grill and buy a cold drink and the best hamburger you ever tasted for fifteen cents.

Occasionally, we rowdy boys would try to swim

Vicente, granted to Francisco Sepulveda, and the *Rancho Boca de Santa Monica* grant, a mere 6,656 acres given to Francisco Marquez and Ysidro Reyes. Marquez and Reyes soon began cattle ranching on their joint land, built simple adobe homes and started raising their families. Even though they privately owned the beautiful area called Santa Monica

Pascual Castulo Marquez (left), the youngest son of Pascual Marquez, and Charlie Marquez ride in a wagon used to haul gravel from a quarry in Santa Ynez Canyon to Santa Monica where it would be used in the construction of roads.

alongside Buster Crabbe, the Olympic swimmer who trained every day by swimming from Santa Monica Canyon to the Santa Monica Pier and back. Even at our best, we could only keep up with him for a few strokes. At ten years of age I'd never even seen a swimming pool, but I was an excellent swimmer since I had learned in the ocean. During the summertime, if the weather permitted (and it nearly always did), my buddies and I spent every day at the beach.

Years passed and I was allowed to wander further from home. My friends and I would ride our bikes to Ocean Park, spending entire days inside the Fun House there, or we would make our way down to the Venice Pier. I remember well the marathon dance contests at the La Monica Ballroom on the Santa Monica Pier. I stared in wonder at the exhausted dancers who tried to stay on their feet in hopes of some small prize. Fishermen on the pier pulled in large fish of all kinds, and during the Depression it was thrilling to see men unload gunny sacks full of fish from incoming boats.

I saw Santa Monica beach change dramatically during my lifetime, and as I started looking into the history of both my family and the area, I began to understand that such radical changes were long a part of the beach's past. When my great-grandfathers moved to Santa Monica Canyon, the area was considered to be wilderness. Francisco Marquez and his wife Roque Valenzuela built an adobe house in the upper

mesa of the canyon—the first permanent structure in the area. They had eleven children, only five of whom survived to adulthood. Ysidro Reyes and his wife, Maria Antonia Villa, built their home in the new rancho on land that is now the Huntington Palisades. Later, the Reyes family abandoned that location in favor of a place near what is now 7th Street and Adelaide. They had eleven children, and Reyes often complained about the wild animals coming down from the mountains that ate his chickens and small animals.

In 1879, Francisco Marquez's youngest son Pascual married Ysidro Reyes's daughter Michaela. Marriage, as well as their common interest in land, united the families. Pascual and Michaela had ten children, one of whom was my father. During the course of my grandfather's life, Santa Monica Canyon went from being considered rough country to a popular weekend resort.

For me the beach has never lost its appeal, although times are different now. Sure, people still pile into their cars and drive to the beach every summer, with the hope of finding a parking space, but these visitors lie on a blanket with a bottle of sunblock rather than the old umbrellas we used in the 1930s and '40s. And there's so much technology on the beach nowadays—cell phones, boom boxes, laptops, even DVD players—that our little portable radios with glowing tubes seem totally ridiculous. These things might seem like

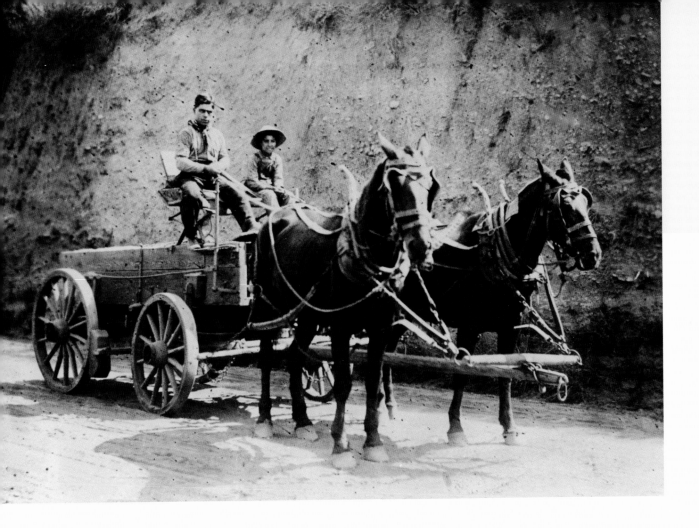

small details, but I assure you that if you had been on the beach during Muscle Beach's heyday, you would have tossed aside the DVD player. We didn't have to bring entertainment to the beach; the beach *was* the entertainment.

Memories remain for those of us who wax nostalgically about what Santa Monica Beach used to be. Sadly though, many of the important and beautiful buildings featured in the photographs in this book are no longer in existence today.

Not photographed in this book because it's not at the beach—but of tremendous personal importance to me—is a little portion of land in Santa Monica Canyon on San Lorenzo Street that remains much as it was more than a hundred years ago. This area, the only portion of the original Mexican land grant that remains in the hands of my family, is the site of the Pascual Marquez Family Cemetery.

When the Marquez and Reyes families first moved to *Rancho Boca de Santa Monica* it was a day's trip to the nearest Catholic cemetery so Francisco Marquez set aside a portion of his land for a cemetery within view of his adobe home. Though no official records were kept, it is believed that the cemetery was established in the late 1840s. Over the years, member of the Marquez and Reyes families, along with their close friends, were buried there. In 1916, Pascual Marquez was

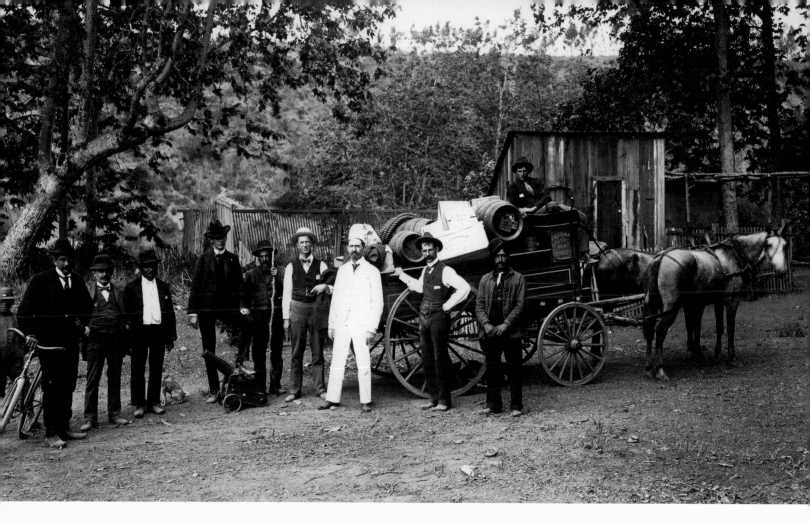

the last person to be buried at the cemetery. In tribute to Pascual's love for his home, his casket was placed at the same angle and in the same place as the bed in which he was born. His granite headstone remains there today, and my family continues to care for and maintain the cemetery. I'm extremely proud that this small piece of land—and of Southern California history—has been designated as a cultural-historic landmark by the City of Los Angeles. Today the cemetery's simplicity and charm is nearly hidden in a heavily populated residential neighborhood filled with houses that range from huge estates to modest homes built in a variety of architectural styles.

My family's contribution to early California history led me to a lifelong search for historical documentation of the Marquez and Reyes families as well as the history of the *Rancho Boca de Santa Monica*. After many years of collecting photographs of family members and scenes of early Santa Monica, I realized that I had a visual record, encompassing more than a century, of the development of the beach at Santa Monica. Many of the photographs, taken years apart, were of the same scene photographed from the same location by different photographers. The result was documentation of transformation, rich both for its aesthetic beauty and vast information.

A Canyon Barbecue, Early 1900s

In keeping with the hospitality and tradition of the old rancho families, Pascual Marquez (center, with long stick) hosts a Mexican barbecue on his land in Santa Monica Canyon. Provisions for the barbecue are on the wagon.

This book is a collection of many of those photographs—and depicts the dramatic changes that have occurred to the beach over the last one hundred twenty-five years. The abbreviated history related in the text highlights some of these transformations and serves as an introduction to the photographs. My hope is that you enjoy these photos and spend time with them, as I have found each image provides an entrée to a part of Santa Monica's history that might have been forgotten had the camera's shutter not captured it. I am exceedingly grateful that these talented photographers, both known and unknown to us today, were there on the sunny Santa Monica shore to record the constructions, crowds or calamities that shaped its history.

Regarding the historical information stated in the text, I relied heavily on the microfilm copies of the *Santa Monica Outlook* newspaper located at the Santa Monica Public Library. I also used the minutes of the Santa Monica Board of Trustees for facts regarding the beach. The report produced by the engineering companies hired to investigate the failure of the concrete pier supplied details regarding the Municipal Pier. I used ephemera and advertising material that I have collected over the years for information about some of the beach clubs.

I want to express my sincere thanks to my dear friends Warren and Dorothy Thompson who both read my first draft many years ago and offered constructive comments that led to this finished work.

Gary Kurutz, curator of special collections at the California State Library, and Jennifer Watts, curator of photographs at the Huntington Library, both expressed an interest in my project and generously allowed the use of photographs from their respective collections.

Marc Wanamaker and his extraordinary Bison Archives supplied photographs of some of the beach clubs.

Thanks also go to Shirleigh Brannon, history librarian at the California Department of Transportation.

Cynni Murphy at the Santa Monica Library was kind and generous with her help.

I am grateful to Andrea Richards for her editing and Amy Inouye for her graphic design. They both took on the project as their own and did a magnificent job.

I also thank Marian Hall for introducing me to Angel City Press's Paddy Calistro and Scott McAuley, who shared my passion for the history of Santa Monica Beach.

Dan Tillmanns, a native of Santa Monica, was a help to me beyond measure. His amazing knowledge of Santa Monica history is astounding. I am forever grateful to him for his attention to detail when reading my manuscript.

—Ernest Marquez

CHAPTER ONE

THE PERFECT RESORT

SANTA MONICA CANYON, 1880s

Santa Monica Canyon was the first beach resort in Southern California. Tents and other temporary shelters housed visitors who camped at the mouth of the canyon.

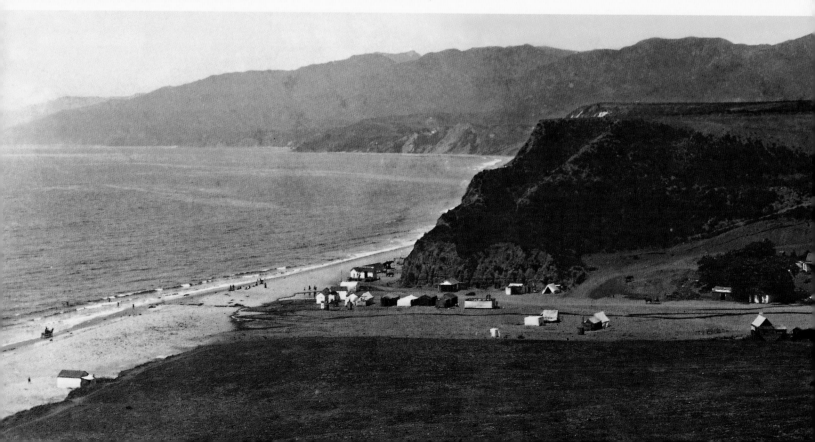

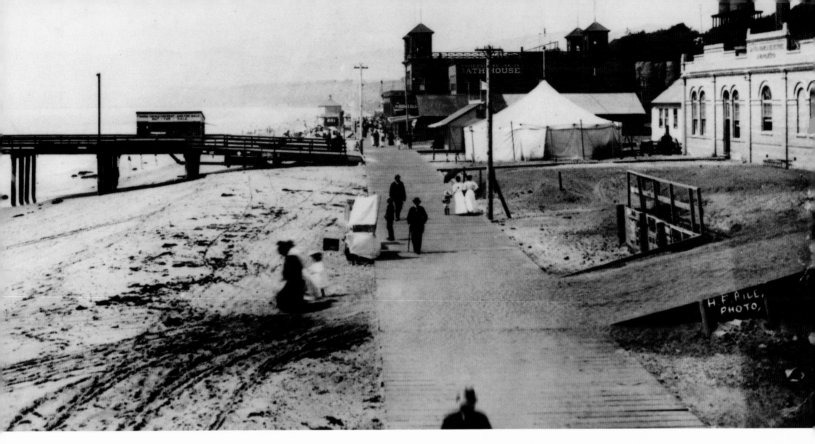

WALKING ALONG THE NORTH BEACH PLANKWALK, 1899

This view of North Beach taken by H.F. Rile shows the wooden walk that extended from the North Beach Bath House (in the distance) to the Arcadia Hotel. The building to the right is the Santa Monica Electric and Power Company.

In the 1850s, years before the town of Santa Monica was founded, a beautiful setting known as Santa Monica Canyon was already attracting vacationers from Los Angeles, twenty-one miles away. These visitors came by wagon, an all-day trip over dirt trails wide enough to accommodate only a horse and wagon or a *carreta* pulled by oxen. They set up their tents facing the sea beneath majestic sycamore trees and close to a little creek whose waters ran down into it year-round. Camping happily in idyllic surroundings, families cherished the opportunity to splash or swim in the ocean, to hike up and down the canyon, or hunt for seashells at its mouth.

As time went by, more and more summer campers, undeterred by the difficulty of getting there, came to the canyon to exchange the confining walls of their *adobes* and the heat and dust of *El Pueblo de Los Angeles* for cool ocean breezes and the peaceful sounds of nature. The Marquez and Reyes families, who owned *Rancho Boca de Santa Monica* (the Mexican land grant that included this lovely area), warmly welcomed all vacationers and allowed them to stay on their homeland as long as they liked. By the 1870s, accommodations for summer vacationers to the canyon included a colossal tent, big enough for thirty families, as well as a small grocery store stocked with food and camping supplies. Later, two hotels opened nearby, the Morongo House and the Seaside Hotel.

About a mile and a half to the south of Santa Monica Canyon, the township of Santa Monica was founded in 1875. As the new town's appeal increased, fewer vacationers came to the canyon. Instead, visitors opted to stay at the new Santa Monica Hotel, a two-story wooden building that opened at the corner of Ocean and Railroad Avenues (the latter now Colorado Boulevard) in the newly established town. With a fireplace in every room, the hotel offered luxury not to be found in the rustic setting of the canyon. Moreover, the nearby Los Angeles & Independence Railroad, which went into service that same year, began carrying visitors to the beach year-round on weekend or weeklong excursions. Increasing numbers of people began taking advantage of such easy access, and Santa Monica was soon on its way to becoming a major seaside resort.

Of course, going to the beach in the 1870s wasn't quite like it is today. Some Victorian codes of decency lingered and few people were bold enough to appear in swimsuits in public view. For the most part, if people wanted to relax in the water they visited a bathhouse on the beach to soak in a porcelain tub rather than take a dip in the ocean. Bathhouses had comforts that the ocean did not possess, such as rooms for rent with bathtubs filled with warm saltwater from the ocean or huge plunges (which we now call swimming pools).

The first bathhouse on the beach was located at the foot of a wooden stairway leading from the top of the cliffs directly in front of the Santa Monica Hotel. Built in March 1876 by Michael Duffy, the Duffy Bath House consisted of two long narrow structures with a total of sixteen dressing rooms, each with its own freshwater bath and a shower. On hand were one hundred twenty bathing suits and towels that could be rented for the day. For the entry fee of twenty-five cents, patrons received the use of a bathing suit and a dressing room. For the more adventurous visitor who chose to risk real surf, Duffy anchored a buoy some distance from the shore with a rope attached for bathers to hold. By June 1877 the Santa Monica Bath House, a larger bathhouse, was under construction next to Duffy's. Boasting features such as twenty-five rooms for rent (each eight feet square) and a fancy sitting room in the front, the Santa Monica Bath House featured enormous bathtubs and two steam rooms, one for women and another for men. Built on land owned by the town's founders, Senator John P. Jones and Robert Baker, the bathhouse's proprietors, Mr. and Mrs. Charles Waller, looked after the daily visitors' needs. Advertisements for the Santa Monica Bath House touted the value of hot saltwater baths as cures for ills from "biliousness" to rheumatism.

On June 9, 1886 the *Los Angeles Times* published an article praising Santa Monica's beneficial beauty stating ". . . No one who has ever visited this resort only seventeen miles by rail from Los Angeles who has not been willing to

SANTA MONICA HOTEL, 1876

The first hotel in the new town was made up of two, two-story buildings. The first structure (foreground) featured an office, dining room, bar and baths on the first floor, and sleeping rooms upstairs. The other building (with the four chimneys) housed sleeping quarters.

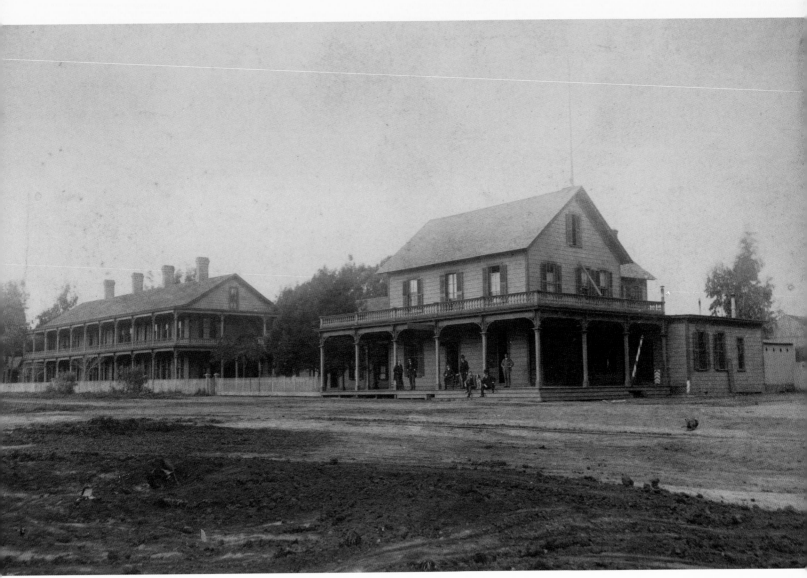

admit that as a place for healthful homes, both in summer and winter, it is unsurpassed nowhere. There is something about the climate which invigorates and refreshes the whole system, there is not a few people who have almost discarded doctors and physic when suffering from biliousness, dyspepsia and kindred ills depend altogether upon a trip to Santa Monica and there, in a brief period, regain perfect health . . . " Despite the awkward language, the message was very clear: Santa Monica was the Southern California beach resort of choice even before the turn of the twentieth century.

At the same time that bathhouses were becoming the rage, the railroads were bringing more people to Southern California from points East. The temperate weather and the beautiful Pacific mesmerized these visitors and many never left. To take advantage of this influx of new sun and sand worshipers, entrepreneur William I. Hull opened a tent manufacturing company on the beach at the foot of Railroad Avenue in 1884. He rented camping equipment and tents to visitors who wished to stay more than a day. Soon it became commonplace to see more than two hundred tents of all sizes scattered along the beach, with horses or carriages tied up alongside. Two years later, Hull built Central Bath, a bathhouse next to his tent business. Also in 1886, the Santa Monica Hotel was remodeled and enlarged by twenty rooms

SANTA MONICA BATH HOUSE, 1887

The beach proved so popular with visitors that the Santa Monica Bath House was soon surrounded by many other vendors, who set up tents on the beach and sold ice cream, fruit and even cigars.

to accommodate increasing demand.

By the mid-1880s Santa Monica had about three hundred permanent citizens and twelve saloons. In fact, the saloons outnumbered any other sort of business in town. Often called "disreputable," these establishments were well patronized by locals and tourists alike, much to the displeasure of many citizens who felt Santa Monica should be a quiet, residential town. Alcohol-fueled mirth appalled conservative citizens, and in 1890 the city's board of trustees voted to make the town dry. The decision was greatly promoted by Frederick Rindge, a wealthy and religious man, who offered to personally pay the city revenue lost from sus-

pending the sale of alcohol. True to his word, Rindge paid twenty-five hundred dollars to the city. (Rindge later became the owner of the *Rancho Topanga Malibu Sequit,* now known as Malibu.) The controversial measure passed and Santa Monica was left without its famous saloons. But the measure was sufficiently watered down so that the saloons soon reopened as restaurants. According to the ordinance, liquor could not be served without a meal—what constituted a meal, however, was not specified. Several saloons placed a box of crackers on the table as a concession.

Santa Monica was incorporated as a city November 30, 1886. The following year twelve plats were recorded in

the county recorder's office. The buildings on these plats included Steere's Opera House (on the northeast corner of Utah—now Broadway—and 3rd Street) and St. Augustine's Episcopal Church (which still stands on 4th Street just south of Wilshire Boulevard), as well as several business blocks and a number of residences on the flat land above the beach.

The idea of living on the beach didn't appeal to most people because it was impractical; there was no easy access to the shore. Steep vertical cliffs ranged in height from 165 feet at the northern end of Santa Monica Beach (next to the entrance of Santa Monica Canyon) to fifty-three feet at the southern end, where the cliffs ended at a wide arroyo at Railroad Avenue. Thirty-foot high cliffs continued on the other side of the arroyo and slowly diminished in height until they reached Front Street (now Pico Boulevard) where there was another wide cut, described on early maps as "Pico Gulch." From there and to the south, the land gradually flattened out below what is the present-day Strand Street, midway between Pico and Ocean Park Boulevards. For most of the city's citizens, and certainly for its visitors, getting to the beach was difficult, a challenge that made the wide, sandy beach all the more alluring.

The owners of the Santa Monica Hotel solved the beach access problem by building a wooden staircase that went down the cliff to the bathhouses. At the base of the steps a wooden boardwalk led to the bathhouse. Next to the base of the cliffs was a dirt road for horses and wagons. Further north on the beach, the city funded the construction of a much larger wooden staircase at the foot of Arizona Avenue. Built in 1876, the structure had ninety-nine steps and extended from the top of the palisades to the sand below. Thus, two staircases—the Santa Monica Hotel's and what has always been called the 99 Steps—were the only routes for pedestrians from the town to the beach, save for a few perilous footpaths.

In 1886 work began on the construction of Santa Monica's first luxury resort hotel, the Arcadia. Located on the bluff, the grand, five-story hotel opened for business in January 1887. Proprietor J.W. Scott had wisely purchased land on the south side of Railroad Street in 1885 for three thousand dollars, and in turn subdivided it into forty lots, thirty of which he sold for a total of thirty thousand dollars. He invested his ten-fold return in the lavish hotel. The result became one of the most celebrated spots on the Pacific coast. The grand Arcadia featured one hundred fifty rooms with either unobstructed landward or seaward views. The ocean itself was a mere 185 feet away. From the charming observation deck located in a roof tower, visitors could enjoy a panoramic view of the entire Santa Monica Bay as well as a landward view toward Los Angeles.

Without a doubt the finest seaside hotel in Southern California, the Arcadia Hotel brought out romantic notions in its guests. Postcards and letters written by Arcadia guests often made mention of the phosphorescent surf on a moonlit night, and how while listening to the hotel's string orchestra, the water seemed to dance to the rhythm of the music. Dining there was an exquisite experience, with magnificent meals prepared by master chefs and served in an elegant dining room. The hotel's managers lured away a famed chef from the prestigious Hotel Green in Pasadena and soon had a restaurant that rivaled the Green's. Along with the main dining room, there was also a glass-enclosed breakfast room and a dining room specifically for grilled fish where patrons could order, at a moment's notice, almost any kind of fish available on the West Coast.

After-dinner entertainment at the Arcadia included

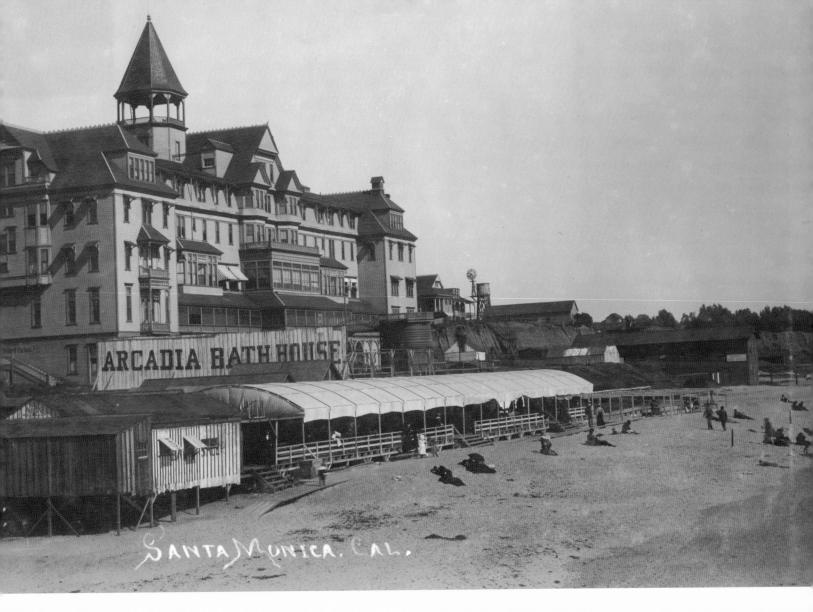

ARCADIA BATH HOUSE

SANTA MONICA, CAL.

THE ARCADIA HOTEL

Built in 1886, south of where the Los Angeles & Independence Railroad wharf once stood, the Arcadia was the largest structure in Santa Monica. The building adjacent to the south is the Paradise Hotel. The Arcadia went through a number of owners and was opened and closed throughout the years of its existence. The hotel was torn down in 1909 to make way for a new project called Seaside Terrace. The grove of trees on the right stand where Pico Boulevard is today. The image was taken about 1890 and signed C.J.D. Photo.

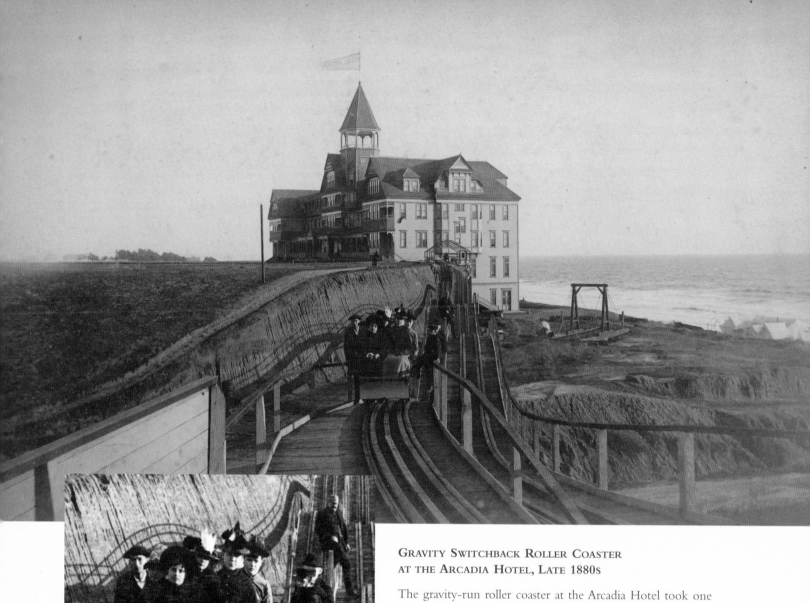

GRAVITY SWITCHBACK ROLLER COASTER
AT THE ARCADIA HOTEL, LATE 1880s

The gravity-run roller coaster at the Arcadia Hotel took one minute to make the trip across the arroyo. An enlarged section of a photograph by E.G. Morrison shows how unimpressed riders were with the Arcadia's unusual attraction. Even the attendants could walk alongside the car as it slowly carried the passengers from one side to the other.

dancing to a live orchestra in the hotel's spacious ballroom. For the beach-bound, the hotel offered hot saltwater baths in its own bathhouse, which was located on the beach directly below the hotel. But by far the hotel's most unusual attraction was its own roller coaster (the first in Santa Monica) that crossed the arroyo separating the town proper from the Arcadia. The two-track, gravity-run switchback coaster provided a novel way to travel back and forth to town. The open car left the hotel with a push, and then sped down an incline gaining momentum so it could climb a rise back up in the track, and then down another—repeating this motion for the one-minute ride. The coaster, designed by La Marcus A. Thompson (who conceived of the roller coaster as a means of transportation) could carry ten passengers; a round-trip ride cost five cents. Though inventive and functional, the coaster was certainly not a thrill ride, as several photographs reveal; riders look thoroughly bored by the slowness of the car.

Whether a guest was from Los Angeles or a long-distance visitor from the east, one thing was certain: people fell in love with their lodgings. The Arcadia's popularity and penchant for drawing high-profile guests led the town's first newspaper, the *Santa Monica Outlook,* to publish the hotel's registry list each week. Unfortunately, the hotel was plagued with financial problems and was sold several times during its lifetime.

The difficulties that beset the Arcadia Hotel did not affect the other businesses on the beach, however, and they continued to grow very rapidly. In 1879 the Eckert & Hopf Pavilion restaurant opened on the cliff near the Arcadia. It became a familiar landmark and one of the most popular eating places on Santa Monica Beach. In the latter part of 1887, the Crystal Plunge, an open-air cement swimming pool, was built on Ocean Avenue and Front Street, where the Casa Del Mar Hotel currently stands. Then called Pico Gulch, this area of deeply cut land was probably created by the runoff of water from the flatlands to the ocean during rainstorms in preceding centuries.

On December 7, 1887, H.X. Goetz was granted a contract for the construction of a wooden bridge on Ocean Avenue to span the arroyo between the Arcadia Hotel and the town (the same area that the roller coaster spanned). A schooner brought in lumber for the bridge. The vessel anchored offshore and unloaded the lumber directly into the water, floating it ashore. This overpass was referred to as Bridge #1 by locals and ran parallel to the ocean. Goetz, a prominent designer and builder in Santa Monica, would later build several other important structures in Santa Monica, including the North Beach Bath House, Santa Monica City Hall and the public library.

Santa Monica Beach was booming in 1889 when tragedy struck. On January 15 the Santa Monica Hotel caught fire and burned to the ground. Only the brick fireplaces and chimneys stood among the smoking rubble as a reminder of Santa Monica's first hotel. But despite the disaster, Santa Monica's reputation as a resort town, and not just a quiet weekend retreat, was well established. That year the Southern Pacific Railroad brought two hundred thousand visitors on its trains to the beach. On a Sunday as many as three trains would arrive at the same time, each with eleven passenger cars attached to the locomotive. Also in 1889, the new electric interurban system called the Los Angeles Pacific Railway completed its track to Santa Monica, and a huge crowd greeted its first car packed with passengers.

The influx of visitors was more than the hotels and boarding houses could accommodate, so the majority

camped in tents along the beach. Senator Jones and Robert Baker, owners of the beach, objected to the city trustees about the tents being set up on their property. The campers and their tents were forced to move further south, toward the area that would soon be established as Ocean Park. Perhaps Jones and Baker had a change of heart, because in 1891 the men deeded the land on top of the bluffs overlooking the beach from Railroad to Montana to the city, on the condition it be kept in perpetuity as a public park. This land, combined with another gift to the city of the property from Montana Avenue to Santa Monica Boulevard by Robert C. Gillis, became a park named for its "perfect view," Linda Vista Park. In 1915 the name of the park was formally changed to Palisades Park.

By 1894, Senator Jones was seventy-five years old, and his sons Robert and Roy took over some of his business affairs. Acting as the Santa Monica Land Company, the Jones brothers decided it was time to update their beach landholdings by replacing the seventeen-year-old Santa Monica Bath House with a new one. Designed by the prominent Los Angeles architect Sumner P. Hunt, this new North Beach Bath House featured a large, old-fashioned open fireplace complete with gas logs, cast iron pots and kettles. On the second story of the building Eckert & Hopf opened another restaurant. Soon, the Jones brothers built other structures around the North Beach Bath House, including a swimming pool, a billiard hall and a bowling pavilion. The bowling pavilion was state of the art, with eight modern alleys made entirely of selected maple, patented return runways and an abundance of assorted lignum vitae bowling balls (since lignum vitae is the heaviest and densest wood in the world, it's hard to imagine how heavy these balls must have been). Inside the pavilion were seats for three hundred spectators.

Outside of the North Beach Bath House was a twenty-foot-wide wooden boardwalk (then called a plank-walk) that extended south past the Arcadia Hotel and made walking to the bathhouse's other buildings easy. The Camera Obscura, a small structure that patrons entered to witness a marvel of optics, was placed next to the boardwalk. For only ten cents, the curious could enter the dark room of the Camera Obscura and see a real-life moving picture of the activity outside. In 1905 a severe storm damaged the structure and it was moved to Linda Vista Park above the beach. (In 1955 the Camera Obscura was moved again to its current location at 1450 Ocean Avenue, where it continues to evoke wonder from all who enter.)

The North Beach Bath House complex redefined the bathhouse to include every convenience and attraction a beach visitor could desire. A guest could swim, bowl, play billiards, visit a shooting gallery, compete in a diving contest or watch an equestrian show on the beach with Lipizzaner horses. In addition to all the on-site fun, local organizations sponsored parties and special events at the North Beach Bath House or on the beach nearby. Knowing well that the environment of play and comfort they had created was key to the appeal of the beach, the Jones brothers expanded their amusement empire in 1898 by building a pleasure pier in front of the North Beach Bath House. People strolled and fished from the two-hundred-foot-long North Beach Pier. Soon after the pier's construction, on June 20, 1898, Santa Monica city trustees moved that a special policeman be appointed to patrol the beach and abate indecent exposure. (Clearly, some people had completely abandoned those Victorian codes of decency.)

By the turn of the century, Santa Monica was fully developed as a beach resort. As if foreshadowing an era that

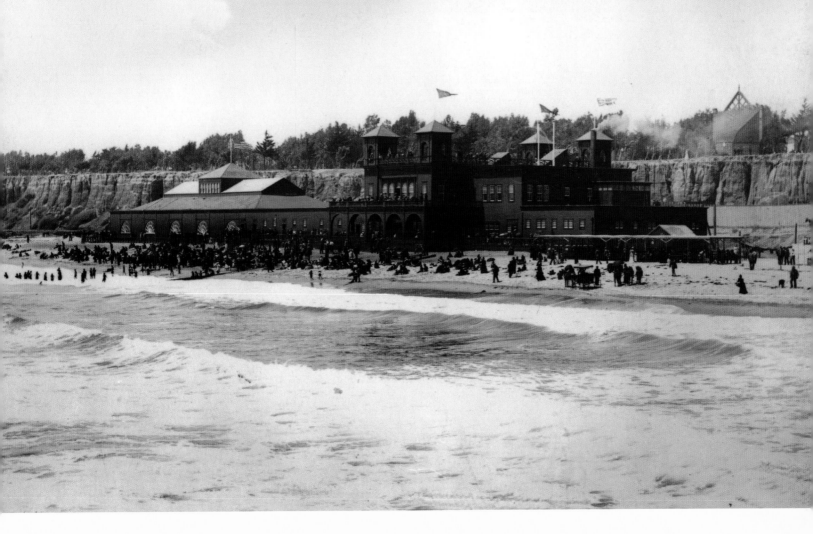

THE NORTH BEACH BATH HOUSE

Robert and Roy Jones, owners of the North Beach Bath House, claimed it was the most magnificent bath house on the Pacific Coast. It had everything a visitor to the beach could want, from a heated plunge to a bowling alley and restaurant.

would prove to be even more dazzling, in 1899 the Santa Monica Electric and Power Company constructed a large brick building on the beach next to the North Beach Bath House to power homes and businesses in Santa Monica.

As the twentieth century dawned in Santa Monica, the city lights were on. But even that magnificent incandescent display couldn't compete with the dramatic moonlight on the beach and the draw of the sunshine by day. In most people's eyes, Santa Monica Beach was the brightest spot on the Pacific coast.

CHAPTER TWO

ATTEMPTS FOR A SEAPORT

Los Angeles & Independence Wharf, 1877

Steamships and sailing vessels are docked at the railroad's wharf. These ships brought in supplies and railroad equipment for the continued construction of the Los Angeles & Independence Railroad.

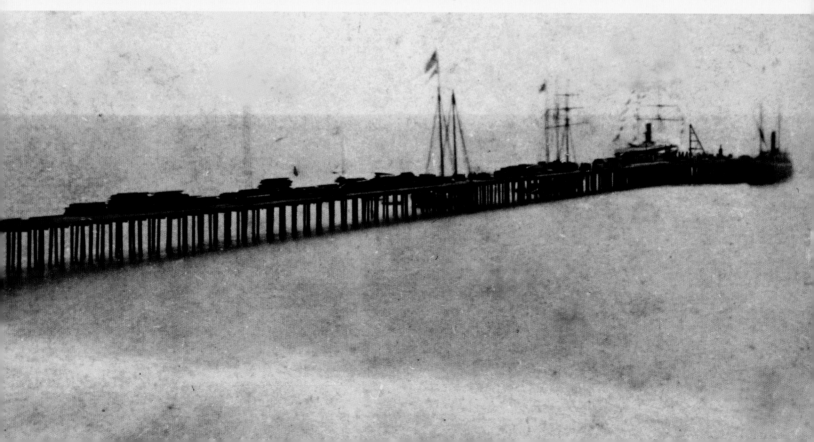

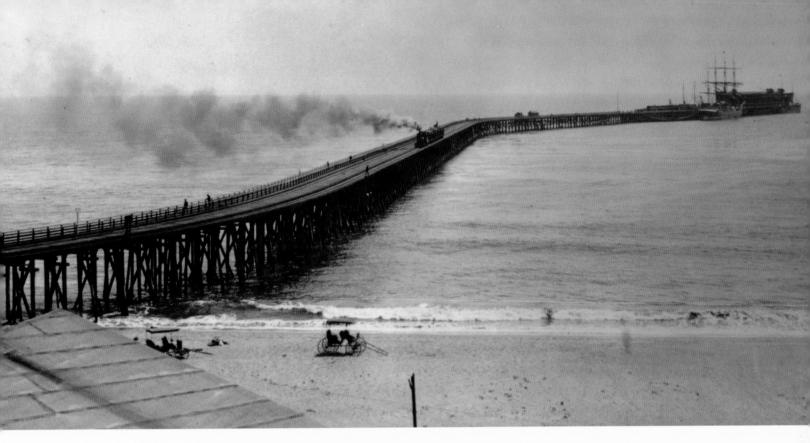

THE LONG WHARF, 1893

A photograph by the R & E Company captured a Southern Pacific train leaving the Long Wharf, headed for Santa Monica. The railroad began moving passengers and goods from ships docked at the Long Wharf—officially called Port Los Angeles—in 1893.

Imagine the beauty of Santa Monica Beach in the 1870s: a wide, white sandy shore where only the waves interrupted the dramatic sunsets, and temperatures hovered year-round at sixty-eight degrees. The place was meant to be a resort, practically preordained as the pristine gateway to the Pacific. But moneyed interests had another view; they weren't swept away by the beauty. They recognized the perfect location for a seaport and saw dollar signs. Santa Monica, with its vast shoreline, they reasoned, represented a perfect harbor and an ideal place for a railroad depot. These businessmen envisioned Santa Monica as a gateway to commerce, a harbor that could dominate the West Coast. Yet, if those entrepreneurs hadn't aggressively attempted to exploit the area, one of the world's most famous beaches might have remained an inaccessible expanse of sand.

From the early days, the development of Santa Monica and its beach was a direct result of railroad expansion. In December 1874 John P. Jones, a wealthy Nevada senator and businessman, visited the Santa Monica area on a scouting mission. He was looking for an ocean terminus for the railroad he intended to build from his Panamint silver mines in Independence, California. At the time, the Southern Pacific Railroad carried all freight to and from Los Angeles via the harbor at San Pedro—but Jones wanted his own exclusive outlet to the sea.

Upon his arrival on the California coast, Senator Jones met with Colonel Robert S. Baker, who had extensive landholdings in the area. Baker had recently purchased two enormous territories of land, the *Rancho San Vicente,* (totaling more than thirty thousand acres) from the heirs of Francisco Sepulveda and an undivided one-half (approximately thirty-three hundred acres) of *Rancho Boca de Santa Monica* from Maria Antonia Reyes, the widow of Ysidro Reyes. The reason Jones chose Baker as his escort on his California excursion was patently clear; shortly after the senator's visit, an announcement was made that he had acquired a three-quarter interest in Baker's landholdings for $162,500. Within a month, the two men laid out plans for a town and registered it as the Township of Santa Monica, borrowing the name from *Rancho Boca de Santa Monica.* With the new designation, they immediately began development of the Los Angeles & Independence Railroad. The first section of rail was to extend from Santa Monica to Los Angeles, and then on to Independence in the Owens Valley, east of the Sierra Nevada mountains.

Both Senator Jones and Colonel Baker were self-made men—Jones earned a considerable fortune from his silver mines and Baker owned a mining supply business in San Francisco. Establishing Santa Monica was a financial investment; should the new town and seaport prosper, Jones and Baker stood to make considerable gains selling land. But this entrepreneurial effort was always secondary for Senator Jones—primarily, he wanted a railroad route for his silver mines. Despite these California business interests, Jones remained a resident of Nevada, where the well-loved politician served thirty years in the U.S. Senate.

By February 1875 construction of the new railroad was underway. Because Southern Pacific Railroad refused to carry materials for competitors, all building materials had to be brought in by sea. At the foot of Railroad Avenue a 1,740-foot-long wharf extended into the ocean from the area originally called Shoo Fly Landing. It had a warehouse and depot at the end so ships could dock to unload railroad supplies and building equipment. Chinese laborers brought from San Francisco graded the tracks, which when finished stretched from the end of the wharf to a depot some seventeen miles east in Los Angeles.

In May advertisements promoting the new town of Santa Monica were published in newspapers throughout California and in other parts of the nation. With that promotion, Jones and Baker hoped to bring in potential buyers for an auction of residential and commercial lots on July 16, 1875. Indeed, land-hungry crowds came aboard wagons from Los Angeles and on a special ship from San Francisco. The instincts of Baker and Jones were correct—Santa Monica was hot property. Wooden-frame houses and commercial buildings shot up on the treeless flat land above the undeveloped coastline, replacing the wild grass and abundant yellow mustard weed.

On October 17, less than a year after Senator Jones's visit to Santa Monica, the Los Angeles & Independence

Railroad had its maiden run. At the time, track had only been laid as far east as the depot at *Rancho las Cienegas* (today this spot is located roughly at Exposition Boulevard between Crenshaw and Western Avenues). For Jones and the citizens of Santa Monica, the opening of the Los Angeles & Independence was a triumphant occasion. Because the railroad's passenger cars had not yet arrived, travelers sat in chairs directly placed on the beds of flatcars, roofed over with awnings and other fancy decorations. Cheered on by an enthusiastic crowd, the train started its ten-mile trip west from *Rancho las Cienegas* and arrived nineteen minutes later at the Santa Monica wharf, where an even larger throng welcomed the first-ever Los Angeles & Independence Railroad passengers.

A month or so later, the last spike was driven home in front of the new Los Angeles & Independence depot on San Pedro Street near Wolfskill Lane (now Fourth Street) in downtown Los Angeles. Santa Monica was now connected to Los Angeles by rail and was on the map as a seaport for goods destined for Southern California. That very day, Southern Pacific reacted by cutting rates in half for shipments from Los Angeles to the city's harbor at San Pedro. Headed by Collis P. Huntington (a notoriously shrewd member of "the Big Four" railroad magnates, along with Leland Stanford, Charles Crocker and Mark Hopkins), the Southern Pacific Railroad owned the only rail line from Los Angeles to the port at San Pedro, and thereby had attained control over all shipping to and from Los Angeles. In fact, Southern Pacific had no competition at any seaport along the entire Southern California coast—until the Los Angeles & Independence opened. Huntington greeted the news of his new rival with a declaration that he and Southern Pacific would ruin Jones's new railroad. On December 1, when the Los Angeles &

Independence began regular service from Los Angeles to Santa Monica, Huntington announced a further rate cut. To compete, Jones was forced to operate his line at a loss. The fate of the Los Angeles & Independence was becoming very clear.

At first, Senator Jones was not overly concerned about the Southern Pacific's tactics. He was wealthy enough to wait for profits. The railroad became the chief mode of transportation for tourists who visited Santa Monica, and by 1876 two trains a day were making round trips between Los Angeles and the beach. Advertised as "Gala Excursions," the schedule allowed travelers to spend five hours bathing, fishing or picnicking on the beach for a round-trip fare of one dollar per person for adults and fifty cents for children. The trains were an obvious improvement over the horse and wagon, making Santa Monica more accessible to people of all economic classes for weekends or vacations. Steamships carrying passengers and freight were calling at the Los Angeles & Independence wharf, but the *San Francisco Chronicle* reported that the Southern Pacific at the harbor in San Pedro was drawing twice as much business as Santa Monica.

Another financial blow struck Jones in August 1875 when a financial panic in Comstock silver mining securities forced the Bank of California in San Francisco to close its doors. Los Angeles banks were also hurt by the panic that ensued. A final crash occurred in January 1876 and many of Jones's investments became losing propositions overnight. Further construction on the Los Angeles & Independence track between Los Angeles and the Cajon Pass in the San Bernardino Mountains halted. To make matters worse, in September 1876 Southern Pacific completed its line from San Francisco to Los Angeles. Freight coming into San Pedro could be long-hauled to other points on the Southern Pacific

line, but freight coming into Santa Monica could be carried on the Los Angeles & Independence only as far as Los Angeles. The smaller railroad simply could not compete, and Jones's business was in trouble. Rumors spread that Jones was looking for a buyer.

In 1877 the senator offered to sell the railroad to the County of Los Angeles at cost. The county refused the offer for fear of incurring the displeasure of the Southern Pacific, whose power in the state was close to absolute. Jones then approached Jay Gould, the head of the Union Pacific Railroad. Unbeknownst to the senator, however, Collis Huntington had already convinced Gould that the Los Angeles & Independence was a poor investment. So, Gould, too, declined Jones's offer.

Out of funds and desperate, Jones had no alternative but to sell his railroad to the Southern Pacific. The formal transfer took place on June 4, 1877. Immediately, the big railroad raised its Los Angeles-to-San Pedro rates to the highest price in history. When the tracks of the Los Angeles & Independence were connected to those of Southern Pacific, the Los Angeles depot of the former was sold. Thereafter, two trains a day ran to Santa Monica from Southern Pacific's River Station in Los Angeles, one at nine-thirty in the morning, and the other at four-thirty in the afternoon, with an extra train on Sundays. The change in ownership didn't affect travel to Santa Monica Beach, though. It remained a huge attraction for thousands of eager travelers.

Worried that Santa Monica was still a potential threat to their monopoly at San Pedro, Southern Pacific officials dispatched a team of engineers to examine the Los Angeles & Independence wharf on the pretense that it was unsafe. The engineers claimed that the piles of the pier were almost eaten through by sea worms called *teredos*. To prevent

"imminent collapse," the engineers reported, three-fourths of the wharf's pilings needed to be replaced. Rather than invest in extensive and expensive reparis, Southern Pacific executives decided to dismantle the wharf. On January 2, 1879, workers began tearing it down. Despite the engineers' report, the workmen struggled to knock down the piles, which wouldn't budge—clearly the piles were not infested. Ultimately workers had to wait for low tide and saw off the piles. A fraudulent report resulted in this unglamorous end to the Los Angeles & Independence wharf. Santa Monica was removed from all shipping charts, and by 1880 the town was no longer a viable seaport.

A ubiquitous gloom settled over beautiful Santa Monica. Though tourists still flocked to its sand, residents suffered many financial setbacks. Business failures were common, property values plummeted and within a few months some of the disappointed citizens moved away. In little more than a year, Huntington had eradicated the threat to Southern Pacific's monopoly of the Los Angeles shipping industry and nearly destroyed a little town in the process.

But a rate war between other competing railroads soon brought Santa Monica hope and a much-needed commercial upswing. The completion of the Atchison, Topeka & Santa Fe Railroad's intercontinental line once again endangered Southern Pacific's monopoly. The two railroads had lowered rates to as little as one dollar per person for a one-way trip from the East Coast to California. More than two hundred thousand people took advantage of these cheap rates and permanently moved to California. New towns were established along the rail lines in California, and while Santa Monica was not one of the boomtowns, the city certainly benefited from the mass migration to Southern California.

Thanks to this influx of easterners, Santa Monica was

LOS ANGELES & INDEPENDENCE LOCOMOTIVE, 1876

Just a year after an unknown photographer snapped this picture of a Los Angeles & Independence locomotive, the railroad was bought out and shut down by rival Southern Pacific.

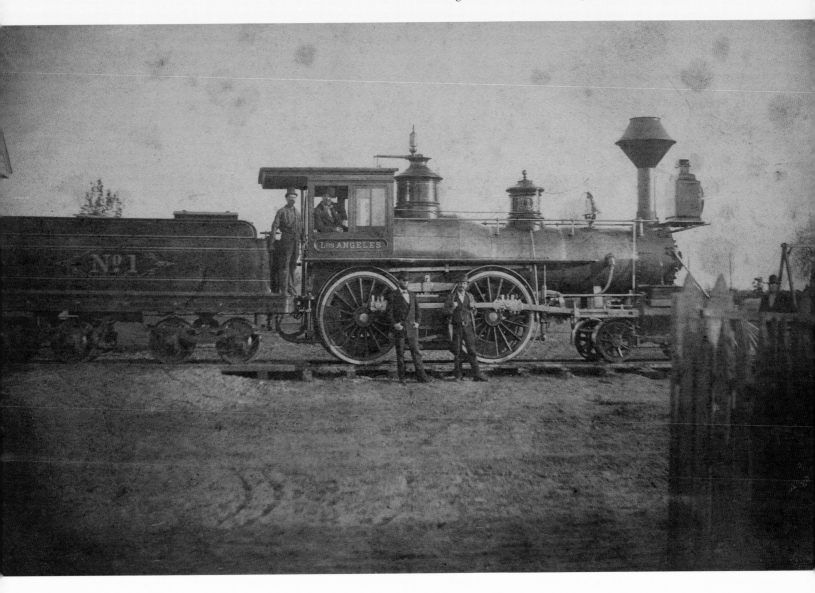

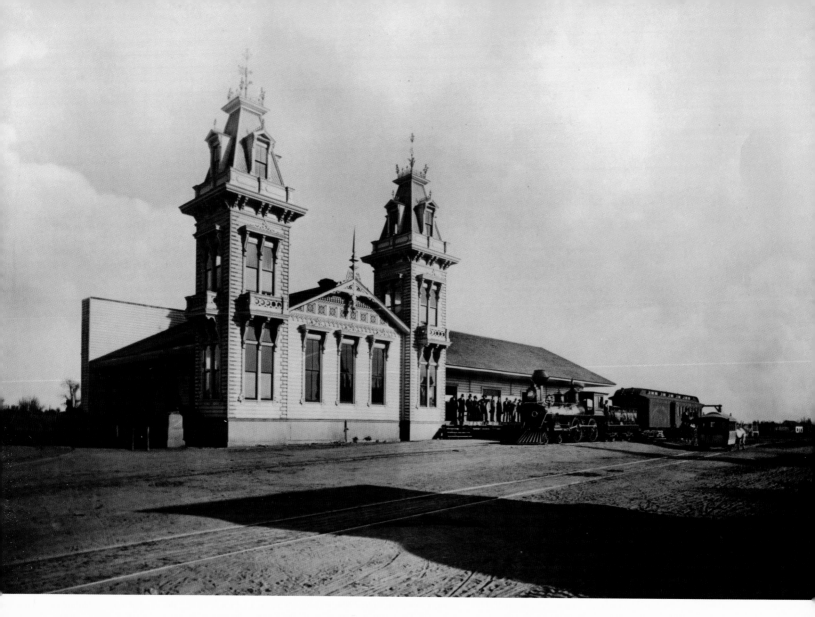

LOS ANGELES & INDEPENDENCE DEPOT
IN LOS ANGELES, 1876

This ornate and unusual building located on San Pedro Street in downtown Los Angeles was closed down as a depot after Southern Pacific acquired the railroad. Soon after that, the building was sold and later torn down to make way for other developments.

again blossoming as both a respectable residential area and a popular beach resort. The 1890 census showed 1,580 citizens, an increase of more than four hundred percent in a decade. By February 1891, it had increased to two thousand. And with the great growth of the town, Huntington rekindled the dream of making Santa Monica a major seaport. Unbeknownst to the citizens, the railroad was developing plans that would bring

about a drastic change in direction and impact to the town's identity. Huntington saw unlimited potential in Santa Monica as a commercial harbor—specifically as the primary deep-water harbor for the city of Los Angeles.

Southern Pacific was slowly losing its freight business to other railroads. Southern Pacific's main rival, the Atchison, Topeka & Santa Fe Railroad, was handling sixty percent of the water traffic coming in and out of Los Angeles through its Redondo Beach wharf. Huntington decided that the only way to ensure control of shipping for Southern Pacific was to have his own harbor. When he announced his intention to leave San Pedro and situate the main deep-water harbor at Santa Monica, many Santa Monica citizens noted the irony—just a few years earlier, Huntington's crew had dismantled a perfectly good shipping wharf in their town.

Huntington's announcement split Los Angeles into three factions: the first favored San Pedro and were against Santa Monica as a seaport, the second sided with Huntington and favored Santa Monica and a third group supported Redondo as the seaport for Los Angeles. The ensuing battle over a harbor lasted nine bitter years and went all the way to the U.S. Senate for resolution. Instead of waiting around for the results, Huntington set to work. Through his Pacific Improvement Company, he purchased the right-of-way along the beach as far north as Santa Monica Canyon from Senator Jones and the right-of-way to land north of the canyon from brothers Pascual and Bonifacio Marquez. Then Southern Pacific astounded people on all sides of the debate by announcing plans to build the largest wooden pier in the world just north of Santa Monica Canyon. Many locals were delighted because they believed their city would again become

a major seaport, sixteen years after the first aborted attempt by Senator Jones. However the location was a disappointment for many. The spot Huntington chose required installing nearly two miles of track extending north on the beach (today that would be roughly from the McClure Tunnel at the west end of Interstate 10 to Potrero Canyon in Pacific Palisades).

Work on the wharf began in July 1892 and continued nonstop; crews worked day and night on the massive project. Construction of the railroad along the beach began, and at the same time workers started excavation for the tunnel under the cliffs at the foot of Railroad Avenue so the trains could reach the beach. Further up the beach the 99 Steps had to be remodeled and raised to accommodate the trains that would run underneath.

Thousands of curiosity seekers came to watch the construction, incredulous at the wharf's size. By 1893 the rhythmic pounding of five powerful pile drivers, each equipped with a three-thousand pound hammer, could be heard for miles around. These awesome hammers drove ninety-foot piles into the ocean's floor. When the wharf was completed, it was 4,720 feet long. Declared to be "the most perfect wooden pier in existence," the wharf had no official name and was variously referred to as the Santa Monica Wharf, the Southern Pacific Wharf, the Southern Pacific's Mammoth Wharf—even Santa Monica Harbor. Finally, on April 29, 1893, Huntington officially designated it Port Los Angeles. But most people simply referred to it as the Long Wharf.

Even before the completion of Port Los Angeles in September 1893, ships had begun to call there. The first was the San Mateo, a collier that arrived May 11, 1893, carrying a group of passengers from San Francisco. The big steam trains

that continued to run from Los Angeles to Santa Monica on a regular basis had a new final stop—the end of the Long Wharf. Upon reaching their final destination passengers could transfer to a Pacific Coast steamship headed either to San Diego or San Francisco.

Huntington did everything he could to sway Congress's decision about the harbor, including a threat to abandon the harbor at San Pedro because of allegedly rocky and unstable land for his wharf and tracks. Of course, Southern Pacific had been operating out of that harbor for years, but Huntington was taking a stand—he would have his harbor in Santa Monica or not at all. From 1893 (the year the Long Wharf was completed) to 1896 a total of 759 ships from all parts of the world called at Port Los Angeles. Congress eventually appointed three different boards of engineers to resolve the harbor controversy, and all agreed that San Pedro was the logical site for L.A.'s official deep-water harbor, despite Huntington's heavy lobbying. On October 10, 1897 the last board filed its final ruling in favor of San Pedro. The ten-year battle over a seaport finally ended, with Santa Monica, Collis Huntington and the Southern Pacific cast as losers. Although many Santa Monica citizens were disappointed, visionaries heaved a sigh of relief, recognizing the long-term value of remaining a residential town with an irresistible shoreline.

In 1899, a Japanese fisherman named Hatsuji Sano, who had emigrated from Japan the year before, arrived at Port Los Angeles. He became the first resident of what developed into a Japanese fishing village north of the Long Wharf. Over the next ten years, the village prospered and became a desirable summer vacation spot for Los Angeles's Japanese population. Two hotels were opened, a beach resort in the

canyon named *Rako Kan* and another, the *Boyo Kan*, in the village. The village's three hundred permanent residents built their houses on land leased from the Southern Pacific Railroad. Most residents relied on commercial fishing for their livelihood and used the Long Wharf as a landing platform on which to unload fish, which were then boxed and transported to market. The village was destroyed by fire in 1916.

Though passenger steamers also used the Long Wharf, Los Angeles merchants gradually deserted Port Los Angeles to do business in the official Los Angeles harbor at San Pedro. Collis Huntington's death in 1900 also marked the end of his harbor. His successor at Southern Pacific had little interest in the expensive maintenance of Port Los Angeles. By 1908 Southern Pacific's locomotives no longer traveled to Port Los Angeles and the Long Wharf was leased to the Los Angeles Pacific Railway, which operated it for the next three years. In 1911 the Pacific Electric Railway Company (a huge interurban system created by Henry Huntington, Collis's nephew) assumed control of the Los Angeles Pacific Railway, the Long Wharf and the property surrounding it. In 1913 Pacific Electric officials ordered the dismantling of the wharf's depot building, coal bunker and the last sixteen hundred feet of the Long Wharf. They retained the rest of the wharf as a fishing pier for the public. In July 1920, a final decision was made to dismantle the remainder of the wharf, and Port Los Angeles was no more.

By that time, Santa Monica's citizens and visitors may have been happy to lose Port Los Angeles. Plans for amusement piers, bathhouses and pavilions along Santa Monica Beach were in various stages of completion. Forget the grief of seaports, railroads and warehouses—Santa Monica was ready for fun.

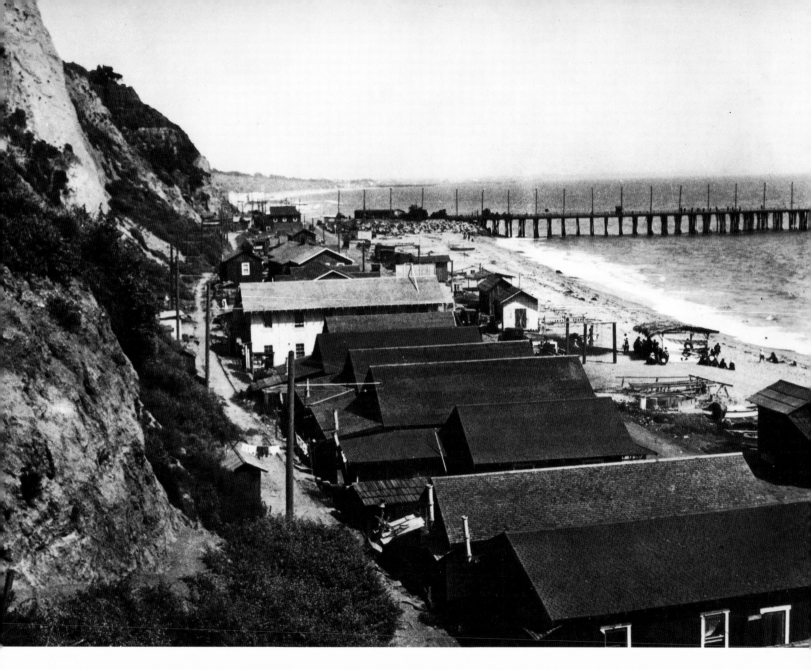

Japanese Fishing Village, c. 1915

When filmmakers of the day needed a Japanese setting, they often turned their cameras to a community of about three hundred Japanese fishermen and their families who established a village just north of the Long Wharf. The livelihood of the village was dependent on the catch from Santa Monica Bay, be it halibut, albacore, yellowtail or barricuda, as well as smaller fish that could be caught in nets. Today, Pacific Coast Highway runs through the exact spot where the Japanese settlers lived before fire destroyed the village in 1916.

THE SEASIDE PLAYGROUND

NORTH BEACH BATH HOUSE, C. 1900

Beach-goers dressed in suits and ties, relax on the sand in front of the beach's most popular bath-house. The bowling pavilion, North Beach Bath House Pier, Camera Obscura and Shoup's Tavern are to the south. The pointed tower of the Arcadia Hotel overlooks the scene.

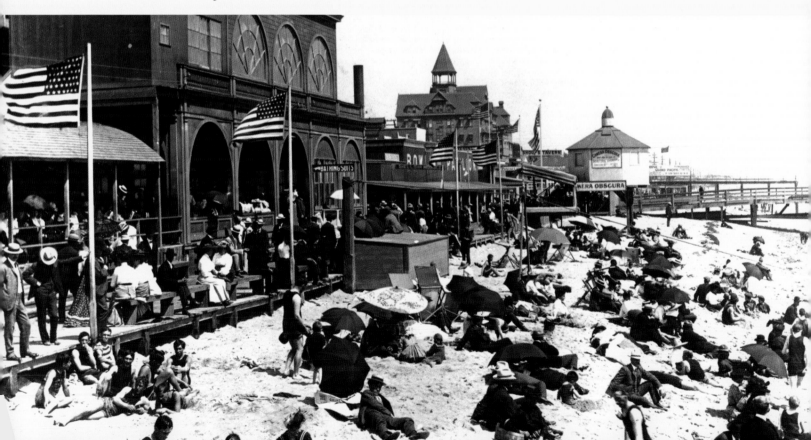

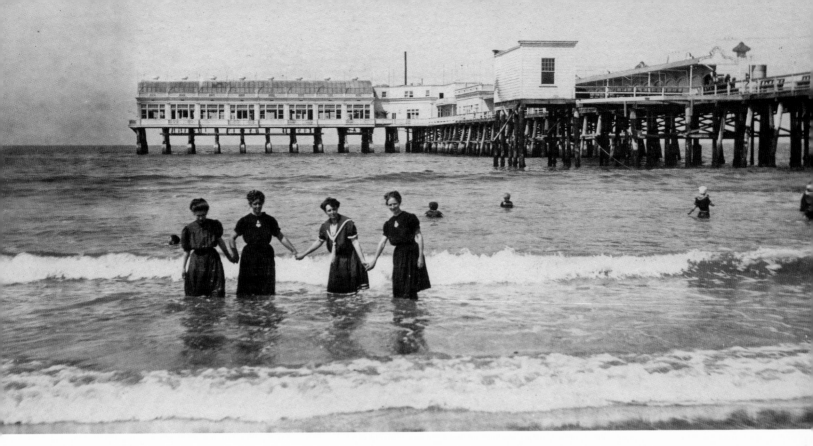

BATHERS BY THE BRISTOL PIER, 1905

In this real-photo postcard, women enjoy the surf in front of the Bristol Pier. On the pier, the building parallel to the shore is the Bristol Café.

By the turn of the nineteenth century thousands of people were coming to visit Santa Monica Beach and its attractions, not just from nearby Los Angeles, but from all over the world. In the decades that followed, beach development continued to include a host of awe-inspiring amusements. From bathhouses to beach clubs, roller coasters to ballrooms, Ocean Park to Pacific Ocean Park, Santa Monica became synonymous with leisure and fun. Pleasure piers stretched out into the ocean, offering entertainment rather than shipping wharfs, and by the 1920s few visitors even knew that this beach was once intended to be a seaport. Instead, the beach was *the* place to be, either at an exclusive supper club like the famed Nat Goodwin's or at the La Monica Ballroom where couples kicked up their heels to jazz bands. Santa Monica was a fun-loving democracy, where visitors, rich or poor, received a day of free sunshine and a night of rowdy fun.

In the first few years of the new century, most beach visitors still congregated near the two largest structures on the beach, the Arcadia Hotel and the North Beach Bath House. However, other smaller bathhouses drew a number of customers as well, including several located at the northern end of Santa Monica in Santa Monica Canyon. In 1887 Michael Duffy built his second bathhouse on the beach on land belonging to Pascual Marquez. Duffy named the Pascual Marquez Bath House in his honor, and horses and wagons brought patrons until the bathhouse's closure in 1892. Then, in 1915, Frank E. Bundy, a real estate developer, built the Santa Monica Canyon Bath House at the same location where the Marquez bathhouse once stood. Across the street, at the foot of Chautauqua Boulevard, was the Will Rogers Bath House, a brick structure. (At the time, Will Rogers owned a large portion of the beach in front of the Santa Monica Canyon. Years later, in 1941, the State purchased his land and thereafter preserved it from development. It was given the name Will Rogers State Beach.) To keep up with the influx of competition, the owners of the North Beach Bath House made several improvements to their facilities in 1901. The Jones brothers enclosed the bathhouse's roof garden for an auditorium space and extended a heavy rope from the beach into the ocean for bathers to hold while wading in the surf. This rope helped bathers, who were wearing woolen bathing suits that became heavy (not to mention itchy) when wet, from being knocked over by incoming waves. During the summer of 1902 the *Los Angeles Times* ran an article that boasted about the safety of Santa Monica Beach, "...It is safe to say that since this little city had been laid out, nearly a million people have bathed in the surf there; and while there have been a number of fatalities due to suicide, heart failure and apoplexy or cramp, there has not been one authenticat-ed instance of any person being overcome by a treacherous current or tide, or any person having been lost who was from any public bath house."

But the city of Santa Monica hardly needed the good press with all the exciting events that were happening on the beach. One of the biggest events was the arrival of the U.S. Navy's Atlantic fleet. On April 18, 1908 the largest crowd to ever assemble in Santa Monica jammed the Palisades and the beach, as people positioned themselves for a view of the fleet. A flotilla of sixteen battleships and ten auxiliary vessels, all painted a gleaming white as a sign of peace, sailed up from San Diego for an official visit to Los Angeles/Santa Monica, one of many stops on a promotional cruise. This worldwide tour of the "Great White Fleet" was Theodore Roosevelt's way of "speaking softly and carrying a big stick." Even with the guns of the ships muzzled, the fleet was an impressive display of naval power.

Though the big Southern Pacific Railroad steam trains stopped running along the beach in 1908 after Port Los Angeles closed, the Long Wharf continued to draw visitors. In 1911 the Pacific Electric Railway Company assumed control of the wharf and the property surrounding it. They electrified a trolley line all the way to the end of the wharf, and the wharf became part of Pacific Electric's mammoth interurban electric system, which extended into almost every city and town in Los Angeles and Orange counties. In fact, the wharf was a stop on the famous Balloon Route Trolley Trip, which was a one hundred-and-one-mile trip that cost a dollar and lasted all day. The ride out on the wharf was described in advertisements as "the only ocean voyage in the world on wheels; and never any sea sickness." And without a doubt, traveling almost a mile over the ocean in a trolley car was a memorable experience for many a tourist.

There were a few setbacks to the city's burgeoning seaside playground, including severe storms in February and March of 1905 that caused considerable damage to the beach from Santa Monica to Venice. Heavy waves and high tides smashed the North Beach boardwalk, and two hundred feet of North Beach Pier was swept away. Both the bandstand and the Camera Obscura were left teetering. The beach was littered with pilings and debris washed ashore by the storm. South Santa Monica piers suffered damage, and one of the more unpleasant results of the storm was that the city's sewer outfall pipe was completely destroyed.

The swelling numbers of tourists and residents and the destruction of the outfall pipe during the storms presented Santa Monica with a problematic sewage situation. In 1908 the town leaders decided to build a cesspool and a sewer outfall at the foot of Colorado Avenue. Engineers were hired to design a pier that would hold the outfall pipe. The revolutionary design the engineers presented would be the first of its kind on the Pacific coast; a steel reinforced all-concrete pier sixteen hundred feet in length. Experts argued that the effects of seawater on the concrete over time were unknown and that the plans for the new pier were too risky. In spite of the controversy, the city proceeded with construction. A temporary sewer pipe was placed on the North Beach Bath House Pier while the concrete pier was under construction.

During the course of construction the workers encountered many serious setbacks. Molds leaked while piles were being cast, causing the concrete to become weak and permeable. Work on the pier stopped while new molds were made. At other times piles would crack or break because a tackle broke while they were being hoisted into position. Several storms with heavy swells caused severe damage when piles were left in place unsupported. In some cases even powerful equipment could not remove rejected piles so workers had no alternative but to repair and patch the piles, leaving them as part of the structure. Iron casings were needed to protect the piles located near the shore since broken piles from other wooden piers acted like huge battering rams with the force of the surf.

But finally, on September 9, 1909, the monolithic pier was completed at a cost of one hundred thousand dollars. That day, five thousand people came to the beach to celebrate the grand opening of the Municipal Pier. A parade traveled from City Hall to Colorado Boulevard in a procession that included city officials, a band, the police force of Santa Monica, the Elks, several Marine squadrons and the sailors from two Navy cruisers stationed in the bay. The Municipal Pier quickly became one of Santa Monica's most popular tourist attractions and offered beachcombers yet another reason to choose Santa Monica over other nearby beach destinations. People loved to stroll out over the ocean, just as they had once done on the Long Wharf, and look back at the shoreline from a point of view previously afforded only to sea birds. The novelty of the Municipal's construction only added to the wonder.

Unfortunately, less than a year after the Municipal Pier was built, its piles needed repair. Eleven piles needed a small amount of patching at the waterline. Repairs were made, but funds ran out before the job was complete. A year later the dismantling of the wooden Long Wharf caused driftwood to batter the piles of the Municipal Pier. The city's worst fear became reality on August 17, 1919 when the pier began to shake and groan beneath the weight of thousands of sightseers. A section of its north side, twenty feet in length, sank almost two feet, but fortunately the pier did not collapse. Panic was averted as police evacuated the Sunday sightseers.

THE SANTA MONICA BEACH PIERS, 1917

This photograph of the Santa Monica beach piers—the Municipal Pier and Looff's Pleasure Pier—shows the many attractions of the newly opened pleasure pier including the Blue Streak Racing Coaster. Of course, the greatest attraction was already in place: the beach.

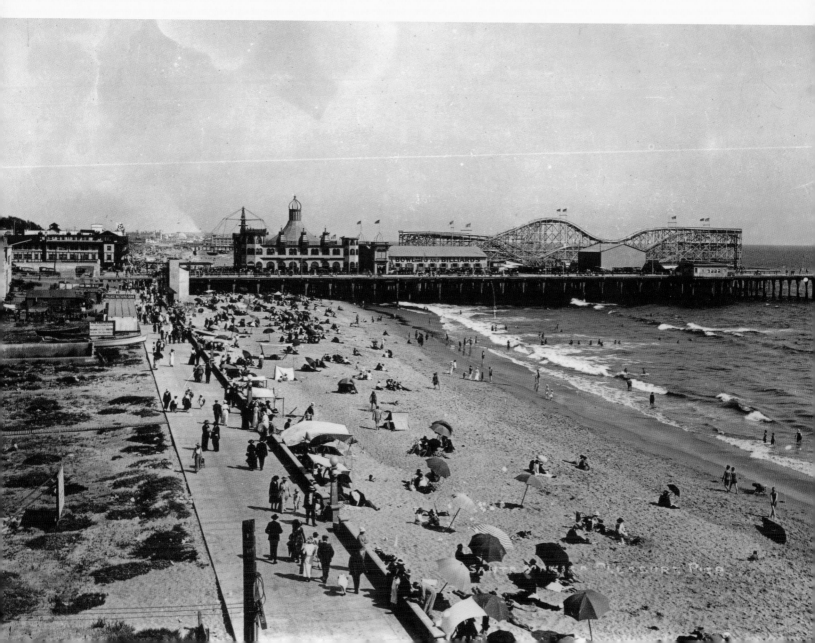

Following the near tragedy, a board of expert engineers condemned the Municipal Pier and it was closed to the public. The pier's problem was porous concrete, which had allowed salt water to corrode the steel reinforcing rods. The consulting engineers recommended that the concrete piles be replaced with creosoted wooden piles and timber caps and struts, retaining the existing deck structure. They believed such a substructure would make the greatest possible use of the original investment and keep the public safe. Work began September 5, 1919, and it took workers more than a year to complete the project. The new and improved Municipal Pier finally reopened to the public on January 19, 1921.

By then ocean piers were vital beach amusements and familiar sites along the beach—especially in south Santa Monica. Ocean Park, the area of beach south of Pico Boulevard, boasted numerous popular piers including the Horseshoe Pier, Ocean Park Pier and, a little further south, the Venice Pier. Though always considered a part of Santa Monica beach geographically, Ocean Park was created in 1895 when developers, frustrated with Santa Monica's Board of Trustees, decided to create their own town. The trustees worried that development of south Santa Monica would take business away from north Santa Monica, and their concerns were well-founded.

In 1897 developers Abbot Kinney and Francis Ryan built the 1,250-foot Ocean Park Pier at the end of Pier Avenue. The pier, accessible to the public and fishermen, was wildly popular. Then in 1904 Abbot Kinney announced that he would develop the land just south of Ocean Park—he would build a city that looked like Venice, Italy, complete with canals and gondolas. Along with his dream city, Kinney constructed a new nine-hundred-foot-long pier simply called the Venice Pier at the end of Windward Avenue. Though both piers were destroyed by the storm of 1905, they were quickly rebuilt.

Together the towns of Ocean Park and Venice became known as the Coney Island of the Pacific. Countless thousands of tourists came and spent their dimes and nickels on the seemingly unlimited number of attractions available there. From riding a live camel or a gondola in Venice, to sliding on a gunny sack down the Dragon Slide or riding any one of several giant roller coasters, the areas of Ocean Park and Venice offered boundless fun. One could play bingo at parlors on the piers and promenade, or go swimming in the beautiful Ocean Park Bath House, built in 1905. The building that housed the huge salt-water plunge resembled an Arabian palace, with domed towers and a glass skylight. At night when the building twinkled with white lights, it was an amazing sight.

In 1911 another former partner of Kinney's, Alexander Fraser, replaced the Horseshoe Pier with a huge project he called Fraser's Million Dollar Pier. That same year, developer Charles Lick constructed his Lick Pier contiguous to Fraser's. On Tuesday, September 12, 1912 a fire started next to the Casino Ballroom on Fraser's Million Dollar Pier, and soon destroyed both piers. They were quickly rebuilt and reopened May 30, 1913. Later, in 1919, Ernest Pickering purchased Fraser's Million Dollar Pier, enlarged it and renamed it Pickering Pier.

The threat of fire was a constant danger to the wooden pleasure piers and their buildings, which were also made entirely of wood. But visitors had fun—not disaster—on their minds and never let the possibility of a devastating fire deter the merriment. Of course, fire hydrants that pumped in seawater were readily available on the piers, but these proved ineffective in the intense heat of a blaze since firefighters could rarely reach them. On January 6, 1924, the Pickering and Lick Piers burned down. This time only Lick rebuilt his pier. That same year, Eddie Maier, a local brewery owner, and his partner William Stutzer built the Sunset Pier

THE SANTA MONICA BEACH PIERS, 1928

Taken by Adelbert Bartlett, this view shows the concrete Municipal Pier (right) and the
Santa Monica Pleasure Pier, complete with its new Whirlwind Dipper roller coaster and
the four-year-old La Monica Ballroom at the end of the pier.

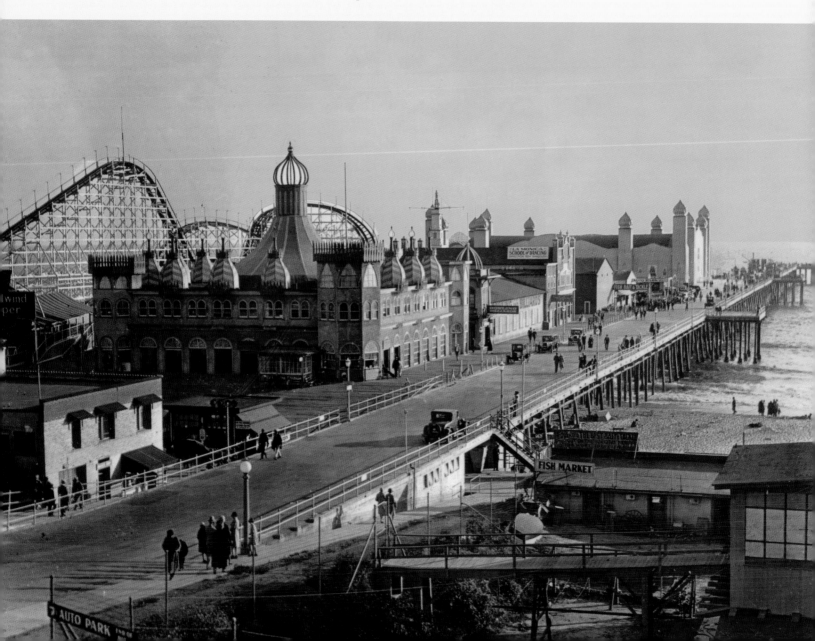

(sometimes called the Center Street Pier) at the end of Center Street in Venice. Its only major attraction was a large dance hall at the end of the pier.

Just north of the Horseshoe Pier and Fraser's Million Dollar Pier, just about back in Santa Monica proper, was another pleasure pier called the White Star Pier, built in 1905 at the foot of Hollister Street. The White Star featured a bandstand for live concerts halfway out on the pier. Unfortunately, the White Star Pier never prospered due to those competing attractions nearby at Ocean Park and Venice. Renamed the Bristol Pier in 1909, the pier was redesigned in an L-shape, with a café built on the foot of the L. The Bristol Café's waiters dressed elegantly in black pants, white shirt and black vest, with white aprons around their waists. In 1919 the portion of the pier running parallel to the shore was removed and the remaining pier widened to accommodate a new restaurant. Workers moved the existing Bristol Café to the widened section and attached a large, four-story building to it. The also added a parking lot on the beach that accommodated three hundred fifty automobiles. Actor Nat Goodwin, a well-known personality of the time (nicknamed Marrying Nat since he had been married eight times), took command of the new site. He opened Nat Goodwin's Café, a high-class restaurant and a frequent hangout for famous movie stars. When Goodwin opened his café, the name of the pier was once again changed to the Crystal Pier.

But only one pier managed to outlive all the others and remains an outstanding tourist attraction: the Santa Monica Pier. Originally, what we now call the Santa Monica Pier was, in fact, made of up two piers, the Municipal Pier and the Looff Pleasure Pier, built side by side. Charles Looff, a Danish woodcarver who had created the first carousel in the United States, realized that the pleasure piers in Venice

and Ocean Park were geographically distant enough to allow for another amusement pier in Santa Monica. So in 1916 he began negotiations with the city to build an amusement pier adjacent to Santa Monica's Municipal Pier. On June 7 the city of Santa Monica granted Looff a twenty-year franchise for the construction of an amusement pier next to the Municipal Pier. The agreement stipulated that Looff would pay the city two percent of gross annual receipts after the first five years of operation. In August work began on the wharf utilizing timbers and piles salvaged from Port Los Angeles. Incredibly, the old piles were still in excellent condition after twenty years in the water. Completed a year later in 1917, Looff's pier had 178,200 square feet of surface, plenty of space for a large number of unique amusements and free parking as well. The Pacific Electric trolley came directly to the pier, which made it easily accessible. Surely the most impressive structure on the pier was the Hippodrome Carousel Building, located at the foot of the pier. The dreamy building, whose center dome soared sixty-four feet above the deck of the pier, was a hundred feet square and housed Looff's Hippodrome carousel. The carousel was fifty feet in diameter with forty-six horses, four camels, four goats, four giraffes, a three-seat chariot, a two-seat chariot, forty-nine horses and electric wiring for two hundred twenty lights. A ninety-six key Ruth organ provided musical accompaniment for the ride.

Next to the Hippodrome was the Bowling and Billiard Building, which sported eight of the Brunswick-Balke Colender Company's latest all-maple bowling alleys and six automatic pinsetters. Two of the alleys were reserved for duckpins, and the other side of the room featured the finest billiard tables available. Outside of the Bowling and Billiard Building stood another attraction called the What Is

It? that featured a swing bridge, drop floors, rocker floors, roll floors, and bumper floors. The funhouse ended with a seventy-foot maple slide.

The Pleasure Pier had plenty more to offer. The Aeroscope, located on the south side of the Hippodrome, was a giant steel tower that stood sixty feet high with six steel arms at the top. From each arm, steel cables held a six-passenger steel boat—as the arms of the Aeroscope turned, the boats rose into the air. The Whip featured cars on a turntable that spun around in an elliptical motion. The centrifugal force created by this rapid motion would press the rider to the back of the seat of the car, and sometimes closer to other persons in the car—perfect for first dates. But the favorite attraction of thrill seekers was the Blue Streak Racing Coaster, a roller coaster designed by John A. Miller. Two trains raced side by side, at a top speed of fifty miles per hour on the coaster's double track. Though the coaster was originally built for Wonderland Park in San Diego, it was dismantled and rebuilt at Looff's Santa Monica Pier in 1916.

These daredevil rides weren't for everyone and thankfully there was plenty else to do at the pier. At the foot of the pier next to the promenade, there was a bandstand and palm-covered pergola where picnickers could sit at tables and listen to concerts by the Royal Italian Band. All around, concessionaires sold the usual snacks: popcorn, soft drinks, hot dogs and ice cream. But no liquor—the city's lease stipulated there would be no alcohlic beverages sold or served on the Pleasure Pier.

In 1917 Charles Looff sold the pier to the Santa Monica Pleasure Pier Company, which was headed by Looff's eldest son, Arthur. The new company announced further improvements to the pier including the addition of a ballroom, restaurant, shooting gallery, thousand-seat theater building and more concession booths. Unfortunately, the competition from the larger amusement parks at Ocean Park and Venice hurt, and by 1924 the Santa Monica Pleasure Pier had deteriorated from neglect. Many of its attractions were no longer open and the owners were feeling the pinch from the loss of patrons who were going to the southern piers instead. The Santa Monica Pleasure Pier Corporation put the pier up for sale.

On May 13, 1924, a new company called the Santa Monica Amusement Company purchased the franchise and planned an overhaul of the property. They added six hundred feet of new pier. A new single-track roller coaster called the Whirlwind Dipper (owned by Arthur Looff, who just could not stay out of the business) built by Church and Pryor Company, replaced the old Blue Streak Racing Coaster. The most impressive addition to the pier was the construction of a gigantic ballroom that could certainly outdo any rivals to the south in Ocean Park and Venice, and, as the owners said, "was sure to cause a stir throughout the dancing world of the California coast." Located at the end of the new pier, the La Monica Ballroom was designed by T.H. Eslick, an internationally known architect who had previously planned amusement centers in England, Scotland, France, Egypt and India. The huge ballroom, which was designed to accommodate twenty-five hundred couples at a time, covered forty thousand square feet—an area the size of an average city block—and was designed to resemble the pier's Hippodrome building. Ten towers graced the corners, each topped with a minaret. Inside, the dance floor was a work of art comprised of intricately inlaid pieces of imported hardwoods such as beech, Australian rosewood, maple and oak. A rim of covered lights and huge bell-shaped chandeliers suspended on golden ropes illuminated the sculptured designs in the ceiling.

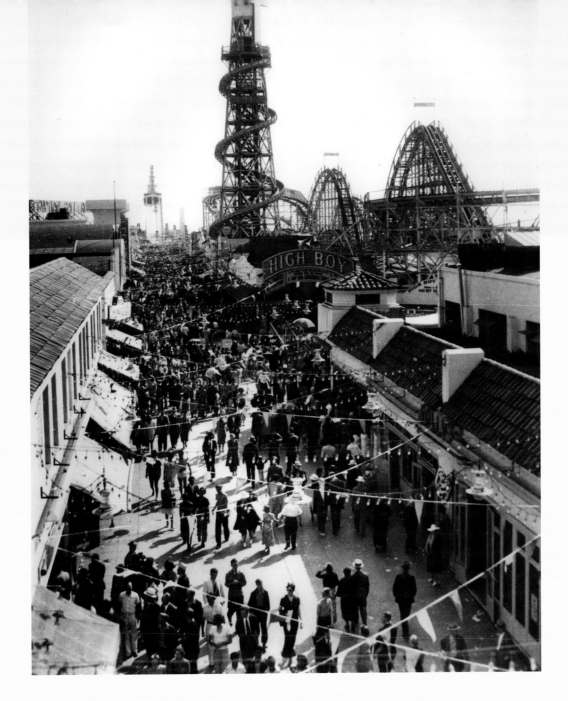

OCEAN PARK PIER, 1929

Large crowds gathered, especially on weekends and holidays, on the Ocean Park Pier to enjoy its many attractions. Taken on the pier, this photograph shows a few of the rides, including the High Boy roller coaster (right), the enormous Lighthouse Slide which towered one hundred fifty feet above the floor of the pier and the Chute the Chutes water ride at the far end of the pier.

Dancers and observers alike delighted in the wall murals of a marine garden painted by V. Ulianoff and J. Thackento, graduates of the Russian Academy of Fine Arts.

The La Monica Ballroom had its official grand opening celebration on July 4, 1924. Don Clark and his Orchestra—who held the esteemed position of house band—and many special events were big draws for local residents, crowds from neighboring communities and travelers from all over the world during the ballroom's inaugural year. There were fashion and automobile shows, weekly carnivals, masque balls, Mardi Gras and fireworks. The pier's new owners spared no effort or expense to create the most lavish model of what a pleasure pier should be. At night the pier and all its buildings—the carousel, roller coaster, Aeroscope and the La Monica Ballroom—were illuminated with thousands of small electric lights that glowed in the night. At the invitation of Don Clark, the famous Paul Whiteman and his Orchestra presented a concert at the La Monica on February 15, 1925. The amusement pier was damaged by storms in 1926 when "dolphin piles" (free-standing piles driven into the sand to protect the pier by absorbing blows from docking boats) broke loose and pounded the deck of the La Monica Ballroom.

Though the dance floor sagged four feet, the building was quickly repaired and the place continued to be a success for the next two decades. During the swing band era from 1935 to 1945 the La Monica booked famous bands led by the likes of Earl Hines, Ben Pollack and Jimmy Dorsey. Dance marathons were a fixture in the ballroom until they were declared illegal. In 1946 Spade Cooley, known as the "King of Western Swing," leased the ballroom to broadcast his radio show on station KFVD. In 1948 the fledgling television station KTLA televised Cooley's shows on Saturday nights live from the ballroom, a television first. (Cooley's success ended on a noir note, however, when he was convicted of murdering his wife and sent to prison in 1961.) After Cooley's departure the La Monica Ballroom was temporarily used as a roller skating rink, as headquarters for the Santa Monica police department during the construction of the new Santa Monica City Hall, and as county lifeguard headquarters in the 1950s. When the lifeguards left for a more elaborate facility, the magnificent structure stood empty and was allowed to deteriorate. Sadly, a mere shell of the once-grand building was torn down in 1963.

Businesses on the piers took a downturn during the Depression, but people needed free entertainment more than ever. Impromptu gymnastic shows began around 1934 at Muscle Beach, the sand just south of the Santa Monica Pier. Amateur performers did acrobatic, gymnastic and weightlifting displays for their own amusement, and for the spectators who gathered around them. Soon the health-conscious young performers became major attractions. Crowds jammed the beach on weekends to watch the amazing feats that took place decades before today's Cirque du Soleil, whose performers are now doing similar acts. Men gracefully tossed girls through the air as if they were birds, or a woman would lift three men over her head, or five men would stand atop each other in a human pyramid. These astounding exhibitions attracted thousands of people and held the spectators spellbound for hours. With athletes such as Jack LaLanne, Steve Reeves and *the* Joe Gold (whose name would later be immortalized as Gold's Gym) flexing their muscles there,

Muscle Beach became famous throughout the world and served as the birthplace of the physical fitness boom. But most importantly, during the 1930s and '40s that patch of beach and the talented hard bodies that performed there offered a much-needed physical and mental escape from the doldrums of daily life.

When Pearl Harbor was attacked on December 7, 1941 and the U.S. entered World War II, fear ran rampant that Santa Monica Beach was vulnerable to attack. Plans were made to protect the area and defense facilities moved into many of the beachfront buildings. Private development of the beach came to a halt during the war, and by its end in 1946 the beach looked much the same as it had before. Sadly, in 1946 the Los Angeles Parks and Recreation Department refused to renew the permit for the Venice Pier and condemned the area. The pier was torn down. Losing the pier and surrounding recreational area was a terrible blow to the city of Venice. Although its boardwalk still is a popular attraction, only a few of Venice's trademark canals and examples of Venetian architecture remain as a reminder of the Venice Abbot Kinney built.

Soon the popular Ocean Park Pier and Promenade would suffer a similar fate. By the 1950s all the piers south of the Santa Monica Municipal Pier were gone, except for the Ocean Park Pier, which had long since lost its appeal and its audience. A new generation of kids had little interest in its old-fashioned amusements—they wanted something flashy, more sophisticated and new. In 1956 the Los Angeles Turf Club (the owners of Santa Anita Race Track) and CBS joined together to lease the Ocean Park Pier and create a new amusement park on the site that could compete with Anaheim's Disneyland. Pacific Ocean Park opened on Saturday, July 29, 1958, and during its first week surpassed Disneyland in ticket sales.

POP, as the park was more commonly called, featured twenty-eight acres of attractions, all with sea-worthy themes. The park extended partly on land and also encompassed the entire Ocean Park Pier. Visitors entered the pier through an area called Neptune's Kingdom. As well as the usual sort of roller coasters and rides, POP also had special rides such as bubble-shaped cars, suspended on a wire, that traveled over the ocean from the entrance of the park to Mystery Island, located at the end of the pier. After a successful year, Pacific Ocean Park was sold for the hefty sum of ten million dollars. In 1965 business at POP began to decline after an urban renewal project led to many street closures, all of which made getting to the amusement park difficult. Eventually, Pacific Ocean Park declared bankruptcy and was closed forever in 1967.

Even though the great era of pleasure piers ended in the 1960s, people still felt the need to protect the one pier that remained. When the Santa Monica City Council made a move in 1973 to tear down the Santa Monica Pier (the Municipal & Looff), citizens responded with public outrage. The overwhelming opposition to the council's proposal led it to revoke the order to raze the pier. Saved from destruction by human hands, the Santa Monica Pier took another beating from nature in 1983 when the El Niño storm washed out the pier's end. Again, Santa Monica citizens rallied to save their pier and it was reopened, replete with a new fun zone, in 1990. Today it remains the sole relic of the golden age of amusements on Santa Monica Bay.

CHAPTER FOUR

CALLING PARADISE HOME

SUNSET BEACH TRACT, C. 1905

By 1905 there were three permanent houses in the Sunset Beach tract where lots were first offered for sale in 1901. They were simple, wooden bungalow-style houses built on the sand. The North Beach Bath House Pier is in the distance, as is the tower of the Arcadia Hotel.

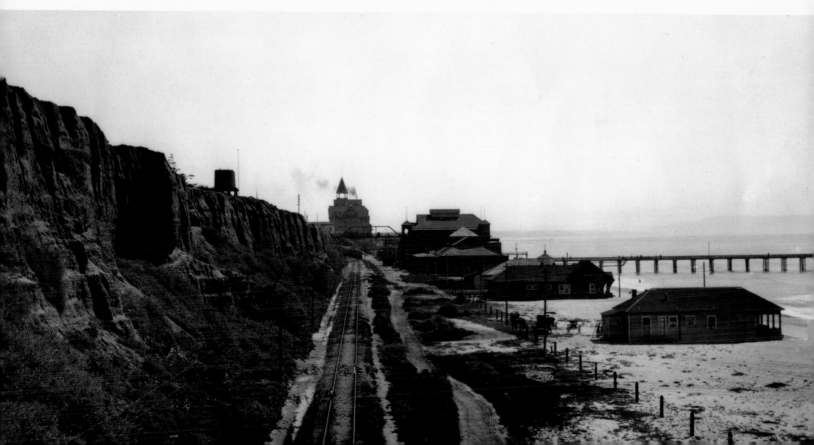

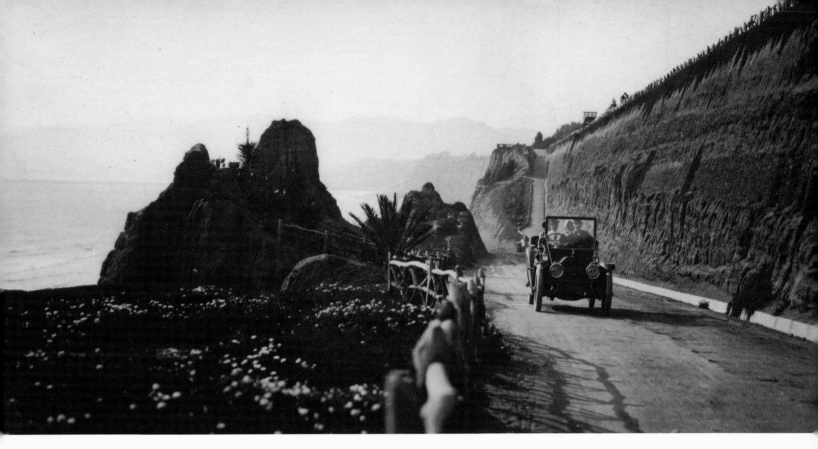

THE CALIFORNIA INCLINE, C. 1915

A real-photo postcard shows a car driving on the California Incline, which at the time was still a dirt road. The land to the left of the road has over the years eroded or caved in. A sheer edge is all that remains in the twenty-first century.

Once visitors to Santa Monica Beach got a taste of the good life, many could not resist putting down roots in this city by the sea. Santa Monica quickly expanded both in population and number of buildings. From the modest homes on Sunset Beach to the magnificent mansions built on Palisades Beach Road, the construction of houses in the first two decades of the new century physically transformed the beach landscape and shifted ownership of its sands from the public to the very private sector. And sometimes the common people, who had cherished the beach most, lost out.

At the beginning of the twentieth century, most of the beach land in Santa Monica (except the right-of-way held by the Southern Pacific Railroad) was owned by the Santa Monica Land and Water Company, headed by Robert C. Gillis. He had purchased most of the holdings of Senator Jones and Arcadia Bandini de Baker (the widow of Colonel Robert Baker who died in 1894) and eventually became a wealthy land developer. In fact, until his death in 1947, Gillis controlled thousands of acres of prime property, including most of the beach in Santa Monica.

In 1901, Gillis decided to establish the first residential community on the beach and subdivided a thousand feet of his land north of the North Beach Bath House into forty-four lots (each averaging about twenty-five feet wide by one hundred feet deep). Naming the area Sunset Beach, Gillis built a cement walk on the sand parallel to the ocean so that beachside homes would be easily accessible. Other necessities, such as electricity, gas and sewers were installed and soon several well-built cottages were constructed on the lots. These homes were leased to tenants for periods of five or ten years.

At that time, Sunset Beach, located just north of the North Beach Bath House, was the northernmost beach development. The rest of the land north to Santa Monica Canyon remained untouched, with only ice plant and weeds growing wild in the sand. The Santa Monica Land and Water Company considered this section of the beach too narrow for commercial use (it averaged sixty-five to one hundred thirty feet from the cliffs to the high tide line) and offered to sell all the beach land from Sunset Beach to Santa Monica Canyon to the City of Santa Monica for twenty-five dollars a foot. City officials who wanted to take advantage of this offer were overruled when some citizens complained that the transaction was a raid on the city treasury. This shortsighted decision forever changed the course of beach development since it ceded control of the land to private interests. The roots of contemporary controversies over public versus private beach ownership and use all along California's coast can be traced back to these early-twentieth-century decisions in Santa Monica.

Since the city failed to purchase the beach land from the Santa Monica Land and Water Company, Gillis decided to go public with its holdings. New residents bought land and built their houses right on the beach. Among the first to purchase a lot was H.C. Howeidell, a well-known architect who would later design the Henshey's department store building at the southeast corner of 4th Street and Santa Monica Boulevard. Howeidell filed a building permit for the construction of a home at 1339 Palisades Beach Road on lot 24 in 1909. Soon cottages of various sizes appeared on the beach.

At the same time as homes were cropping up on Sunset Beach, the automobile was quickly taking over as the principal means of transportation. Access to the beach from the city's flatland was always a concern to city officials. Although a 1903 proposal extended Montana Avenue down an incline in the cliff to the beach below, city officials scratched that plan in 1905 and cut an incline into the side of the cliff angling down to the beach from the foot of California Avenue to the beach below. The Southern Pacific Railroad granted permission to cross its right-of-way on the beach. Then called Linda Vista Drive, this incline remained a dirt road for many years. The name was later changed to California Incline after the name of Linda Vista Park was changed to Palisades Park. The incline provided the important link between the town of Santa Monica and its beach.

By 1913, rather than traveling en masse on trains, tourists and residents alike were driving to the beach (and everywhere else) in private cars. In 1914 the City of Santa Monica decided to widen the narrow beach road from Sunset Beach to Santa Monica Canyon. One year later, city planners

decided that the proposed road should be named Palisades Beach Road and the beaches around it should be renamed Palisades Beach (replacing the nomenclature North Beach and Sunset Beach). By 1916 work was finally underway to build the two-lane road, which was twenty feet wide and paved with a four-inch reinforced concrete base. The 99 Steps were remodeled again to allow the road to pass underneath. This road extended from Railroad Avenue north as far as the city limit at Santa Monica Canyon. Over the years the busy road has been called Roosevelt Highway (named after Theodore), Palisades Beach Road and finally the Pacific Coast Highway. Once the last name took hold, most residents simply refer to it as the PCH.

Gillis believed the very narrow beach that comprised the rest of his property was unfit for development, and asked the city's permission to experiment with a way to expand the beach. At that time engineers were experimenting with the use of groins—small jetties that prevent beach erosion. Extending from the shore into the ocean's tidelands, these solid structures, usually constructed of wood, cause sand to be deposited on the high side of the groin. The result of this buildup of sand is an extension of the width of the beach. Gillis received permission from the city to build the groins, but not without controversy. Since the accumulation of sand caused by the groins would, over time, expand the beach land, the city wanted to be sure that any additional land created would belong to the public, and not the Santa Monica Land and Water Company. Gillis and city officials agreed to use the mean high tide line as the dividing line between Santa Monica Land and Water Company's holdings and public land—anything above the high tide line belonged to the company and the sandy beach beyond the high tide line was free for public use. Of course, the two sides debated the exact location of this all-important mean high tide line,

but in 1921 the city resolved the dispute by surveying the land and establishing the line's permanent location. By 1923 two groins were under construction: one on the beach at the foot of the California Incline, and the other near the mouth of Santa Monica Canyon. Although the groins made little difference in the actual width of the beach, people were so eager to live on the beach that Gillis was easily able to sell his northern properties.

By the mid-1920s, the motion picture industry was creating millionaires seemingly overnight, so it's no surprise that movie stars, producers and directors were among the first to build homes on the beach. Many of these powerful players already had mansions in Beverly Hills, Hollywood or the suburbs of Los Angeles, but now the new trend was to live on the beach—and no celebrity was going to miss a chance to build his or her mansion at the shore. An exodus from Hollywood to Santa Monica began. Though Malibu, the beach town twelve miles north of Santa Monica, is known as the home of the movie colony, the rich and famous only settled there after there was no more space on Santa Monica's beach.

The first fantastic beach homes were built on the stretch of sand below the California Incline that extended north to the city limit at Santa Monica Canyon. Only a slender two-lane Palisades Beach Road separated the lots from the Pacific Electric Railway tracks running along the base of the cliffs. For its geographical splendor and financial exclusivity, this section of Santa Monica Beach became commonly known as the Gold Coast, and movie stars such as Harold Lloyd, Cary Grant and Mae West made their second (and sometimes third) homes there.

Hardly mere beach cottages, the majority of homes on the Gold Coast were meant to be lived in year-round. Though the lots were small (about thirty feet wide and one hundred twenty feet deep) this hidden coastland offered pri-

vacy and seclusion, two attributes that made the area even more attractive to movie stars. Owners agreed with a city regulation that lots would remain the same size as they were originally sold; any accretion or increase of the beach land caused by man-made objects such as groins, or the natural buildup of sand, would be public property. Hollywood personalities made up for the diminutive size of their lots by purchasing several at a time.

Among the first famous people to move to the beach during the 1920s were Mary Pickford and Douglas Fairbanks, who built their home at 704-705 Palisades Beach Road in 1922. This power couple, who were two of the top stars in the world, also had a home located on Appian Way on the south side of the Municipal Pier. A home at 905 Palisades Beach Road, originally built in 1923 by the Santa Monica Land and Water Company, became known as the Talmadge house, since it was occupied at one time or another by each of the three Talmadge sisters, Norma, Constance and Natalie, all of whom were noted silent film actresses. This same house later became the home of Hispanic actor Gilbert Roland. Paramount and RKO star Bebe Daniels and her husband Ben Lyon liked Santa Monica Beach so much that they built two homes at 964 and 972 Palisades Beach Road in 1927. Then, in 1928, apparently needing a change (but not of scenery), they built another home on Palisades Beach Road, designed by renowned Santa Monica architect John Byers. The famed architect built a home for J. Paul Getty at the northernmost end of the strip, 270 Palisades Beach Road, in 1934.

Palisades Beach Road might have also been named Studio Mogul Street for all the powerful producers and movie studio owners who lived there: the founders of Twentieth-Century Fox Darryl F. Zanuck and Joseph Schenck; Harry Warner who was one of the famous studio brothers; Jesse Lasky of Paramount; Samuel Goldwyn (the G in MGM); and Universal's Irving Thalberg and his wife, the movie star Norma

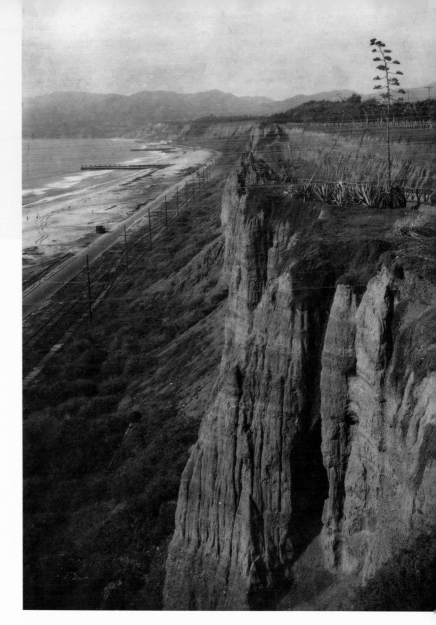

THE GOLD COAST, C. 1920 & 1926

When this photograph was taken, the beach area below the California Incline was still undeveloped except for a two-lane paved road that was laid in 1916 adjacent to the Pacific Electric Railway tracks. Just a few years later, as the real-photo postcard (opposite) shows, new homes and a new sidewalk take up most of the beach area, but the tracks are still located at the base of the cliffs.

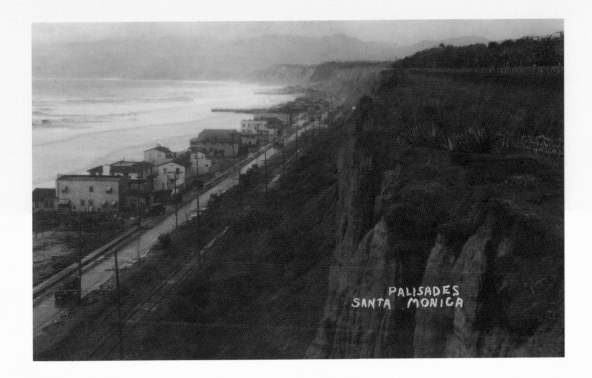

Shearer. Twentieth Century-Fox producer William Goetz and his wife Edith Mayer Goetz resided in a house designed by Wallace Neff at 522 Palisades Beach Road. The Goetzes were in close proximity to Edith's father, Louis B. Mayer (the last M in MGM), who had already lived at 625 Palisades Beach Road for ten years when his daughter built her home there in 1937. Mayer utilized art director Cedric Gibbons in the design of his home, a Mediterranean villa that included a professional projection room (complete with a full-sized movie screen that emerged from the floor on command). In this room, Mayer and his actors would screen each day's "dailies" at night—and reportedly, the first screening of *Gone With the Wind* took place there. After Mayer moved, Peter Lawford and wife Patricia Kennedy lived there and the Gold Coast house served as a frequent getaway retreat for President John F. Kennedy.

A sense of competition developed between the homeowners—each home had to be bigger and better than any other, so owners hired the best architects. John Byers,

Richard Neutra, Wallace Neff, Peter Crawley, Julia Morgan and Sumner Spalding each put their stamp on the strip of homes. Designing and building these large mansions became a real challenge for the architects because, of course, homeowners wanted the full view of the ocean and the coastline from Palos Verdes to Malibu. But the estates were crammed so close together that each inhibited the other's view.

By far the most magnificent home on the beach—the one with the most commanding view—belonged to another mogul and his mistress. Newspaper millionaire William Randolph Hearst built the famous Ocean House, as they modestly called the massive white Georgian-style mansion, for the legendary comedic actress Marion Davies in 1926. The largest and most expensive home ever built on the beach at Santa Monica, the mansion wildly surpassed all other beach houses in terms of luxury and regalness—even though the surrounding estates were owned by some of Hollywood's most elite players.

Hearst spent many millions of dollars acquiring both the property and the exquisite collections that would decorate the home. Naturally, the price dramatically increased whenever a seller learned the buyer's identity. Hoping to thwart inflated prices, Hearst attempted to buy land along the Palisades Beach Road through Brentwood real estate agent George Merrett. But that tactic didn't always work, and Hearst often ended up paying well beyond the asking price for land. As W.A. Swanberg recounts in his 1961 biography of Hearst, *Citizen Hearst,* Will Rogers and Hearst had quite a standoff over one of Hearst's acquisitions. Rogers owned a good deal of prime beach property (much of which later became Will Rogers Beach), including a lot adjacent to one of Hearst's. Thinking it would make a wonderful tennis court, Hearst had Merritt approach Rogers. Since Rogers knew Merritt was Hearst's front man, he asked for an outrageous amount—$25,000. As Swanberg recounts, a bidding war began: "Hearst said, offer him $20,000. Merrett did, whereupon Rogers raised the price to $35,000. Hearst then made a bid of $30,000. Rogers went up to $45,000. It was apparent that Rogers was playing a game at Hearst's expense. But Hearst was determined to have it and kept making bids until he got it for $105,000. 'Pleasure is worth what you can afford to pay for it,' he said philosophically to Merritt." By the time he had finished, Hearst owned ten lots on the beach. He hired Julia Morgan, the architect of his castle at San Simeon, to design Davies's home and William Flannery to head the massive construction project. The result, built in stages from 1926 to 1930, was a private residence containing 118 rooms and fifty-five bathrooms.

When Davies moved in to her new home at 415 Palisades Beach Road in the summer of 1926, she found sixteen telephone lines and thirty-seven fireplaces (some of which were over two hundred fifty years old) already installed. Hearst imported many of the rooms for Ocean House in their entirety from Europe, just as he had done for San Simeon, and specially built spaces to accommodate them. Tudor-style paneling, antique murals and priceless mantelpieces were assembled in various rooms. The 1740 bedroom of the Earl of Essex (shipped from England) became a projection room. Another of Hearst's imports was the downstairs bar called the Rathskeller. Imported from England, the large room with an oak bar dated back to 1560, and despite the German name, belonged to an inn in Surrey. Installed in Ocean House, the bar seated fifty. Many rooms throughout the house were paneled with commissioned carvings—seventy-five woodcarvers worked for a year on the balustrades alone. The Green and Gold rooms took workers six and a half months to complete (the Gold room, of course, was finished in gold leaf). The main dining room and drawing room were each more than sixty feet long, and came from a castle in County Clare, Ireland. Together they cost almost ninety thousand dollars. Details such as hand-blocked wallpaper from Zuber Works in France and crystal chandeliers from Tiffany added to the mansion's beauty and expense. The mural wallpaper in Davies's bedroom room added seven thousand dollars to the already huge budget. Completed, the home cost more than seven million dollars, three million for construction and the remainder for the furnishings and artwork.

Though unsurpassed in luxury on the beach, Ocean House retained the charming and playful personality of its owner, Marion Davies. Hearst personalized the mansion for her with a gallery for her collection of priceless art treasures (many of which were gifts selected from Hearst's collection at San Simeon) and the dining room featured twelve full-length paintings of Davies in various film roles. But by far the most impressive aspect of her home was Davies's colorful retinue of friends and her legendary parties, with guest lists that read like the *Who's Who* of Hollywood.

Davies lived in the house off and on for fifteen

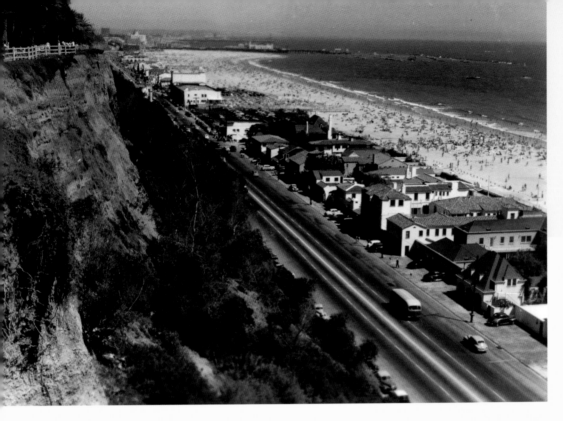

THE GOLD COAST, 1947

Hundreds of people throng the beach near the Gold Coast in the 1940s. Visiting cars parked on the east side of the Pacific Coast Highway, but west side parking was reserved for the wealthy owners of the homes.

years, alternating between Ocean House and her Beverly Hills mansion. Despondent from alcohol abuse and suffering from cancer, she sold Ocean House in 1945 for a mere six hundred thousand dollars—just about the original cost of the thirty-seven fireplaces. The furniture, silver, porcelain and other treasures that filled the home were auctioned off and realized $204,762, a fraction of the cost Hearst paid for them.

Joseph Drown, owner of the Beverly Hills Hotel, purchased the house and property intending to transform the mansion into a beach club and hotel. He replaced the tennis courts with lockers and cabanas and remodeled the second and third floors into a lounge and clubhouse. But taxes were so great on the enormous property that a mere thirty-room hotel couldn't make a profit, so Drown abandoned the project and sold some of the property to the State of California. Between 1955 and 1956 the main house was torn down,

though the servants' quarters were left standing. In 1964 that structure became the Sand and Sea Club when Douglas Badt purchased the property. Today the State owns the whole property and has turned over the responsibility for upkeep to the City of Santa Monica. Sadly, the city allowed the remaining structures to deteriorate—today there is little that remains of the once-opulent structure.

The fate of Davies's Ocean House is like many of the other elegant homes of the Gold Coast, which, as the years passed, were bought, sold and remodeled. A few of the first homes built on the Gold Coast have been preserved in their original condition and are enjoyed by their owners as private residences. While flamboyant glamor that was the Gold Coast in the 1920s, '30s and '40s is gone, those fortunate enough to live on the beach at Santa Monica today possess a grand inheritance of natural beauty.

CHAPTER FIVE

THE BEACH CLUBS

FROLICKING ON THE BEACH, 1930s

There were, and continue to be, many ways for visitors to enjoy the sunny Santa Monica Beach. In the photograph on the left, women in fur coats relax on what we hope is a cool day—the lady on the right appears to have plenty of knitting to keep her busy. On a warmer day, at right, a blanket toss proves to be a more active alternative.

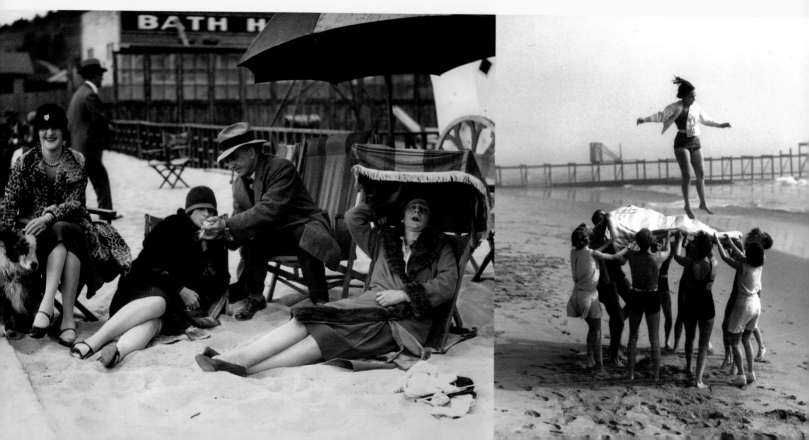

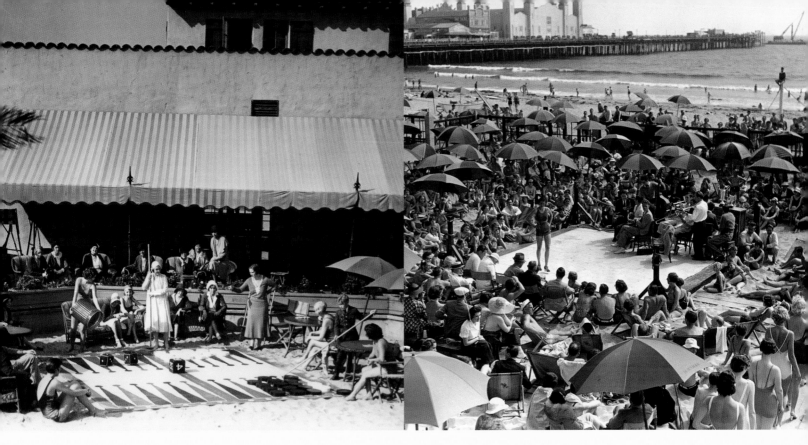

FUN IN FRONT OF DEAUVILLE CLUB, 1930S

Two more photographs from the early 1930s show other beach activities, including a giant game of backgammon and a beauty contest. Note the boy pole-sitting for a better view of the beauties, and the crane on the flat-bottom barge used for the construction of the breakwater at the end of the Santa Monica Pier.

Building a home at the beach wasn't the only way for the upper classes of Los Angeles to claim part of Santa Monica Beach as their own. Another popular trend of the early 1920s was the beach club. These private clubs, some of them extensions of long-established clubs in downtown Los Angeles, offered members social and recreational activities such as dinners, dances and beach parties in a luxurious atmosphere. And for those who wanted to laze on the sand, members shared a private beach where they could mingle with others of their same social class within the club's fenced-in beach area.

Around the same time Pickford and Fairbanks built the first Gold Coast home, the first beach club was founded in 1922. The Los Angeles Athletic Club purchased a two-story brick structure at 1441 Palisades Beach Road and transformed it into the Santa Monica Athletic Club. Its success inspired a string of private beach clubs along the shore. Soon the Santa Monica coast from Santa Monica Canyon south to Pico Boulevard was the site of elaborate, exclusive and highly advertised beach clubs. All classes of people, rich or poor, continued to mingle on the public parts of the beach and the piers, but the beach club members stayed within the confines of their own private beach. Most clubs were restricted and openly discriminated against African Americans, Mexicans and Jews. On weekends during the 1920s the wealthiest Southern Californians rushed to the "club." By day members congregated on the beach with brightly colored beach umbrellas protecting them from the sun. At night, patrons enjoyed entertainment and dancing in the clubs' ballrooms while orchestras played the top tunes of the day.

Near Santa Monica Canyon the exclusive club, called simply The Beach Club, was erected in 1923 and had 617 members. Members of the movie colony purchased property next door and started the Santa Monica Swimming Club.

At the southern end of Santa Monica Beach, at the foot of Pico Boulevard, workers completed the construction of the Club Casa Del Mar in 1924. According to its promotional material, the nonprofit institution boasted to be "the finest beach and athletic club in the world. The most modern conveniences in clubdom will be incorporated as well as additional features which will surpass anything heretofore attempted for the convenience of men and women members, their children and guests." The building comprised six floors and a sub-basement, with more than thirty-five thousand square feet per floor. The club's property was likewise enormous, occupying over forty thousand square feet of

beach in addition to ground subsumed by the club's mammoth building.

Although not openly discussed, some of the beach clubs had illegal gambling facilities with hidden slot machines. At the Casa Del Mar, for instance, a wall was built that could slide down into a special track exposing the slot machines. If a raid by the local police ensued, the walls could be closed and the machines hidden from sight. In 1954 the sliding mechanism got stuck and repairmen were called to fix it. They crawled into the narrow space between the walls and found several thousand dollars in coins lodged beneath the mechanism.

The Casa Del Mar was the first of three large clubs in its vicinity. Directly next door was the Edgewater Club, built in 1925. The Edgewater went through a succession of owners, and by the late 1930s was known as the Waverly Beach Club. Then, in 1944 the club was taken over by the Army Air Corps and used as a rehabilitation center during World War II. By the next year it was back as a private club called the Ambassador Club until 1948 when the Kaiser Foundation bought the building for use as a physical therapy center. Shutters on the Beach, a hotel which stands where the Edgewater and Waverly did, has had its elegant doors open longer than either of those historic clubs.

Just a year after the opening of the Edgewater, in 1926, the Breakers Club opened a short distance north. An eight-story building with three hundred ten sleeping apartments, a dining room, grill, plunge, gymnasium and a tunnel to the ocean for bathers, the Breakers was a class-A beach club through and through. Its ninety-nine-year lease included two hundred twenty feet of beach frontage at Marine and Appian Way. The Breakers Club had a unique interior featuring rooms decorated in different international styles. The eclectic design included a Gothic Passage, a Baronial Hall, an Aztec Lounge and an Arabian Room. As the years passed, the

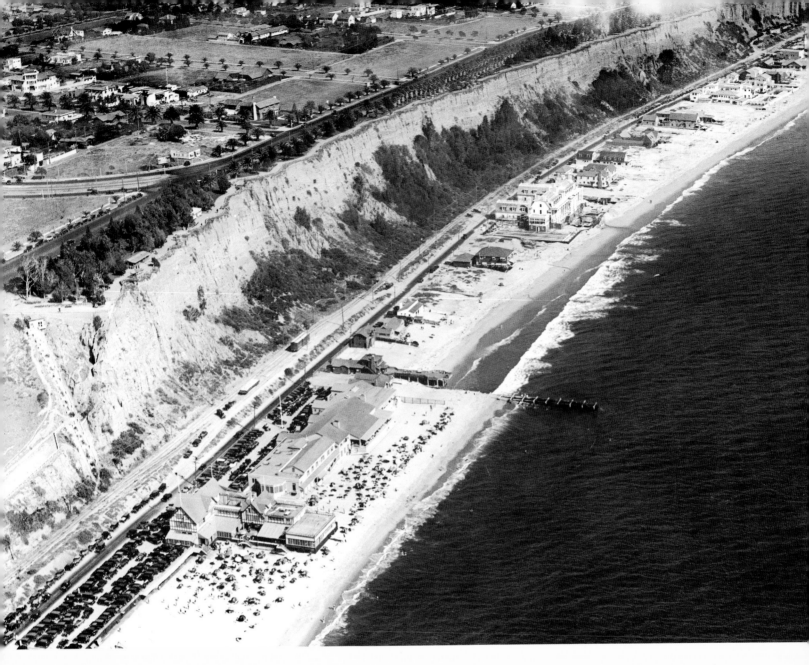

THE FIRST SANTA MONICA BEACH CLUBS, 1926

This aerial photograph of north Santa Monica Beach shows people sunning themselves on the sands near the Tudor-style building of The Swimming Club and its neighbor to the south, The Beach Club. The two were the first private clubs on Santa Monica Beach. Slightly further south is the Marion Davies house under construction.

GABLES BEACH CLUB, 1930

Members of the Gables Beach Club relax on their small, private section of the beach. This photograph shows a portion of the original club, built in 1926.

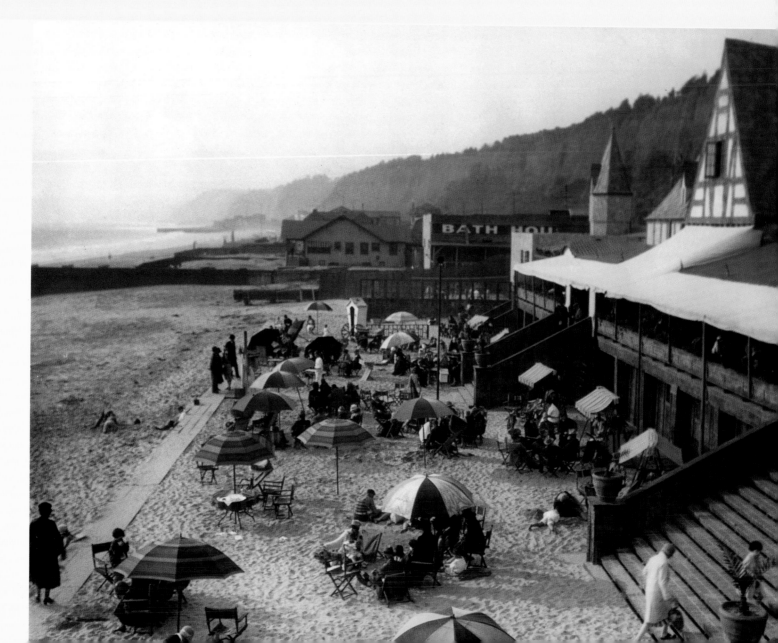

club changed hands many times and was known as Club Lido, the Grand Hotel, Hotel Monica and the Chase Hotel. During its final years as the Sea Castle Apartments, the building caught fire in 1996 and was declared a total loss.

Aside from these impressive clubs built on the south end of the beach, there were several other beach clubs of note, all of which incorporated geographical and architectural fantasies. Considered to be the most beautiful of all was the Deauville Club built in 1927 on the former site of the North Beach Bath House. Patterned after a casino in Deauville, France, the building, with its turrets and slate roof, resembled a French medieval castle. In July 1930, The Deauville Club was taken over by the Los Angeles Athletic Club.

When the United States entered World War II, wartime restrictions created problems for the beach clubs since they could not illuminate the beach or their buildings at night. (Blackout laws also prevented cars from parking on the beach and shining their lights out to sea.) In 1942 the Los Angeles Athletic Club board of directors voted to disband the club and the property was taken over by the federal government for the war effort. It was not until 1959 that a group of Texas financiers purchased the Deauville building. Then in 1962 the club re-opened as the Seaview Beach Club. A year later, that club closed and the building was left vacant. A death blow was dealt on April 5, 1964, when vandals started five separate fires that gutted the building. It was demolished in 1966 and the site became a city parking lot.

Construction began in 1927 on The Gables, an addition to the existing Gables Beach Club, located on the ocean side of Palisades Beach Road. Located across the road, in the gully near the base of the California Incline, the new hotel and beach club was destined to be the most elegant on the beach. Seeking to create "the illusion of European resort hotels," owners of The Gables spared no expense in its construction. Original plans called for a twenty-three-story building, rising from the ocean level to the top of the palisades and then some. Cars and guests would enter the structure from Ocean Avenue, as well as from the beach road below. Aside from several immense ballrooms, twelve private dinning rooms and a two-hundred-and-fifty-car garage, the club's plans also included an outdoor terrace on the eleventh floor for dining, and a beautiful tile swimming pool with twelve hundred individual dressing rooms (each complete with its own shower). But only the first three floors of the club were constructed before the Great Depression hit and the lack of funds caused work to come to a crashing halt. Just a shell of the building remained for many years before it was finally torn down in the 1960s, leaving one wall in place as a buffer for the cliff.

The original Gables Beach Club on the beach side of Palisades Beach Road caught fire August 31, 1930, and half of the building was destroyed. The remainder was salvaged and reopened in 1932 as the Sorrento Beach Club. Next door to the Sorrento was the Sea Breeze Beach Club, opened in 1927. In 1935 it was taken over as a beach outpost for the exclusive downtown Los Angeles organization, the Jonathan Club, which still operates it. Other Santa Monica Beach clubs included the Wavecrest, a big, brick structure at 1351 Palisades Beach Road, and the Miramar Hotel Club built on the shore directly below the Miramar hotel. A tunnel walkway that would span the highway from the Wilshire Boulevard hotel to the beach club was planned, but never completed. The owners of the Miramar also considered, but never built, an elevator in the bluff. It was clear that money was in short supply—the wealthy weren't spending the way they had in the early 1920s. When the Depression put a temporary hold on extravagant lifestyles, the Miramar's beach club was sold, and all the grand plans were shelved.

The Great Depression hit Santa Monica Beach with full force during the 1930s. Members of beach clubs could no

A Human Pyramid, 1930s

Acrobats pose as a human pyramid on the sand at the Gables Beach Club located on the beach near the foot of the California Incline. The wall behind them is next to Palisades Beach Road. The new eleven-story The Gables was to be built on the cliffs on the other side of the road, but it was never completed.

longer pay monthly dues. Soon many clubs were heavily in debt and forced to close their doors. The Casa Del Mar survived by supplementing its income by renting out guest rooms as hotel rooms and thus weathered the Depression without closing. Other than the Casa Del Mar, only three other clubs, The Beach Club, the Jonathan Club and the Santa Monica Swimming Club, managed to survive. Trying to offset the impact of the Depression by giving still-wealthy yacht owners a reason to come to Santa Monica, the city fathers contemplated building a breakwater near the Municipal Pier. Promoters stressed that an offshore breakwater would successfully create enough calm water for a highly desirable small-boat harbor. Their idea was well received.

On September 3, 1931, voters overwhelmingly supported a $690,000 bond for the construction of the Pacific Coast's first steel-reinforced concrete breakwater, a structure that would parallel the shoreline about two thousand feet out to sea. The designers guaranteed one hundred acres of calm water for small sailing vessels and fishing boats, and assured Santa Monica officials that there would be no ill effects to existing beaches.

As originally planned, the breakwater would be constructed of eighteen separate watertight blocks, called cribs. Each crib was over one hundred feet long and thirty-five feet in diameter, containing twenty-two tons of reinforced steel encased in five-inch thick concrete. The first crib, which arrived on March 27, 1933, was positioned several hundred feet from the end of the pier on the ocean floor. But its immense weight caused it to sink lower than intended. Worse yet, the crib had a crack on the seaward side. City officials ordered work stopped. After calling in a consulting engineer for his opinion, the city abandoned the crib-breakwater

concept and built a rock-pile sea wall instead. A huge lawsuit and trial ensued when the city canceled its contract for the cement structure, but the court ruled in favor of the city. On July 6, 1933, the first load containing 453 tons of rock from quarries at Santa Catalina Island arrived for construction.

When the rock breakwater was finished in July 1934, it stood thirty-seven feet high and more than one hundred feet wide at its base, with only about five feet showing above the water line. The city held a huge celebration commemorating its completion. Soon, the Santa Monica Sailing Club (organized in 1932) held small boat races there. Members launched their handmade boats from the beach and sailed a course in the new harbor. By the late 1930s the South Coast Corinthian Yacht Club of Santa Monica joined with the Southern California Yachting Association and sponsored the first Pacific Coast Championship Regatta in Santa Monica Bay. All classes of yachts from ports as far north as Canada came to participate. The regatta put Santa Monica on the map as a yachting center.

True to the city's plan, the yacht harbor was one of Santa Monica's top draws for years. But as time passed, the breakwater lost its effectiveness. Storms repeatedly breached the breakwater, knocking rocks into the sea. Its most devastating effect was changing the contour of the beach: sand accumulated on the north side of the breakwater, extending the northern beach seaward and simultaneously narrowing the southern beaches, which angered south beach property owners. In most people's eyes the breakwater was a dismal failure. Without dependably calm water in the harbor, yacht owners gradually abandoned Santa Monica in favor of the protected harbors at Newport Beach and Balboa. As the small boats moved away, fishing fleets took over Santa Monica harbor, leaving no mooring spaces for even the few pleasure boat captains who wanted them.

The three beach clubs situated south of the breakwater, the Casa Del Mar, Edgewater and Breakers claimed that the construction of the breakwater interfered with the southbound currents that normally deposited sand on their beach and instead caused the sand to be carried away, which greatly diminished the size of their beach. Simultaneously, on the north side of the breakwater, the sand was building up. The owners of the three beach clubs unsuccessfully sued the City of Santa Monica for the diminution of the value of their real estate due to the breakwater's redistribution of sand. As a concession to the clubs' concerns, the city began dredging and sending sand south to build up the beach there. The work was never completed. World War II interrupted the city's plans to repair the damage by the breakwater; the pumping stopped and Mother Nature took over. Today, the wide expanse of land north of the breakwater is obvious. As of this writing the City of Santa Monica and the U.S. Army Corps of Engineers are studying a proposal to rebuild and extend the existing breakwater a couple hundred feet southward.

Many longtime Santa Monicans still harbor fond memories of Santa Monica Beach as it was in the pre-World War II days. In those dark Depression years, when families had little money to spare for amusement, they flocked to its sands for the sun and fun to be had for free. Indeed, the end of so many highfalutin establishments, like the beach clubs with their exclusive zones, had little effect on the lives of ordinary beachcombers. Even today, when expensive hotels, private clubs and residences overlooking the blue Pacific once again dominate the coast of Santa Monica, people of any means can enjoy the beach for only the price of a parking spot (less if one takes the bus). On any fair day, visitors to the beach can be seen by the hundreds, picnicking, bathing in the ocean, playing volleyball and Frisbee on the sand, or just relaxing in the comfort of warm sunshine and the clean ocean air.

THE PHOTOGRAPHS
AND THE
PHOTOGRAPHERS

EARLY DEVELOPMENT AT SANTA MONICA BEACH, 1877

The two low buildings in the foreground compose Duffy's Bath House, the first bathhouse on Santa Monica Beach. The tented structure behind Duffy's with the Seaside Gallery sign belongs to photographer E.G. Morrison who took some of the earliest known shots of Santa Monica, including this one.

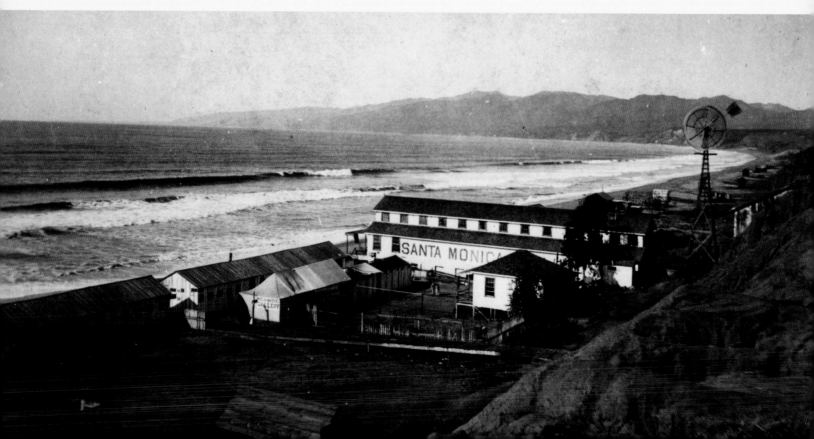

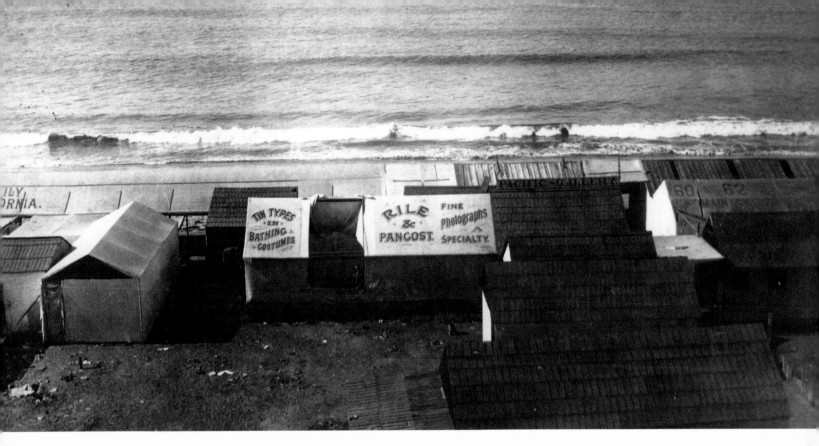

RILE AND PANCOST STUDIO, C. 1887

Rile and Pancost had their portrait studio in the tent on the beach. The roof of the tent could be opened to allow more light to enter while taking photographs. A close look reveals Rile standing at the tent's opening.

When people started coming to Santa Monica, most of them came without cameras—few dreamed of relying on anything but their memories to capture the beauty of the city by the sea and its dramatic beach. For in the late nineteenth century and even into the twentieth century, individuals did not own cameras to document their daily lives. There were no snapshots of friends, candid family photos or albums overflowing with cheesy images from annual trips. Picture making, as it was often called then, was a highly technical and difficult process that was the domain of professionals.

SOUVENIR TINTYPES FROM NORTH BEACH, C. 1896

These tintypes are from H.F. Rile's Pacific Photograph Gallery, which was located on the beach near the Arcadia Hotel. Tintypes create a mirror image of the subject. Notice the lettering on the bathing suits of the men in the first picture that reads "North Beach Bath House" is backwards, while the sign they are holding is not. Clearly, the lettering on the sign was printed backwards so that it would read accurately when photographed.

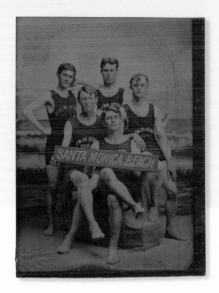

Professional photographers considered themselves to be artists and earned their livings by selling their work as mementos or souvenirs. Some were strictly portrait photographers; others documented street scenes, buildings and scenic views. The first professional photographer arrived in the Los Angeles area around 1850 and others soon followed. It wasn't until shortly after the town was founded in 1875 that Santa Monica's first resident photographer, E.G. Morrison, established his studio in a tent on the beach. A decade later Harry Franz Rile arrived and partnered with Morrison. A few years later, when he bought out Morrison and renamed the business Pacific Photograph Gallery, Rile moved the studio to a new location near the Arcadia Hotel, where business prospered because of the wealthy hotel patrons. Later he opened another studio in Ocean Park. One of the attractions of the gallery was a vending machine where people could spend a nickel for a photo with a scene of Santa Monica. Rile soon added two other partners, first Pancost, then Mensch, whose names were printed on the backs of photographs. Rile went on to become the premier photographer of Santa Monica. He had a wonderful sense of humor and it shows in his advertisements printed on the backs of many of his photographs. ("Remem-ber, Rile is the man for whom you are looken,

'Cause by him you get a good photograph tooken.") During his lifetime Rile made countless photographs of every subject imaginable. These precious images are now spread throughout the country, tucked away in closets or cardboard boxes holding the memories of those who wanted a souvenir of their trip to Santa Monica. Rile lost his sight in his later years and retired in 1915. Equally disappointing, Rile's negatives have disappeared. Born in 1860 at Ft. Kennedy, Pennsylvania, Rile died in Los Angeles on October 26, 1949, at the age of 89.

Two other photographers, Van Buskirk and Collins, set up business on the beach and sold tintypes mounted in paper folders from their Oceanside Picture Gallery. The tintype was a positive image made on a very thin, sensitized sheet of enameled iron or tin. Photographers could produce a tintype in about ten minutes, which made it convenient for beach-goers to take home photographic souvenirs. In addition to the locals, other professional photographers who operated studios in Los Angeles spent many working days in Santa Monica taking pictures. These day-trippers, including Valentin Wolfenstein, William Henry Fletcher and Charles C. Pierce, created some of the photographs in this book. Wolfenstein, who specialized in portraits, arrived in Los Angeles in the late 1860s and opened a studio on the second floor of the Temple

PUT A NICKEL IN THE SLOT

H.F. Rile had a machine in his Pacific Photograph Gallery that dispensed small photographs of Santa Monica landmarks for five cents apiece. These souvenir cards were similar in size to *cartes de visites*, the popular calling cards of the Victorian era. Three cards shown here are by Rile: *S.S. Corona at Mammoth Wharf, Arch Rock* and *Santa Monica from Hotel Tower*. *South Beach, Santa Monica* and *Arch Rock, Santa Monica* were made by William Henry Fletcher.

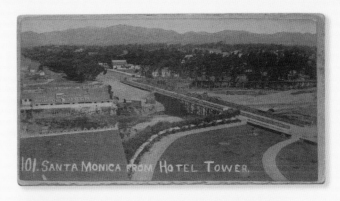

101. SANTA MONICA FROM HOTEL TOWER.

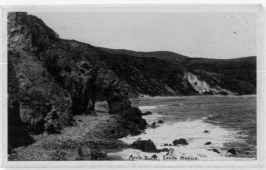

Arch Rock, Santa Monica.

7. S.S. CORONA AT MAMMOTH WHARF.

This pretty little view I got
By pushing a nickel in the slot;
It's cheap enough; well, I should smile.
And for photographs, why call on Rile
AT THE
Pacific Photograph Gallery
AT SANTA MONICA
P. S. *Call or send for a Catalogue of California*
Views. H. F. RILE, SANTA MONICA, CALIFORNIA.

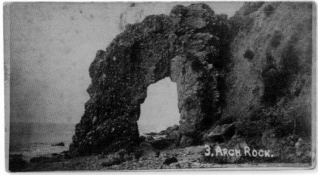

3. Arch Rock.

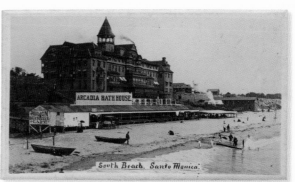

ARCADIA BATH HOUSE

South Beach, Santa Monica.

Block in Los Angeles. But his stay in Southern California was short since he soon suffered financial losses, abandoned his studio and moved away. As a result, his few views of Santa Monica are extremely rare. The one featured on page 96 is from the Huntington Library collection, which generously allowed me to reprint it here. Fletcher, a native of Vermont, established his studio in Los Angeles in 1885. He lived in Angelino Heights, near downtown Los Angeles, and during the course of his career created an impressive number of outstanding photographs of scenes throughout Southern California. Pierce, who was originally a commercial photographer and illustrator, came to Los Angeles from Chicago in 1884 to improve his health and, obviously successful, remained until his death in 1946. During those six decades he compiled a massive collection of images, both his own and those of other photographers, showing the early history of Los Angeles. His collection remains an extremely valuable source of historical documentation of the rapidly changing city.

Other nineteenth-century photographers whose works are featured on the following pages include Frank L. Park, who worked in Los Angeles from approximately 1898 to 1903, Samuel Cohen and A.C. Varela. Cohen's studio, Garden City Foto, was based in Los Angeles from 1896 to 1902. A.C. Varela produced exceptional images of Southern California, but did not stay in Los Angeles long enough to become well known.

The most famous photographer to visit Santa Monica was Carleton E. Watkins, who was a resident of San Francisco, and is recognized today as one of California's outstanding nineteenth-century photographers. He made two trips to Santa Monica, one June 27, 1877, and the other in 1880, both funded by his close friend, Collis Huntington, head of the Southern Pacific Railroad. Watkins, even then, was

famous enough to merit the following lines in the *Santa Monica Outlook*:

C.E. Watkins, photographer paid Santa Monica a flying visit last Monday. He has two [railroad] cars especially furnished in which he lives and moves and carries his apparatus and fixtures. He is now on a business tour and will take views of all the picturesque objects on the line of the Southern Pacific Rail Road as far as Yuma.

The sole twentieth-century photographer whose works are credited here is one of great importance: Adelbert Bartlett. A resident of Santa Monica, Bartlett made his living as an independent photographer from 1918 until he died in 1966. Often his works were sold to postcard companies and newspapers. During his lifetime he produced thousands of outstanding images of Santa Monica Beach and the surrounding areas.

In addition to the photographs of professional photographers, the images in this book derive from other forms of photographic ephemera as well. A big boom in photography occurred after Congress passed an act allowing private printers to print and sell cards that bore the inscription "private mailing card" in 1889. The perfect souvenir, these mass-produced picture postcards could be mailed, which opened the door to a huge new industry. Most of the postcards issued in the late 1890s and early 1900s were full-color cards printed on a printing press. Though the original images were done in black and white (color film had not yet been invented) the technicians at the printing plant colored them. Postcard manufacturers used images taken by professional photographers, such as Bartlett, of scenes and landmarks in their area.

Around 1900, other entrepreneurs expanded the postcard industry to include real photographs. These "real-

photo postcards" depicted scenes of places or of individuals. These photographic images were printed on photographic paper and cut into postcards with space on the back for a message as well as the address of the recipient. Since real-photo postcards were inexpensive (five or ten cents apiece, and only a penny to mail) and readily available to the many tourists who flocked to Santa Monica, they became a favorite way to share the trip with friends and family.

By this time, other popular forms of photo documentation were on the decline, including cabinet cards (photo images framed in a four-by-six-inch cardboard mount stamped handsomely with the photographer's name and address—some even had gilt edges) and the amazing stereo-view (a card with double images that created a 3-D image when viewed through a stereopticon). Sold as souvenirs, cabinet cards and stereographs were fast disappearing from the market as travelers and vacationers could rely on the picture postcard instead.

Or, better yet, soon these consumers could create their own photos.

When George Eastman, founder of the Eastman Kodak Company, introduced the Brownie in 1900, the first mass-marketed camera, it cost one dollar and offered anyone with a buck an opportunity to create his or her own photographs. Soon cameras became commonplace, and pictures taken by amateur photographers were pasted in family albums for private appreciation. Eventually, collectors discovered some of these precious albums discarded in garage sales or offered at estate sales, and the amateur photographer's work became a valuable source of historical documentation. Although the image might be of lesser quality than the professional work of years past, the importance of the image remains.

We are fortunate that the fragile images of the pho-tographs on these pages, some now well over a hundred years old, have survived. They are a valuable and unique source of historical information and serve a dual purpose: they enable us to see past events or scenic panoramas as the photographer saw them, and they are fragile works of art that delight with their aesthetic beauty. What's more, they are historic documents that demand preservation. Unfortunately, the physicality of the photographs makes them vulnerable to damage. Some of the photographs in my collection have been folded, scratched, or eaten by silverfish, others suffered from improper storage before I found them, and we can see fading and water damage. But fortunately, most of the images printed here remain sharp and clear.

The photographs and objects of ephemera appear exactly the way the photographers or artists originally produced them. The sepia color is the original color of the print, though some have faded. Some photos may not be as sharp and pristine as they were when first printed more than a hundred years ago, but they still tell a dramatic story of a period long gone. We just have to take time to look closely and appreciate the information revealed in each remarkable image.

To simplify this photographic journey back to the earliest days at Santa Monica Beach, the images on the following pages are divided into four sections: Santa Monica Canyon; North Santa Monica Beach; South Santa Monica Beach; and Santa Monica Beach: Past and Present. North and South refer to the stretches of sand on the respective sides of the Municipal Pier. The modern-day images in the Past and Present section are photographed by the author.

Many of these photos are the only records of what was Santa Monica Beach in its early days. Unfortunately, the creators of these important images are often unknown, but their photographs live on as reminders of another time.

PACIFIC COAST VIEWS.

No. 8 MONTGOMERY STREET,

Opposite Palace and Grand Hotels, SAN FRANCISCO.

Photographic Views of California, Oregon, and the Pacific Coast generally—embracing Yosemite, Big Trees, Geysers, Mount Shasta, Mining, City, etc., etc. Views made to order in any part of the State or Coast.

No. 70. Santa Monica Bay, Los Angeles Co., Cal.

SANTA MONICA CANYON, 1877

A stereoview by A.C. Varela displays the mouth of Santa Monica Canyon. Visible on the beach are cattle, owned by the Marquez family, who owned the property at the time. In the distance, to the south, is the new township of Santa Monica.

SANTA MONICA CANYON, 1877

This stereoview by A.C. Varela shows the cliffs north of Santa Monica, near Santa Monica Canyon. On the beach below is a wagon trail that would have been impassable during high tide.

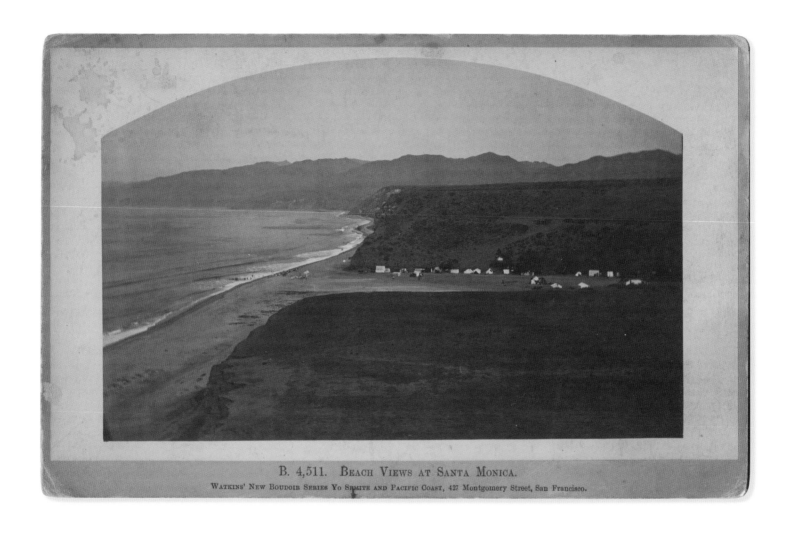

B. 4,511. BEACH VIEWS AT SANTA MONICA.

WATKINS' NEW BOUDOIR SERIES YO SEMITE AND PACIFIC COAST, 427 Montgomery Street, San Francisco.

SANTA MONICA CANYON, 1880

Santa Monica Canyon was a destination for campers and visitors as early as the 1850s. Taken by Carleton E. Watkins, this pastoral photograph of the vast, quiet canyon shows why the area had such great appeal. All of the land visible here was part of the Mexican land grant *Rancho Boca de Santa Monica*.

MOUTH OF SANTA MONICA CANYON, 1890

The canyon's rustic beauty remains relatively untouched in this photograph. Below the bluff is the Pascual Marquez Bath House; the other building is the Pavilion Bath House. The large building with the tower is Grimminger's Pavilion, a popular saloon.

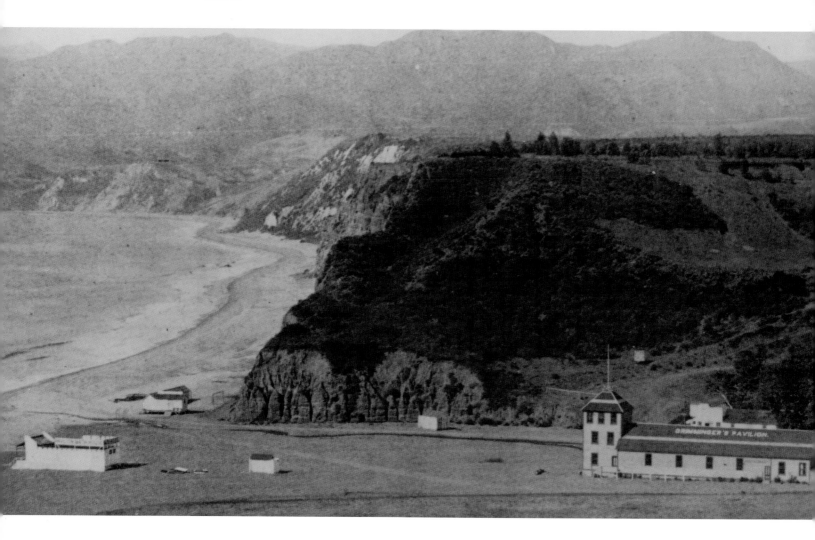

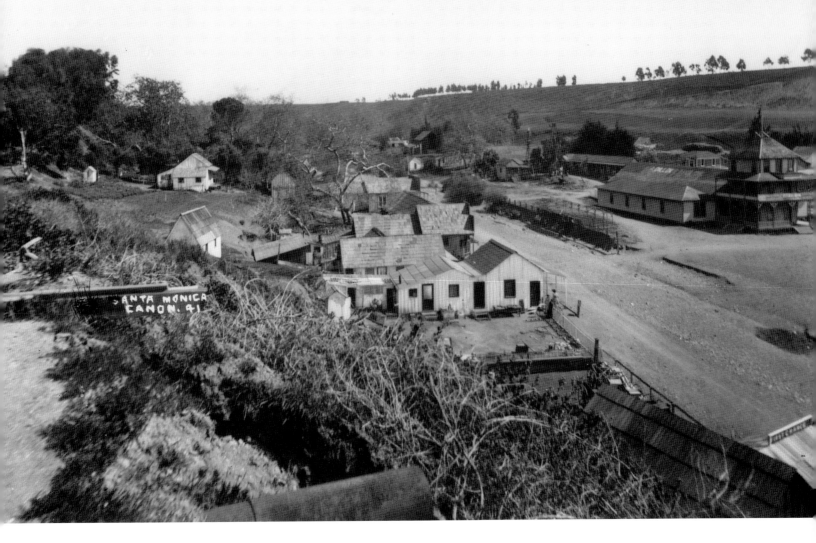

SANTA MONICA CANYON, LATE 1890s

Dillon's Saloon, a restaurant and drinking establishment that catered to the workers at Port Los Angeles, took over the building that was once Grimminger's Pavilion. Because the canyon was not officially part of the Santa Monica township, Dillon's benefited from the anti-liquor ordinance passed by the Santa Monica board of trustees. In addition to Dillon's, there were hotels and stores that marked evolution of the rustic beach resort into a more commercial resort.

SANTA MONICA CANYON, 1892

In 1892 Santa Monica Canyon found itself thrust into the middle of a political battle over where the main deep-water harbor for Los Angeles would be located. Collis Huntington of the Southern Pacific Railroad wanted Santa Monica to be the site. Southern Pacific built a huge wharf just north of the Canyon and put railroad tracks on the beach. A raised section of track at the mouth of the Canyon, blocked easy access to the beach, so the idea of developing the Canyon as a beach resort vanished. The Long Wharf was still under construction at the time this photograph was made, and clearly the person who captioned the photo's negative guessed at the pier's length, as it was actually 4,720 feet.

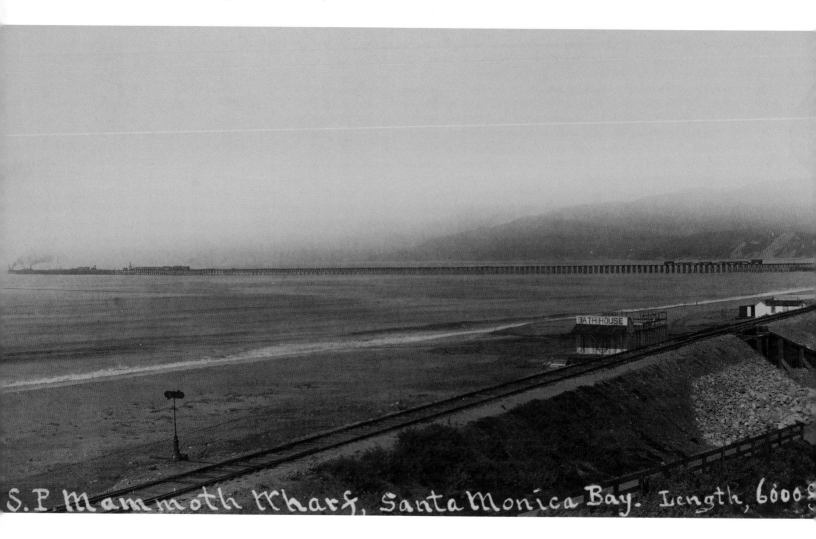

S.P. Mammoth Wharf, Santa Monica Bay. Length, 6000

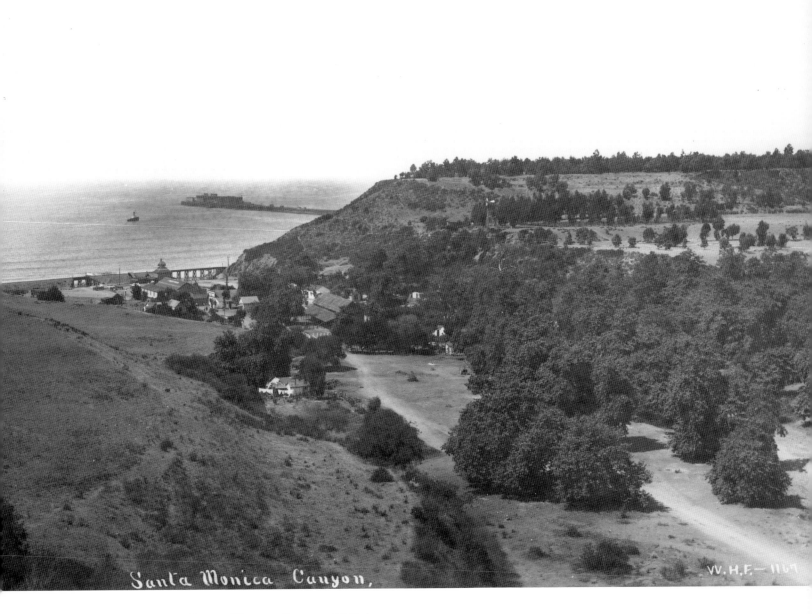

SANTA MONICA CANYON, 1896

The end of the Long Wharf is visible in this image by William Henry Fletcher, but most importantly, note the number of giant sycamore trees that grew in the canyon. When visitors first came to the canyon in the 1850s, they often camped under these beautiful trees.

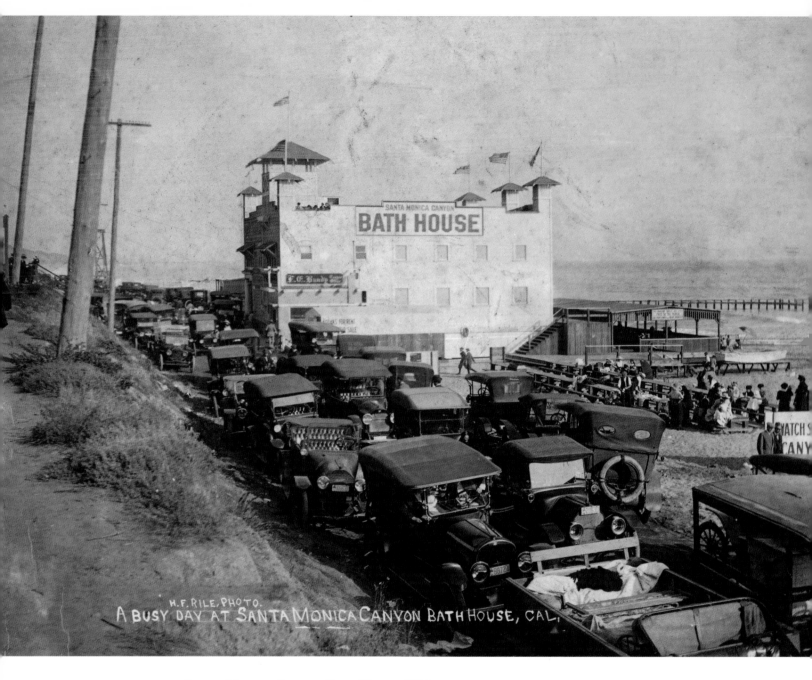

SANTA MONICA CANYON BATH HOUSE, 1916

The H.F. Rile photograph taken on July 4, 1916, shows that on weekends and holidays huge crowds came to the canyon beach and parked their cars in any space they could find.

SANTA MONICA CANYON BATH HOUSE, 1916

In 1915, Frank E. Bundy built his Canyon Bath House on the same site as the old Pascual Marquez Bath House. The bathhouse offered amenities such as picnic tables, a store and bathing suits to rent for those who wished to swim in the ocean. These suits had the Canyon Bath House initials on the front, as evidenced in the family photograph.

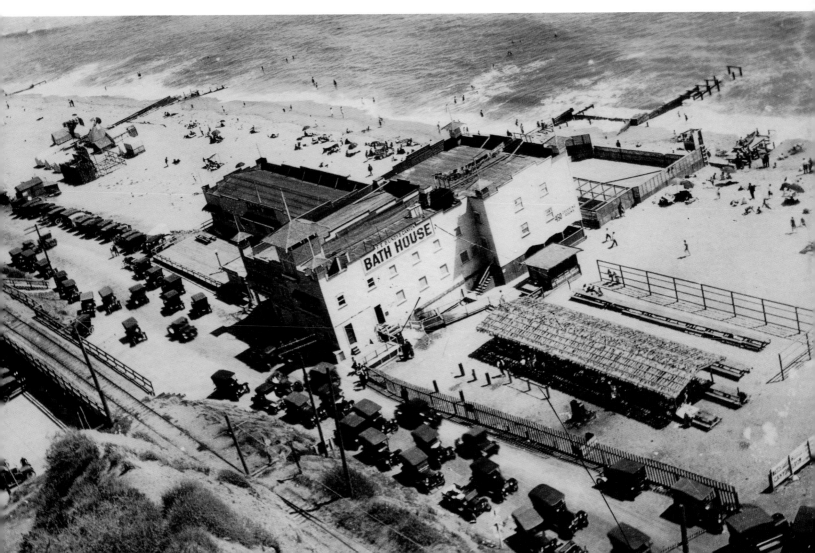

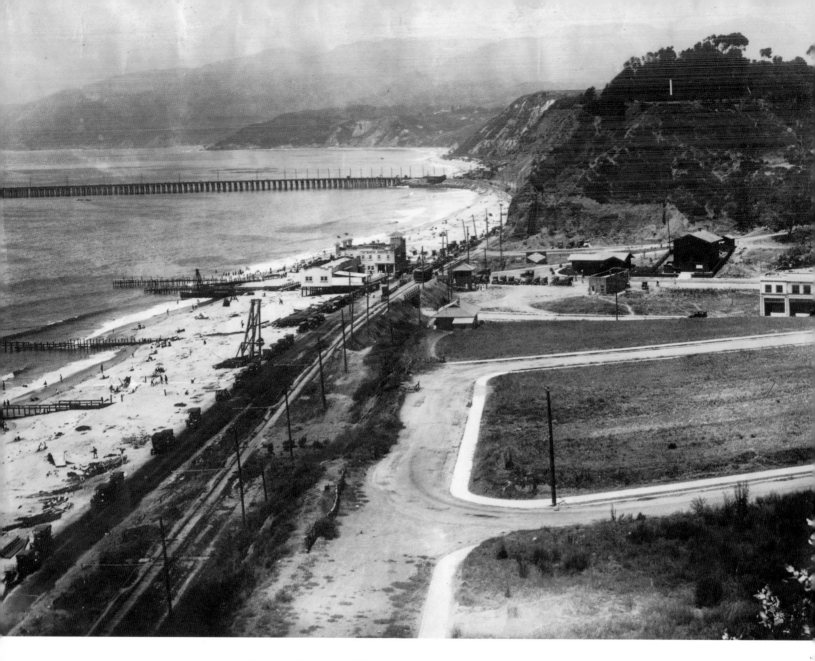

SANTA MONICA CANYON, 1918

By 1920 the Long Wharf would be totally dismantled, leaving Santa Monica
Canyon in the position to become a popular beach destination again. In this 1918
photo, roads were defined to access the residential area overlooking the beach and
canyon. These roads opened the way for more development in the canyon, both
commercial and residential.

Santa Monica Canyon, 1920s

An amateur snapshot shows the Long Wharf, Port Los Angeles, has been complete-
ly removed. The house (lower right) was built on Ocean Way in 1922, and on the
beach is F.E. Bundy's Canyon Bath House.

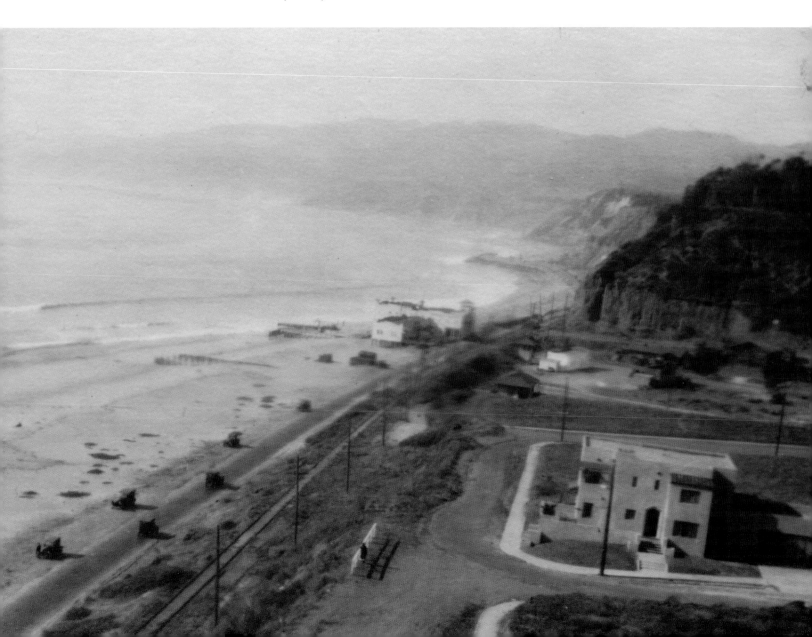

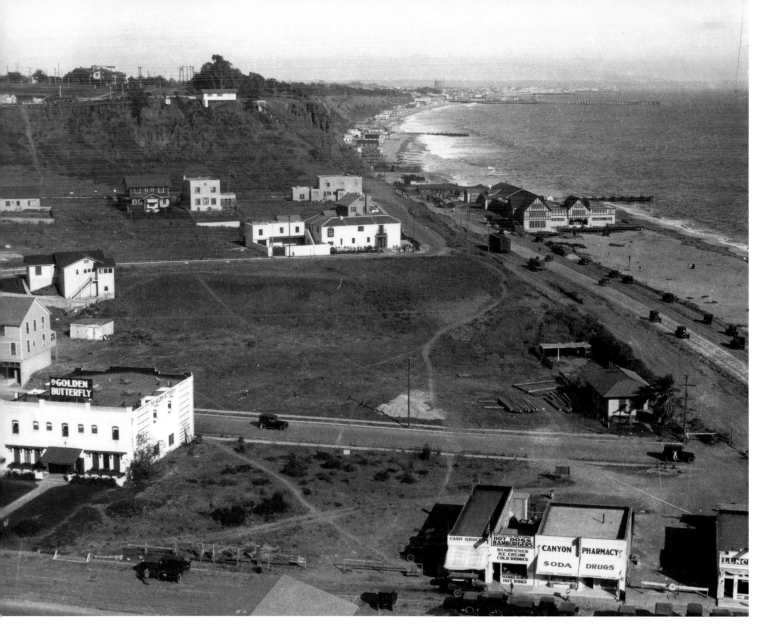

Development in the Canyon, 1920s

The development of Santa Monica Canyon was in full swing by 1923, when a grocery store, Doc Law's pharmacy and several cafes opened for business. There was even an apartment house called the Golden Butterfly. Visible on the beach (middle right) are two private beach clubs, the Santa Monica Swimming Club and The Beach Club.

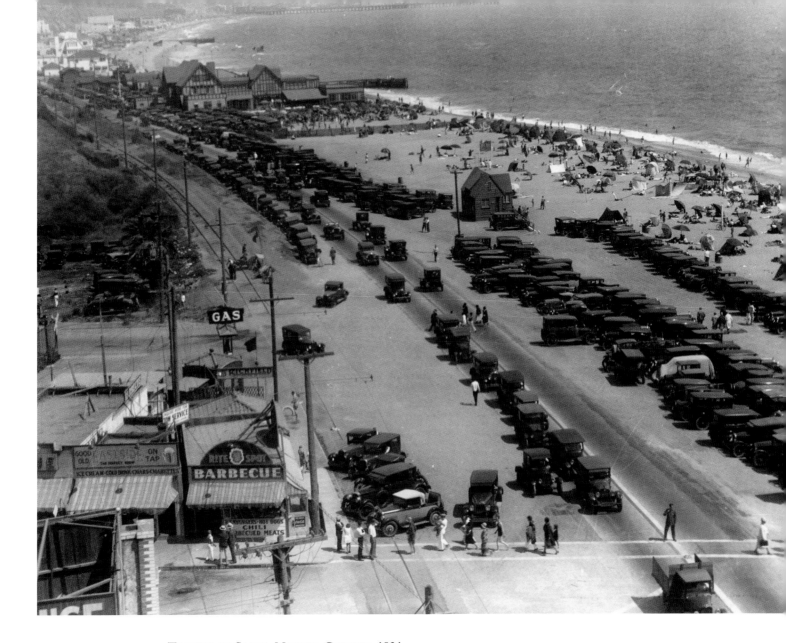

TRAFFIC AT SANTA MONICA CANYON, 1931

Since there were no traffic signals, a policeman controlled the heavy traffic traveling on the Pacific Coast Highway. In 1932 when PCH became a state highway, a pedestrian underpass was added to help people get safely to the beach. As is evident in this photograph, cars sometimes parked directly on the beach. The small wooden house on the beach later became the site of the Los Angeles County Lifeguard headquarters. The other building on the beach is the Santa Monica Swimming Club.

DEDICATION OF WILL ROGERS STATE BEACH, 1942

This photograph by Adelbert Bartlett documents the day land owned by Will Rogers became state property. This beach is located just north of Santa Monica Canyon, where the foot of the Long Wharf once stood. The cross section of a giant redwood tree seen in this image served as a local landmark for many years, but disappeared in the 1950s.

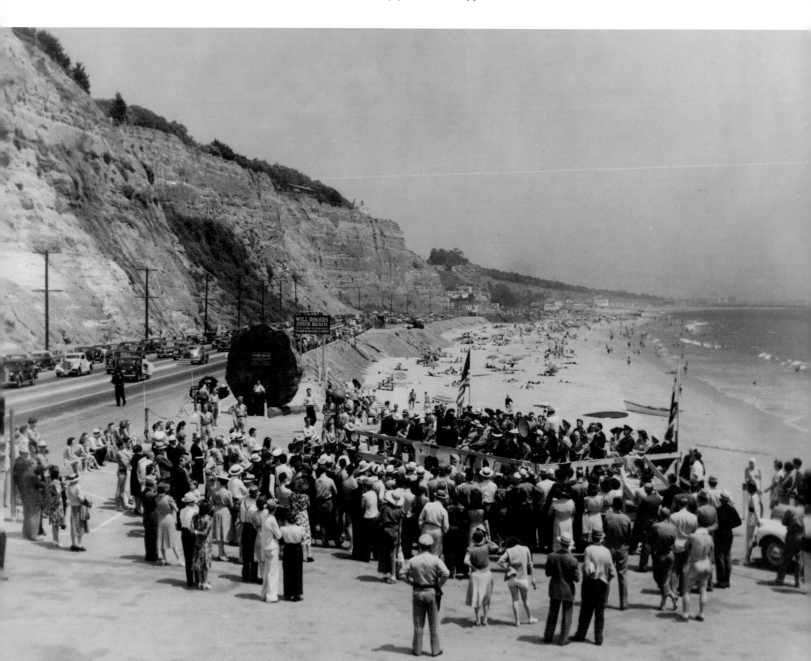

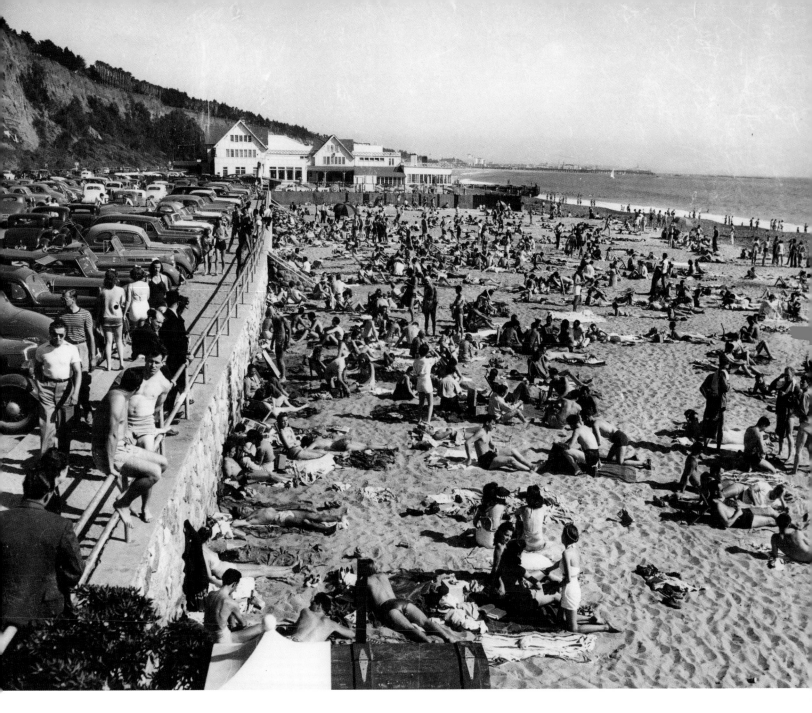

WILL ROGERS STATE BEACH, 1950s

By the 1950s, sun-seekers no longer felt the need for umbrellas and instead spread blankets on the sand to soak in the rays.

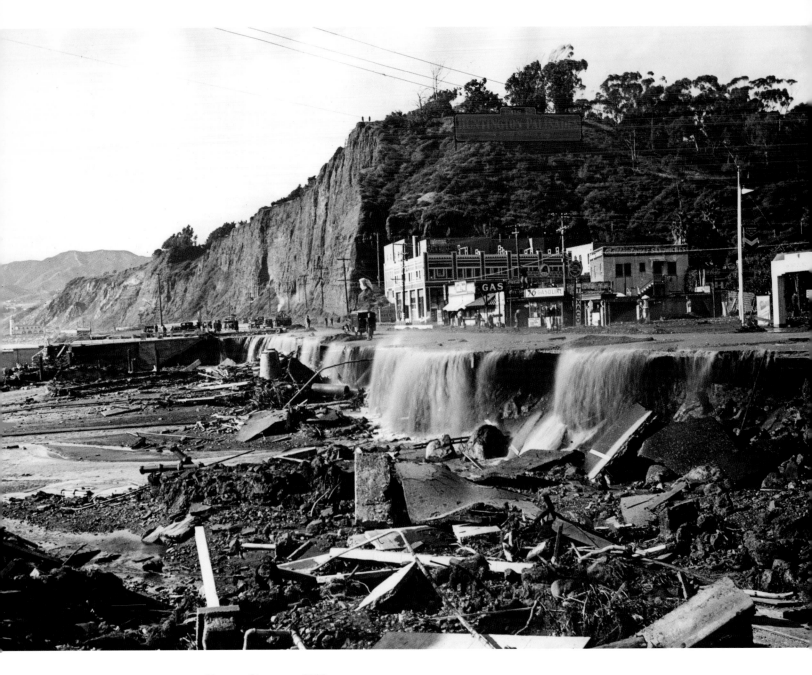

Flood Damage, 1938

A flood caused extensive damage to Santa Monica Canyon's beach and washed away part of the Pacific Coast Highway. Some Canyon business owners had six feet of mud inside their buildings.

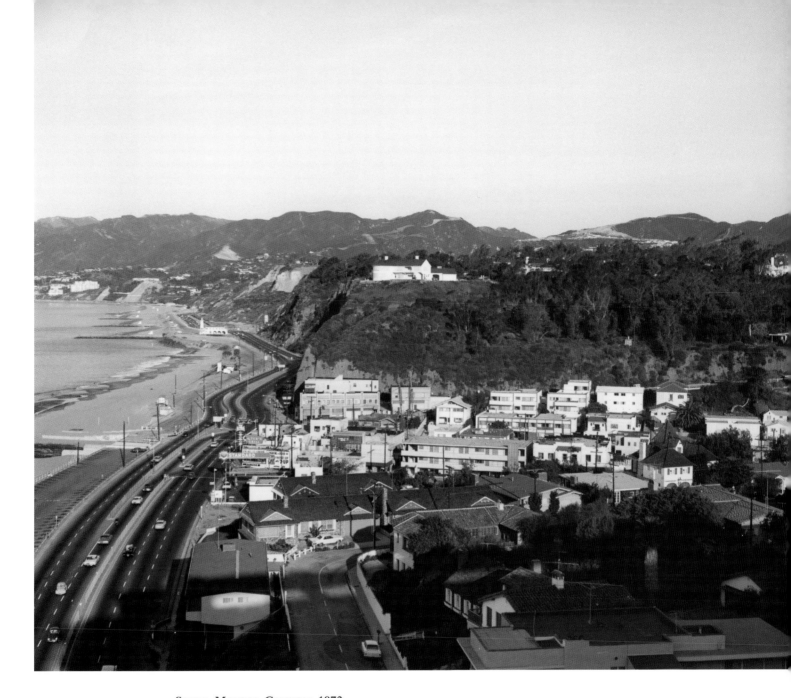

SANTA MONICA CANYON, 1972

Taken in 1972, this view shows the area that the Marquez and Reyes families first
called home back in 1839. The peaceful place that vacationers from the 1850s knew
as a remote spot by a running creek has been irrevocably changed.

NORTH
SANTA MONICA BEACH

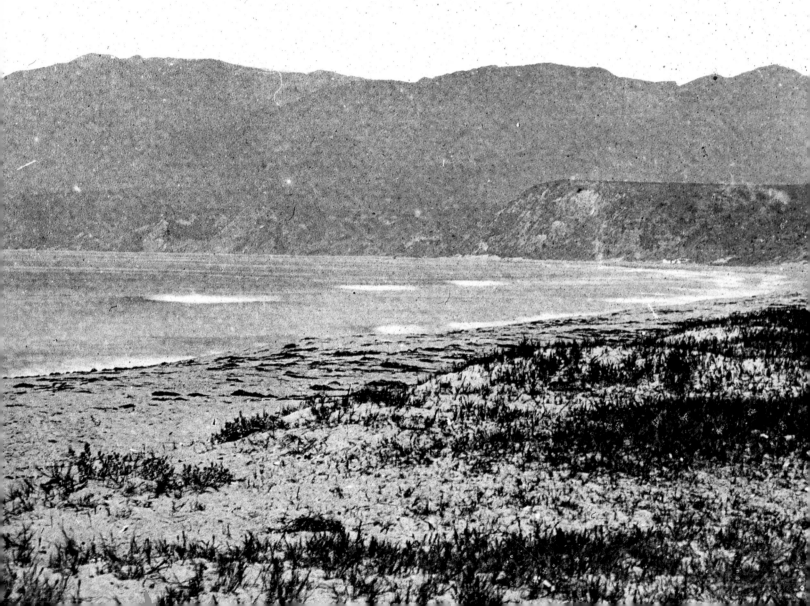

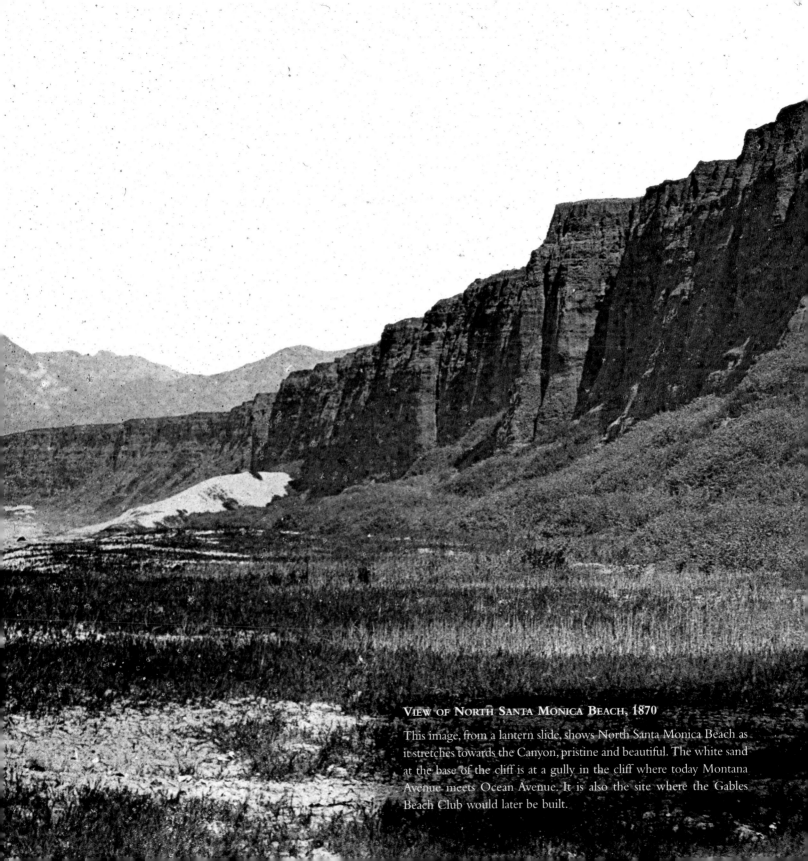

VIEW OF NORTH SANTA MONICA BEACH, 1870

This image, from a lantern slide, shows North Santa Monica Beach as it stretches towards the Canyon, pristine and beautiful. The white sand at the base of the cliff is at a gully in the cliff where today Montana Avenue meets Ocean Avenue. It is also the site where the Gables Beach Club would later be built.

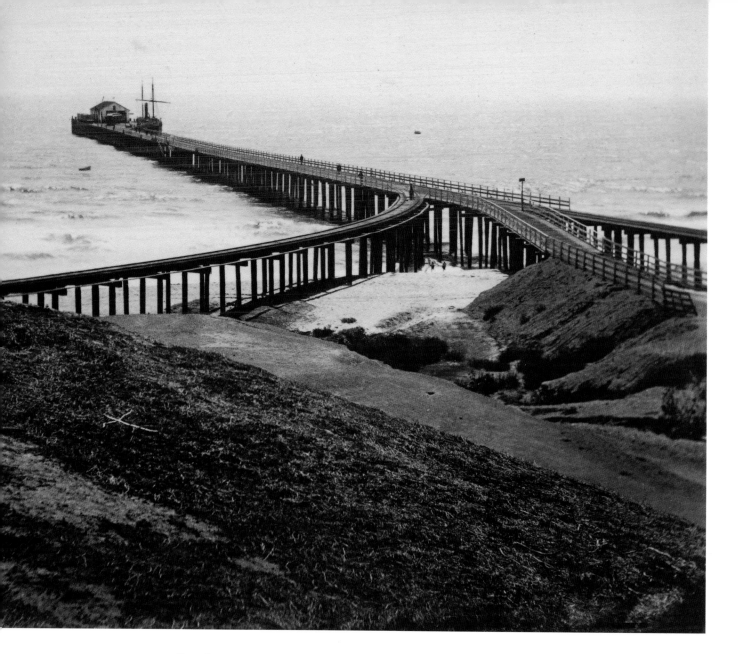

LOS ANGELES & INDEPENDENCE RAILROAD WHARF, VIEW FROM THE SHORE, 1877

Carleton E. Watkins photographed the Los Angeles & Independence Railroad wharf from the land. A depot station at the end of the wharf connected steamship passengers to trains bound for Los Angeles. Two of the three little piers leading to the main wharf were for train tracks and the third was for pedestrians.

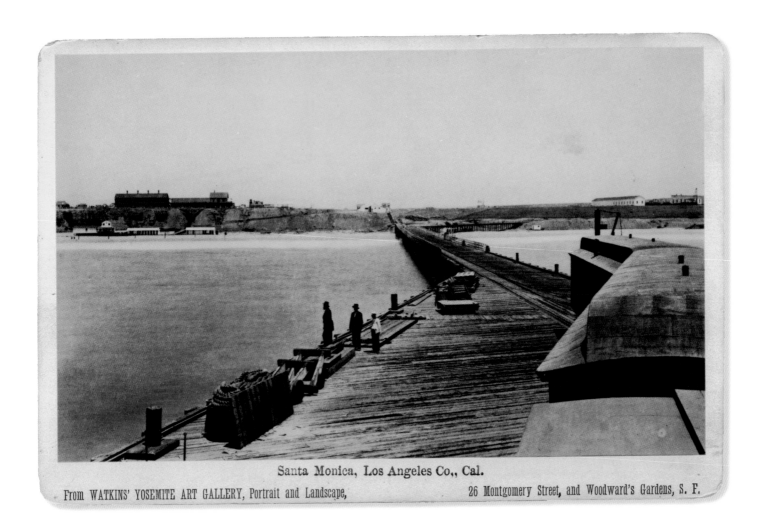

Santa Monica, Los Angeles Co,, Cal.

From WATKINS' YOSEMITE ART GALLERY, Portrait and Landscape, 26 Montgomery Street, and Woodward's Gardens, S. F.

LOS ANGELES & INDEPENDENCE RAILROAD WHARF, 1877

Watkins reverses the view and shows the developing town of Santa Monica from the sea. The Santa Monica Hotel with its four chimneys is on the bluff, as is Gaddy's Union Stable, which stood at the corner of Railroad Avenue and Second Street. On the beach are the Santa Monica Bath House (left) and Duffy's Bath House. Note the footpath that leads from the bluff to the beach.

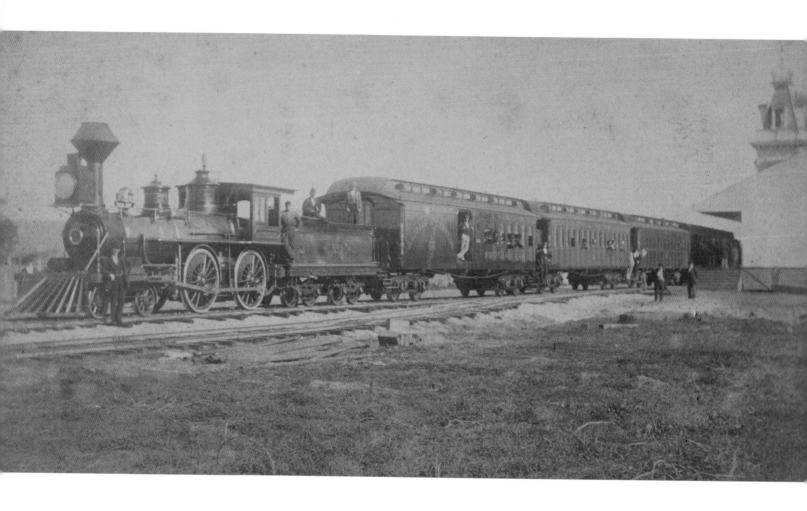

LOS ANGELES & INDEPENDENCE PASSENGER TRAIN, 1876

This train traveled to and from the end of the wharf in Santa Monica to the Los Angeles & Independence depot in Los Angeles. That short route was the extent of the railroad line when the L.A. & I. was sold to Southern Pacific in 1877.

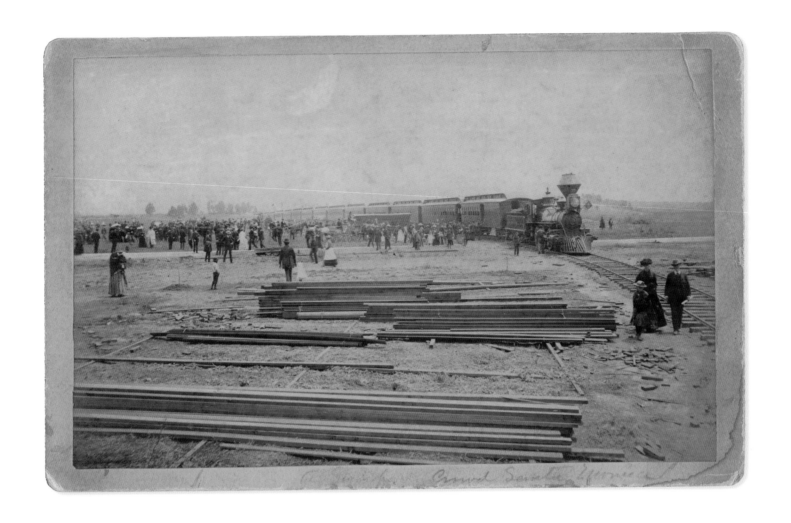

SOUTHERN PACIFIC TRAIN ENTERING SANTA MONICA, 1878

Besides transporting people to the beach, Southern Pacific Railroad trains brought hundreds of potential buyers and curious visitors to see the burgeoning town of Santa Monica. The stacked lumber visible in this photograph by E. G. Morrison was used for the construction of homes and commercial buildings.

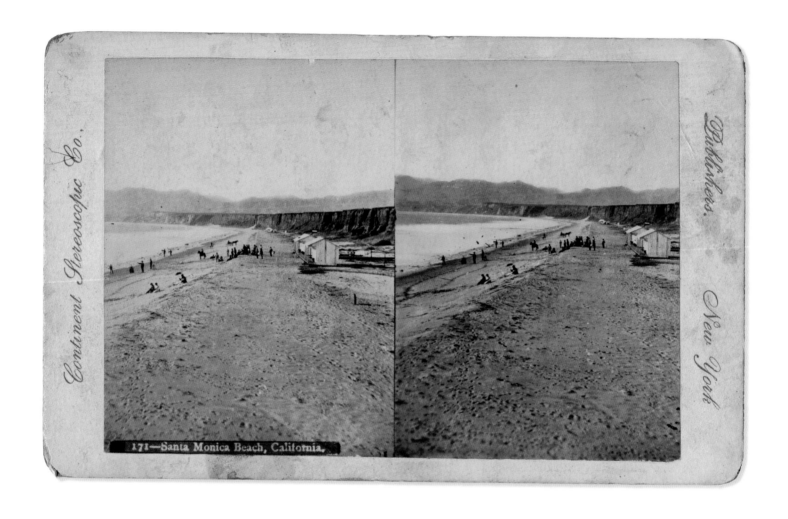

171—Santa Monica Beach, California.

DUFFY'S BATH HOUSE ON THE BEACH, 1876

A stereoview produced by the Continent Stereoscopic Company depicts people on the beach in front of Michael Duffy's Bath House. Duffy built the first bathhouse in Santa Monica in March 1876. Located at the base of the Santa Monica Hotel's stairway, a wooden walkway made the trip to the bathhouse more comfortable than walking on the hot sand.

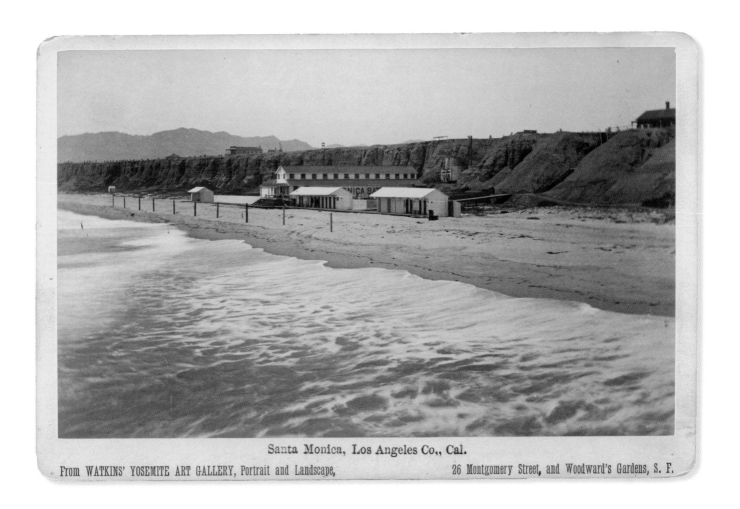

Santa Monica, Los Angeles Co., Cal.

From WATKINS' YOSEMITE ART GALLERY, Portrait and Landscape, 26 Montgomery Street, and Woodward's Gardens, S. F.

BATHHOUSES ON SANTA MONICA BEACH, 1877

A photograph by Carleton E. Watkins of Duffy's Bath House and the newly constructed Santa Monica Bath House shows the water tanks for the latter were still unfinished at the time. The building at the far left on top of the cliff was a building called Ocean House; on the right is the Santa Monica Hotel. Note that there are no trees on the bluff. Watkins must have made this photograph on a cold or rainy day, as there are no people on the beach.

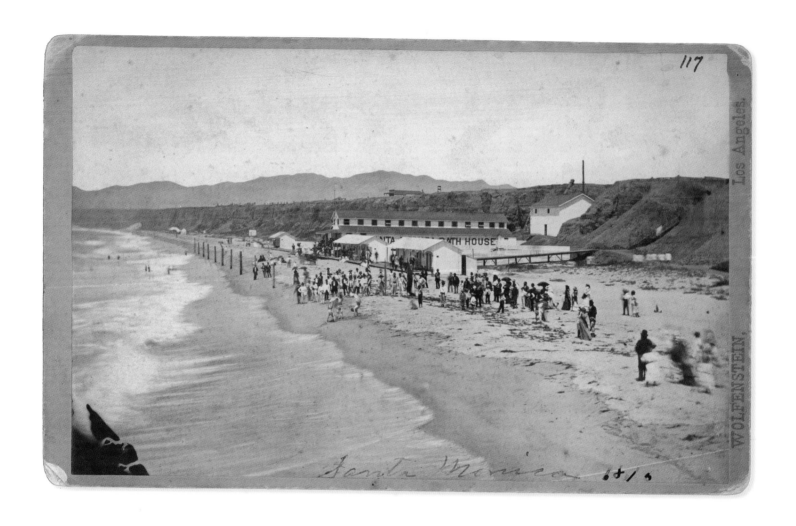

Crowd on the Beach in Front of the Bathhouses, 1877

Valentin Wolfenstein must have taken this photograph shortly after the previous image by Watkins, since the water tanks for the Santa Monica Bath House are complete and housed in the white building nestled in the cliffs behind the bathhouse. These three tanks held from five thousand to seven thousand gallons each of salt water, fresh water and warm water. The action on the beach includes three men performing gymnastic stunts and a few others holding flags.

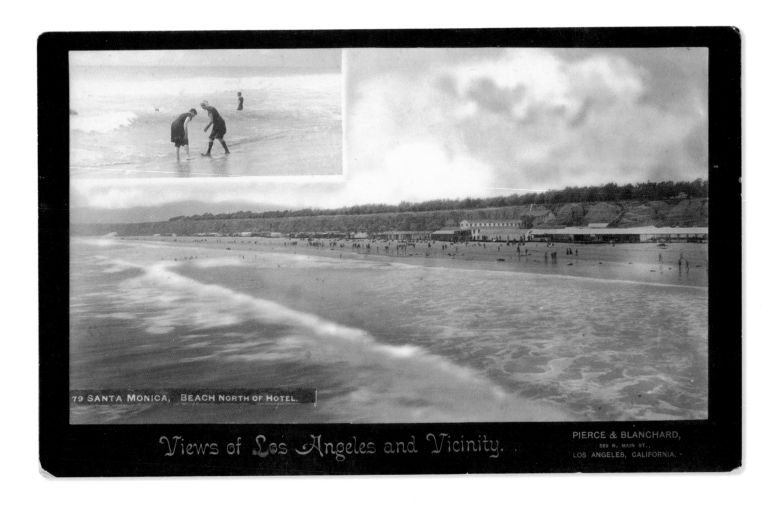

79 SANTA MONICA, BEACH NORTH OF HOTEL.

Views of Los Angeles and Vicinity.

PIERCE & BLANCHARD,
569 N. MAIN ST.,
LOS ANGELES, CALIFORNIA.

THE BEACH NORTH OF THE SANTA MONICA BATH HOUSE, LATE 1870S

A Pierce and Blanchard image shows the growth of businesses around the bathhouses—tents and shanties selling all sorts of goods are scattered along the beach for at least a mile. As the insert image of bathers displays, bathing suits of the time covered most of the body. In addition to the itchy, uncomfortable suit, women wore long stockings and hats. Since bathing suits were not a common household item, visitors to the beach rented them from bathhouses.

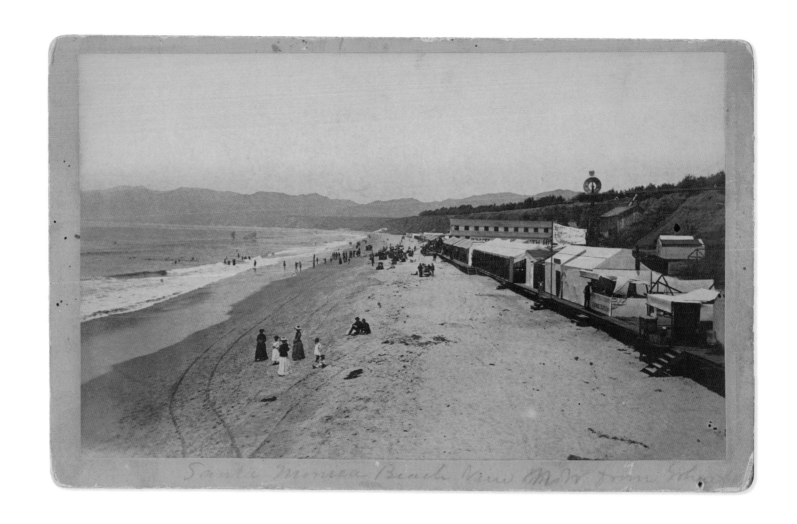

Santa Monica Beach View M.K. from Othie

NORTH SANTA MONICA BEACH, C. 1880S

A photograph by E.G. Morrison shows the many businesses in tents on the beach that catered to bathhouse visitors. To facilitate walking on the sand in front of vendors, a walkway of wooden planks was built.

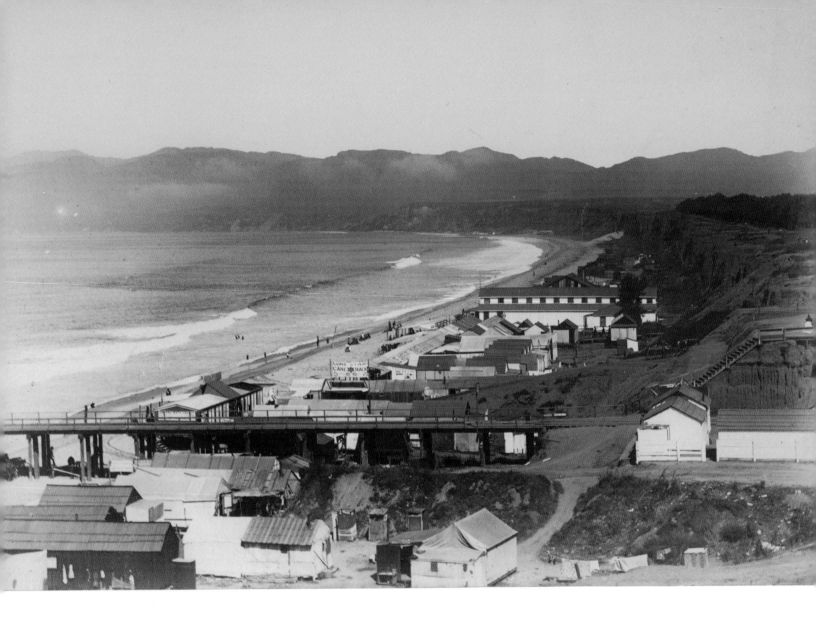

Santa Monica Bath House, 1889

This photograph displays a dramatic increase in the number of buildings near the Santa Monica Bath House—crude wooden shacks and canvas tents (with nearby outhouses) are scattered on the beach. Some of these structures appear to be dwellings with washing on the clothesline, while others are commercial establishments. In the foreground of the image, a part of the Los Angeles & Independence wharf remains standing, despite its sale to Southern Pacific in 1877.

THE SANTA MONICA HOTEL, 1877

On the flat land above the beach, at the intersection of Ocean and Railroad Avenues, the Santa Monica Hotel was one of the few buildings in the developing town. Carleton E. Watkins's composition in this photograph captures the dramatic gorge where the Los Angeles & Independence tracks headed toward the wharf, and the curving tracks of the route to Los Angeles. On the far left, part of Eckert & Hopf's Pavilion restaurant can be seen.

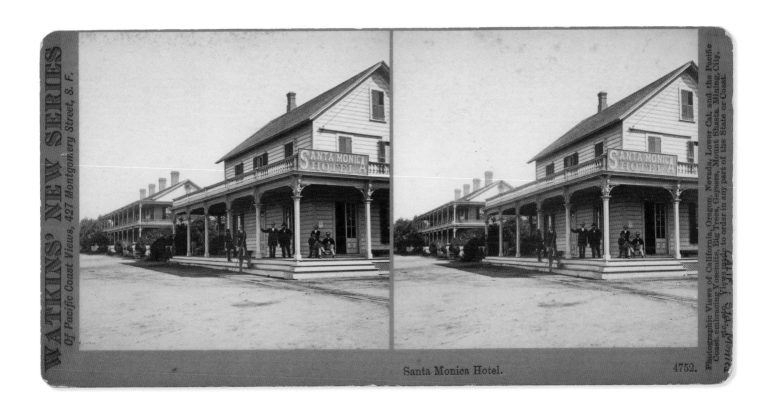

Santa Monica Hotel.

4752.

THE SANTA MONICA HOTEL, 1880

Another photograph by Carleton E. Watkins, this stereoview offers a closer look at
the hotel. Improvements since 1877 include a new sign attached to the balcony and
some landscaping work.

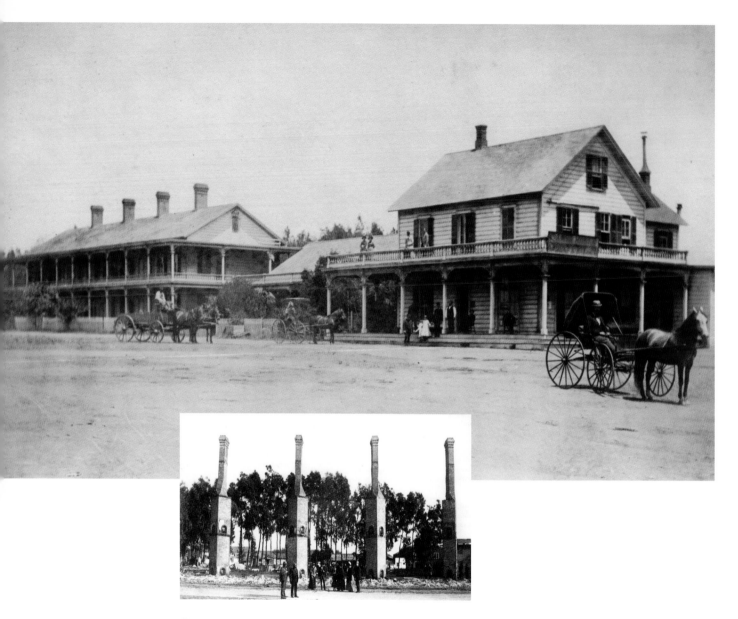

SANTA MONICA HOTEL FIRE, 1889

In January 1889 a fire erupted in the hotel, and because the town had no fire department or trained firemen, the blaze was not controlled and the structure was completely destroyed. As a result of this devastation, the Santa Monica Hose and Hook and Ladder Company #1 was formed to prevent further catastrophes. As the inset image shows, the only remains of the once impressive buildings were the four chimneys of the sleeping quarters.

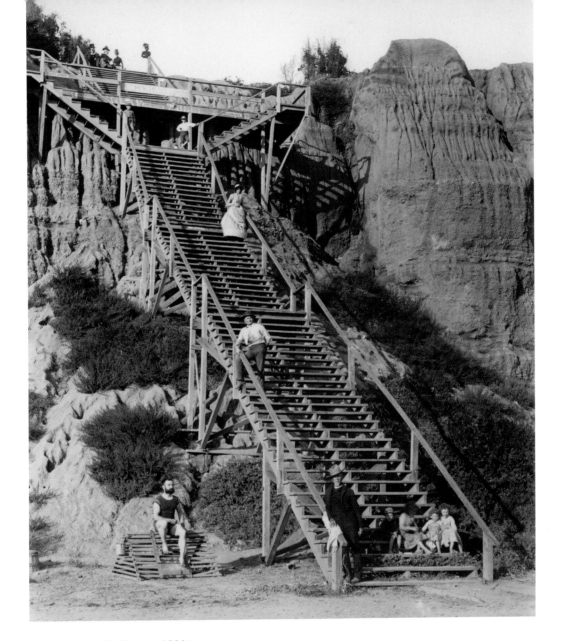

THE 99 STEPS, 1880s

This wooden staircase was constructed in 1875 at the foot of Arizona Avenue to allow easy access to the beach. The structure had exactly ninety-nine steps and was known as the 99 Steps throughout its existence. It was altered in 1893 so that Southern Pacific trains, en route to the Long Wharf, could pass underneath.

SHANTY ON THE BEACH, 1880s

Many temporary dwellings were constructed on the beach in the 1880s. Though these rustic structures lacked running water, electricity and sanitary facilities, they proved popular, and as evidenced in this E. G. Morrison cabinet card, drew friends and family for weekend visits to the beach..

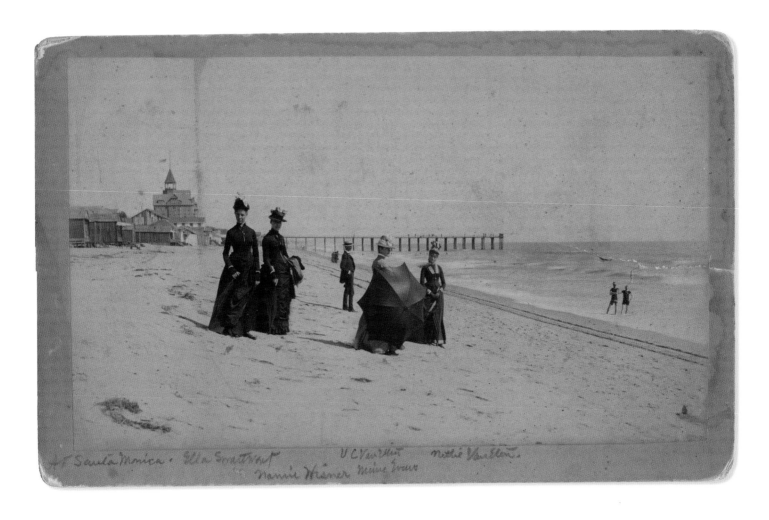

NORTH BEACH, 1888

A commissioned photograph identifies its subjects in handwriting on the back of the image that reads, "Our party at Santa Monica, August 1888. Mr. and Mrs. V.C. Van Ellen, Ella Smartmont, Nannie Wisner and Marie Van Ellen Evans." Of the subjects, only the latter lists her address as Los Angeles—the rest are all tourists from New York. By this time, Santa Monica's beach was well known as a resort destination. Visible in the background are the Arcadia Hotel and the remains of the Los Angeles & Independence Railroad wharf.

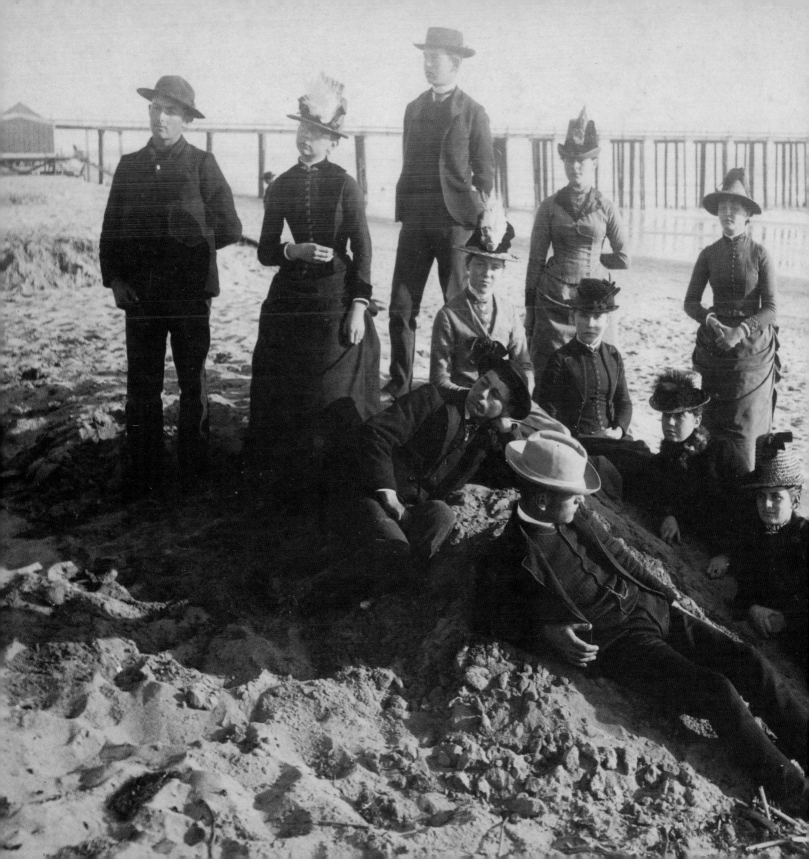

GRADUATES OF SANTA MONICA HIGH
1887

Out-of-town visitors were not the only
ones to enjoy a day at Santa Monica Beach
—locals loved North Beach too. Here the
first graduating class of Santa Monica High
School poses for a portrait. Hand-written
on the back of this picture are a few famil-
iar names: Albert Montgomery, Addie
Boehme (who later married Harry Keller,
whose family owned Malibu before the
Rindge family bought it), Erwin Tredwell,
Dora Elliot, Mamie Rose (whose father
owned the region known, then and today, as
Palms), Fred McComas and Ted Vawter.
Seated are Johnnie Summerfield (who later
became a Santa Monica judge), Emily Tyler,
Annie Suits, Alice Mosse, Madie Vawter and
Court Scott.

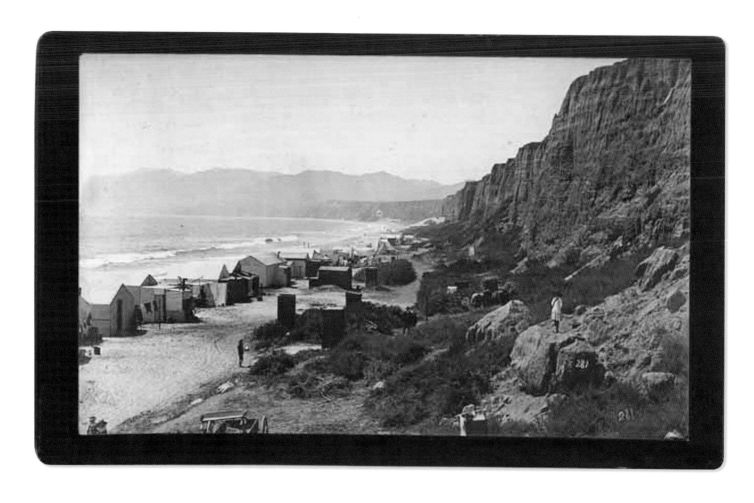

VACATION SHELTERS ON THE BEACH, 1889

Taken from the 99 Steps, this photograph by William Henry Fletcher depicts the canvas tents and shanties that were scattered north along the beach from the Santa Monica Bath House for about a mile. Immediately behind the dwellings are crude outhouses. Fletcher also managed to catch some activities around the homes: notice the laundry drying on the clothesline, the little girl standing on the rock to the right, the man in the center of the image, and the horses and wagons parked near the base of the cliffs.

SOUTHERN PACIFIC TRAIN, 1896

A Southern Pacific train exits the tunnel (built in 1892 to accommodate the new rail line) en route to the Long Wharf. Directly behind the staircase is the Eckert & Hopf Pavilion, and to the right, the Arcadia Hotel. Thomas Edison's film company made a movie of a train traveling this exact route in January 1898. Please refer to the bibliography at the back of this book for information on viewing this film through the Library of Congress online collection.

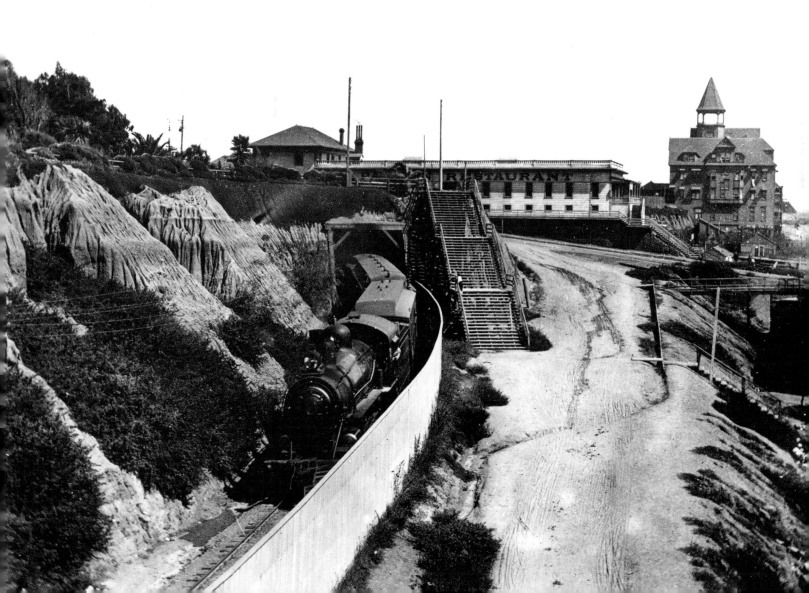

THE SOUTHERN PACIFIC RAILROAD TRACKS, LOOKING NORTH, 1893

An image of Southern Pacific's new track along the beach from Santa Monica to Port Los Angeles taken by Charles C. Pierce shows the tracks as they emerge from the tunnel and head up the coast to the Long Wharf. Note that all the shanties and tents on the beach are gone.

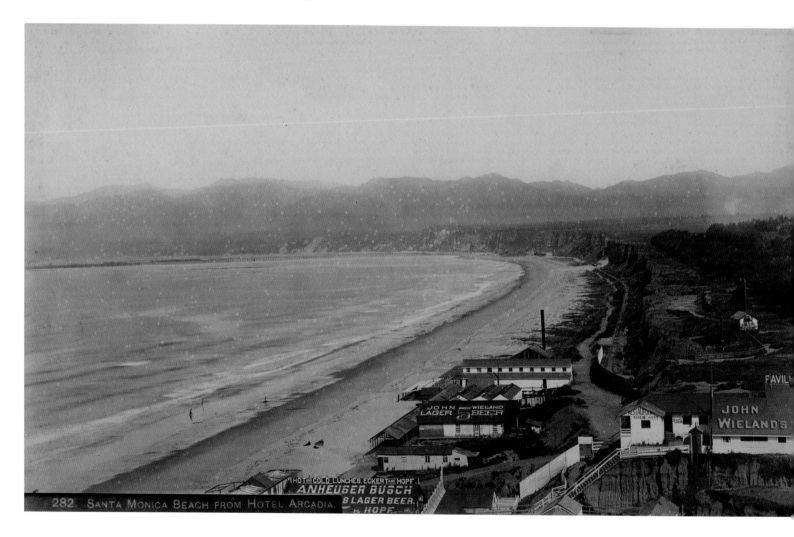

282. SANTA MONICA BEACH FROM HOTEL ARCADIA.

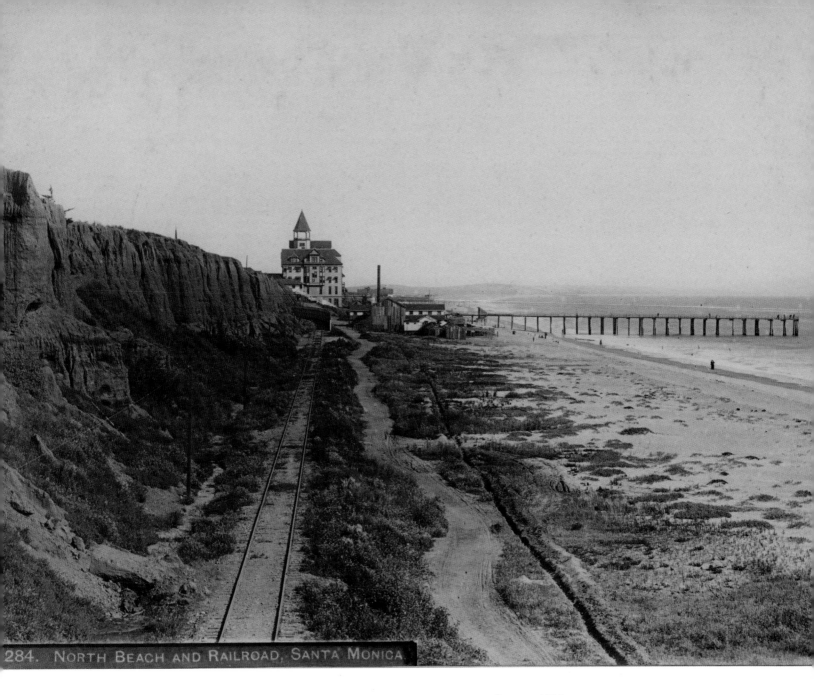

284. NORTH BEACH AND RAILROAD, SANTA MONICA.

THE SOUTHERN PACIFIC RAILROAD TRACKS, LOOKING SOUTH, 1893

Charles C. Pierce took this photograph from the 99 Steps, looking south toward the tunnel. The Arcadia Hotel is in the distance, as well as the Santa Monica Bath House and the remains of the Los Angeles & Independence Wharf.

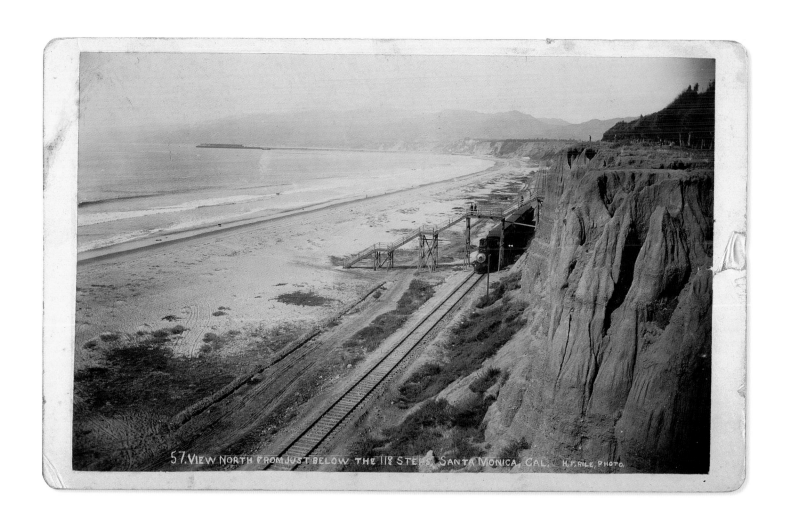

57. VIEW NORTH FROM JUST BELOW THE 118 STEPS, SANTA MONICA, CAL. H.F. RILE, PHOTO.

SOUTHERN PACIFIC RAILROAD PASSENGER TRAIN, 1893

This photograph shows a Southern Pacific passenger train passing under the 99 Steps and proceeding to Santa Monica from the Long Wharf. Note the old wagon trail next to the tracks. The beach land is completely devoid of any structures north of the grand staircase. As the notation by photographer H.F. Rile indicates, nineteen additional steps were added to make room for the train.

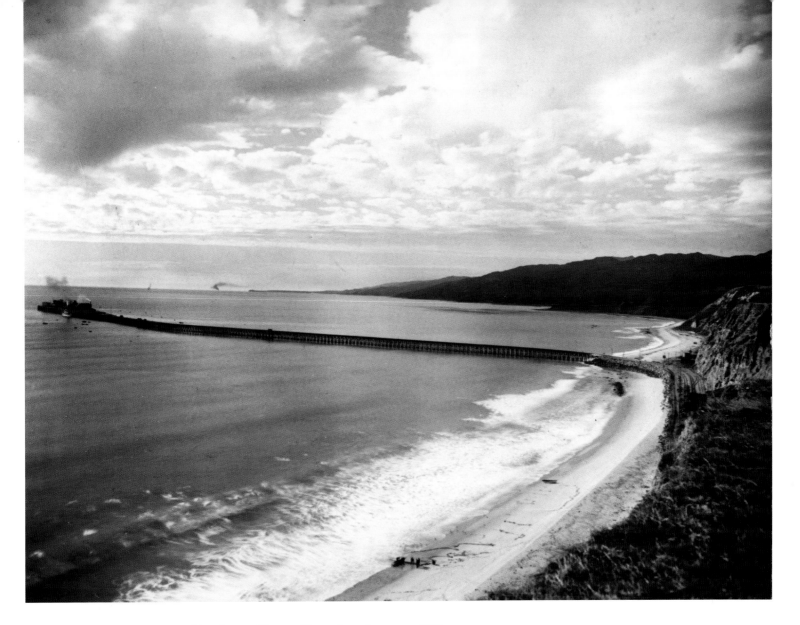

THE LONG WHARF/PORT LOS ANGELES, 1893

Collis Huntington's attempt to make Santa Monica the main deep-water harbor for Los Angeles included constructing the Long Wharf and the railroad tracks that lined the beach. With the wharf's completion, Santa Monica had, for a brief period of time, its taste of industrialization. Thankfully, San Pedro was chosen to be Los Angeles's main harbor, and is now one of the busiest harbors in the nation. One can't help but wonder what Santa Monica would have looked like today had Huntington succeeded in making it a huge commercial port.

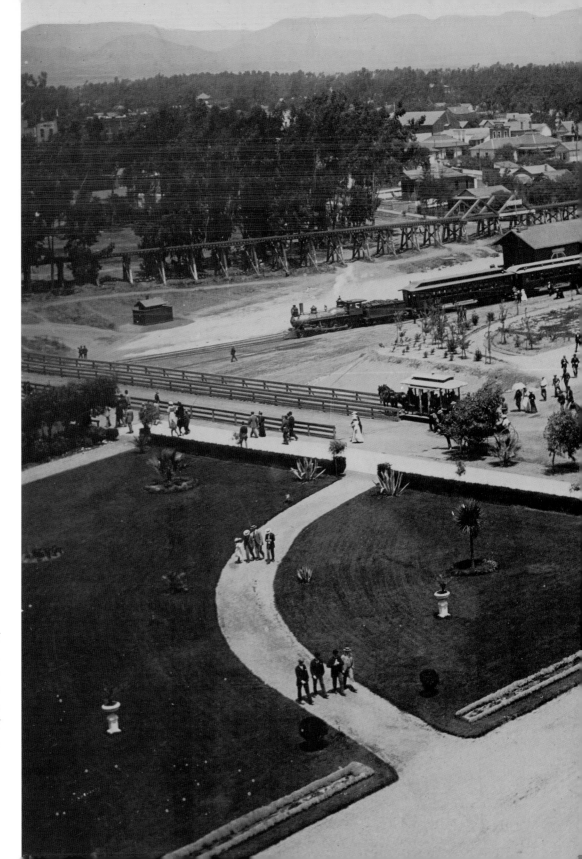

**SOUTHERN PACIFIC
EXCURSION TRAINS AT THE
SANTA MONICA DEPOT,
LATE 1890S**

A photograph by H.F. Rile of Southern Pacific's Santa Monica station, this unique view was made from the Arcadia Hotel's tower. Trains with as many as eleven cars brought thousands of visitors to Santa Monica on weekends.

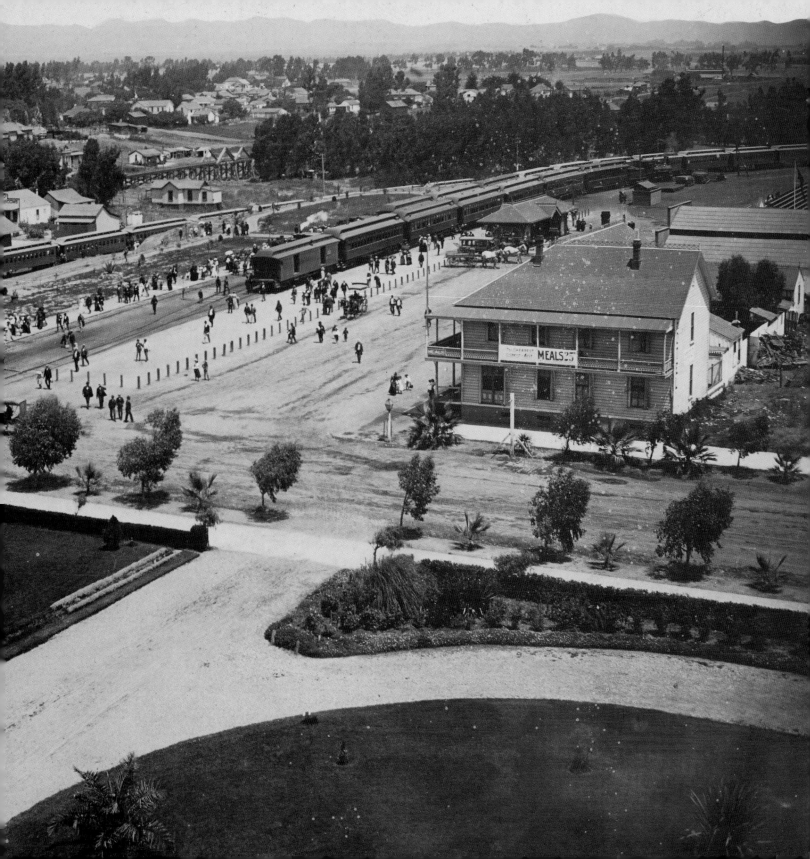

SOUTHERN PACIFIC DEPOT AT SANTA MONICA, LATE 1890s

H.F. Rile took this image of the beautifully landscaped Southern Pacific station located at Railroad and Ocean Avenues (across the street from the Arcadia Hotel).

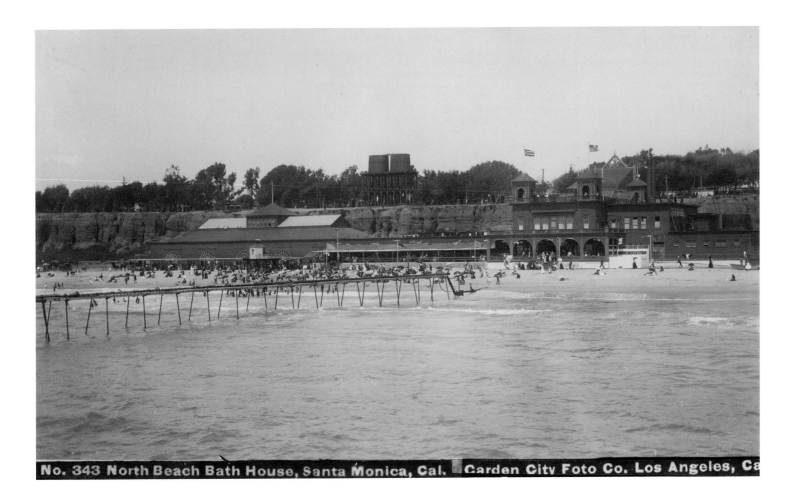

No. 343 North Beach Bath House, Santa Monica, Cal. Garden City Foto Co. Los Angeles, Ca

NORTH BEACH BATH HOUSE FROM THE END OF ITS PIER, C. 1896

The rickety structure visible in this photograph by Garden City Foto carried seawater to the plunge and bathhouse. Behind the bathhouse, on the top of the cliff, two large water tanks hold seawater used to spray the town's dirt roads to minimize the dust.

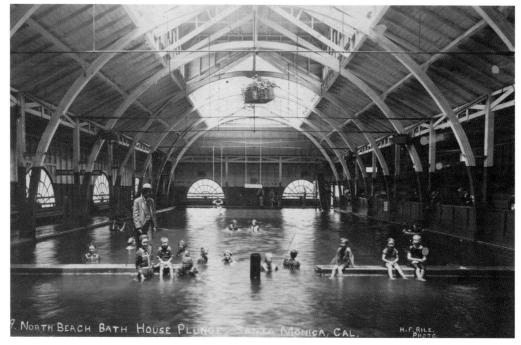

THE NORTH BEACH BATH HOUSE PLUNGE, LATE 1890s

Two images of the interior of the bathhouse show the warm-water plunge. Above is a four-color postcard and below is an original photo by H.F. Rile. Postcard manufacturers often utilized Rile's black-and-white images, and then hand-colored them for mass printing.

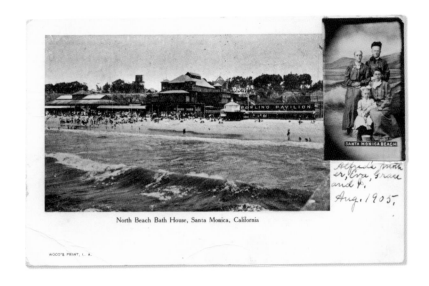

North Beach Bath House, Santa Monica, California

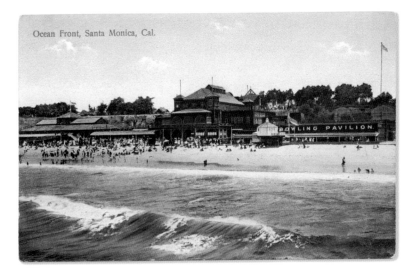

Ocean Front, Santa Monica, Cal.

NORTH BEACH BATH HOUSE, 1905

Colored and printed in Germany, the postcard on the bottom shows the North Beach Bath House after its 1901 renovations, which included enclosing the roof garden into an auditorium. The small building in front of the Bowling Pavilion is the Camera Obscura. The postcard on top features the same picture of the bathhouse, but was printed by a different company and customized by the addition of a small portrait that has been glued to the card. On the back, a handwritten note reads, "Alfred's mother, Eva, Grand and I. Aug. 1905." This unmailed postcard is a wonderful example of a typical souvenir from a beach trip at the turn of the century.

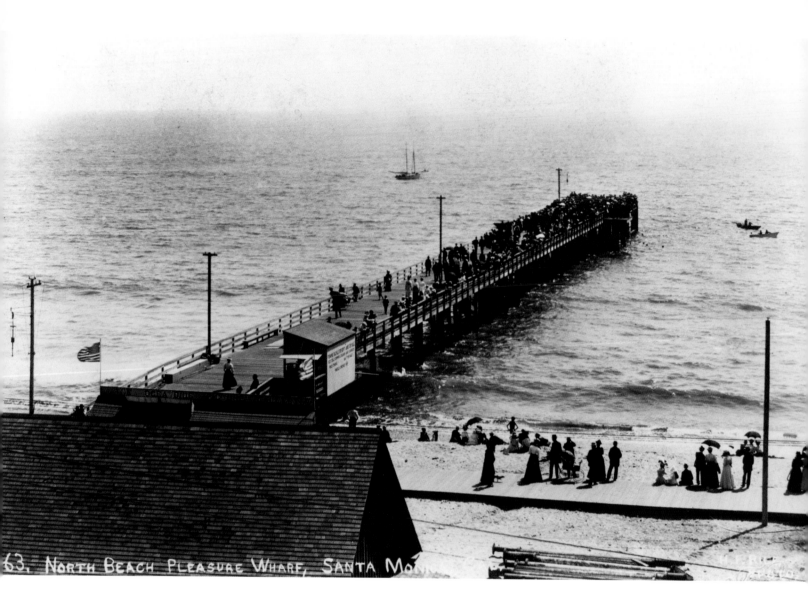

63. NORTH BEACH PLEASURE WHARF, SANTA MON[...]

NORTH BEACH BATH HOUSE PIER, 1898

An H.F. Rile photograph proves the popularity of the North Beach Bath House Pier, and offers a nice glimpse of the arc lights (hanging from poles on the pier) that lit the pier at night—a recent invention at the time.

NORTH BEACH BATH HOUSE PIER, C. 1898

Wooden piers constructed over the ocean proved to be an irresistible attraction for people. The North Beach Bath House Pier, built in 1898, was no exception. As this photograph by William Henry Fletcher attests, people fished off the pier, or simply strolled its length for a better view of the shore and Santa Monica Bay.

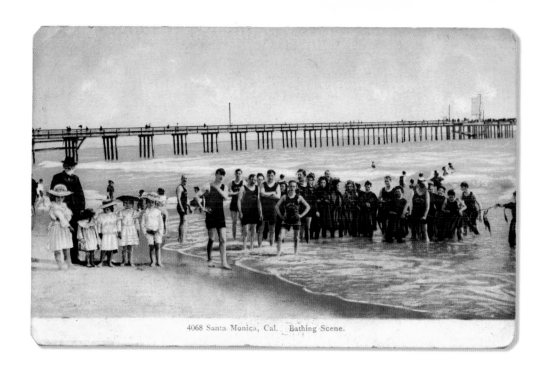

4068 Santa Monica, Cal. Bathing Scene.

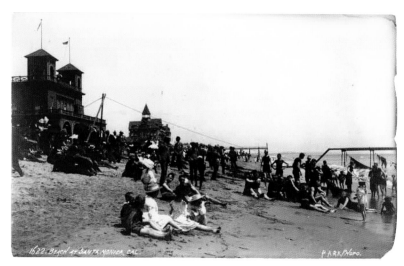

1622. Beach at Santa Monica Cal. PARK Photo.

LOUNGING ON THE BEACH IN FRONT OF THE NORTH BEACH BATH HOUSE 1898

Many of the visitors to the North Beach Bath House enjoyed the water as the color postcard (top) shows. Others, as evident in the photograph (bottom) taken by Frank L. Park, simply sat on the beach, fully clothed, and enjoyed the sun at the seashore.

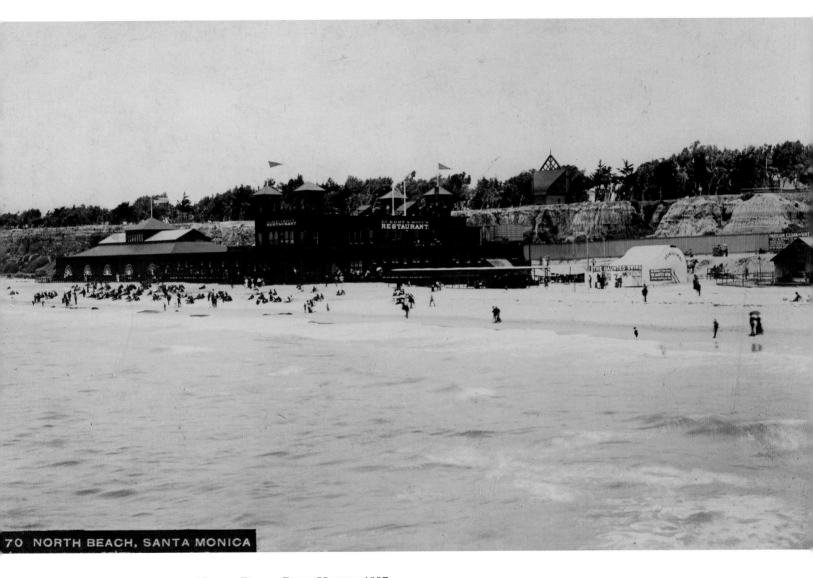

NORTH BEACH BATH HOUSE, 1897

The visitors that the excursion train brought to Santa Monica were treated to the lavish North Beach Bath House and the beautiful white sands of the beach. Built in 1894, it replaced the seventeen-year-old Santa Monica Bath House. This impressive center featured a warm salt-water plunge (the long building on the far left) and an enormous bathhouse (the building with two towers). In the white tent is an amusement ride called the Haunted Swing.

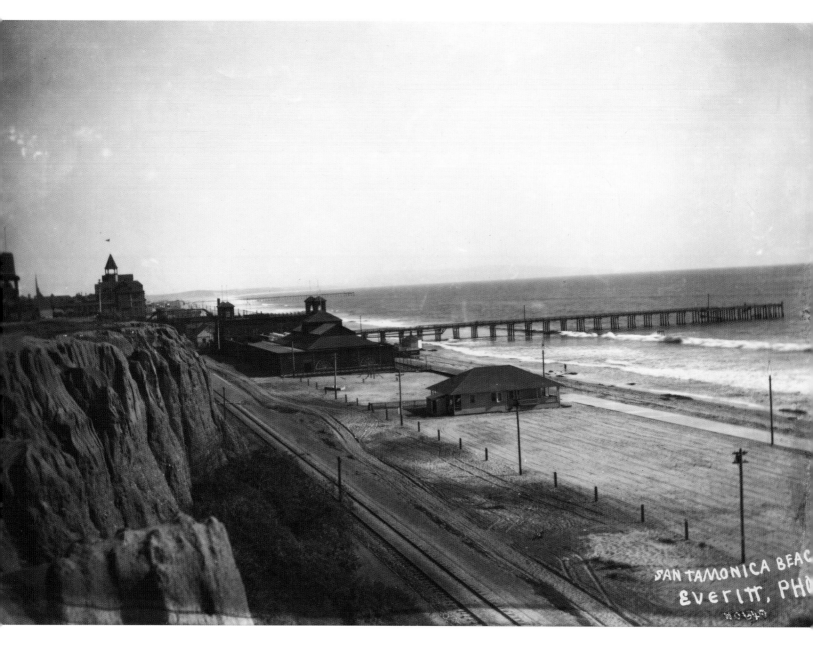

SAN TAMONICA BEAC
EVERITT, PHO

SUNSET BEACH TRACT, 1901

The first house on the beach stands alone, just a short distance from the North Beach Bath House, in 1901. The land pictured here was subdivided into lots twenty-five feet wide and a hundred feet deep. The pier is the North Beach Bath House Pier.

LOOKING S. FROM PALISADES, SANTA MONICA, CAL.

SUNSET BEACH TRACT, 1910

A real-photo postcard by the J. Bowers Photo Company shows new homes on the beach in the early twentieth century. This view, taken from Linda Vista Park, includes the new all-concrete Municipal Pier and a bit of Southern Pacific's railroad tracks. The path lined by the rustic fence is the Sunset Trail, which leads down to the beach.

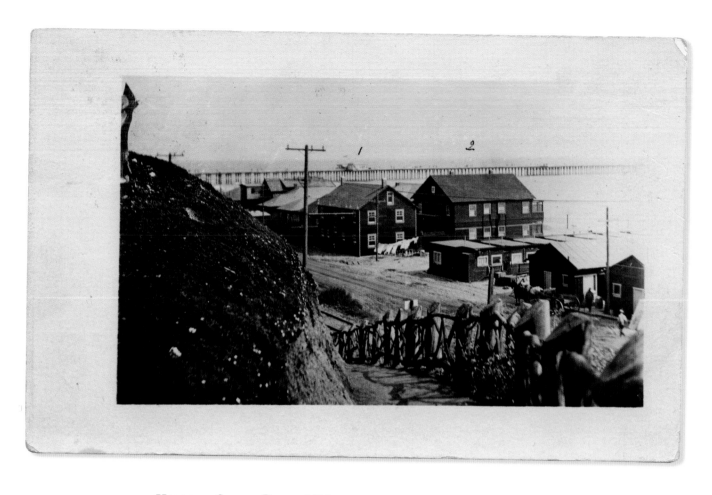

HOMES AT SUNSET BEACH, 1914

A closer view of the homes built on Sunset Beach, this real-photo postcard (sent to a Miss Josephine Schweitzer in Stockton, California) carries a handwritten message on the back that reads:

> Dear Friend, your N.J. card received. Hope you and all the folks are well. I ges {sic} you had plenty of rain for a fine crop this year and plenty work. I am keeping myself buissy {sic} as I have plenty to tend to although I have two ladies to tend to my houses. I find enough for myself to keep buissy {sics}. The other side is {sic} 2 of my houses from the rear. My regards to all the folks. Respectively {sic} yours, Conrad Bartolo.

THE SUNSET TRAIL, EARLY 1900S

A real-photo postcard of the Sunset Trail by Taylor Photo shows the footpath that
led from Linda Vista Park (later known as Palisades Park) to Sunset Beach.

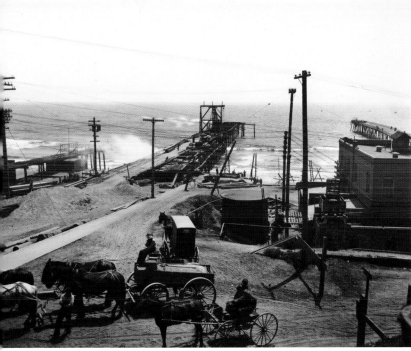

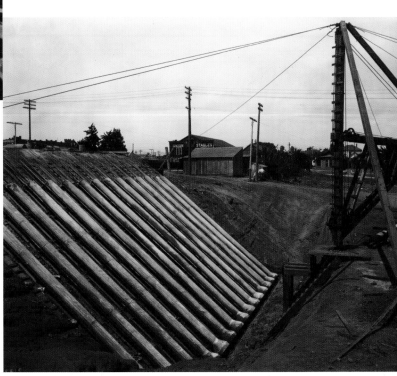

CONSTRUCTION OF THE MUNICIPAL PIER, 1908

These photographs document the early stages of construction for the new concrete pier at the foot of Colorado Boulevard. Top left: The remainder of the Los Angeles & Independence Wharf is visible to the left, and the pier on the far right is the North Beach Bath House Pier. Also on the right, the large brick building is the city's electric power plant. Bottom right: The molds for the concrete pilings that rapidly deteriorated.

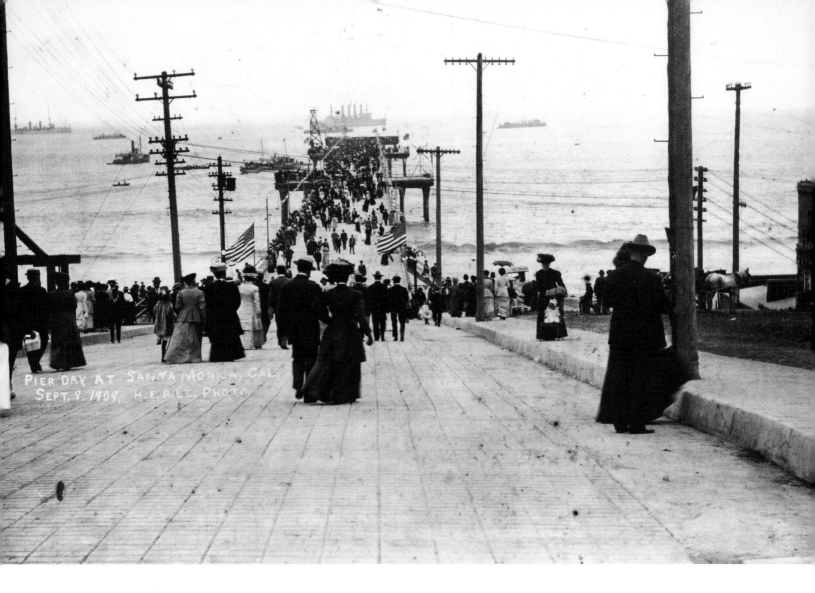

Pier Day at Santa Monica, Cal.
Sept. 9, 1909. H. F. Rile, Photo.

OPENING DAY FOR THE MUNICIPAL PIER, 1909

On September 8, 1909, locals and tourists alike flocked to Santa Monica for Pier Day, the grand opening of the new concrete pier. Visible in the distance of this photograph by H.F. Rile are U.S. Navy vessels, anchored offshore to join the celebration. The souvenir color postcard shows a crowd celebrating Pier Day.

The new Pier at Santa Monica, Cal.

LOOFF PLEASURE PIER, 1917

Completed in 1917, the Looff Pleasure Pier was built next to the Municipal Pier. This photograph was taken shortly after the Looff Pier's opening.

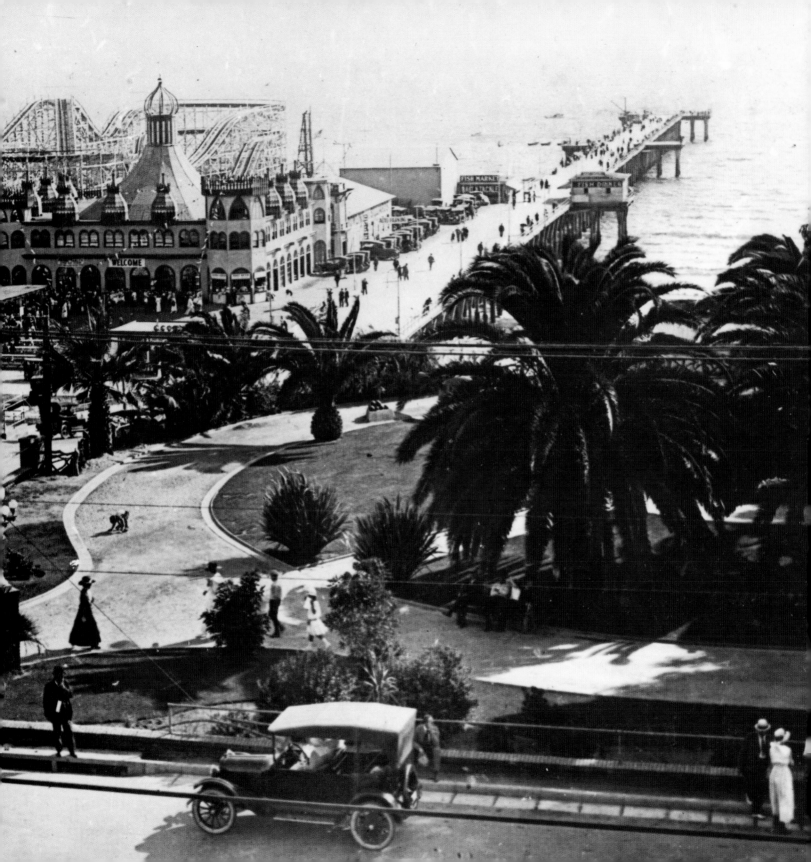

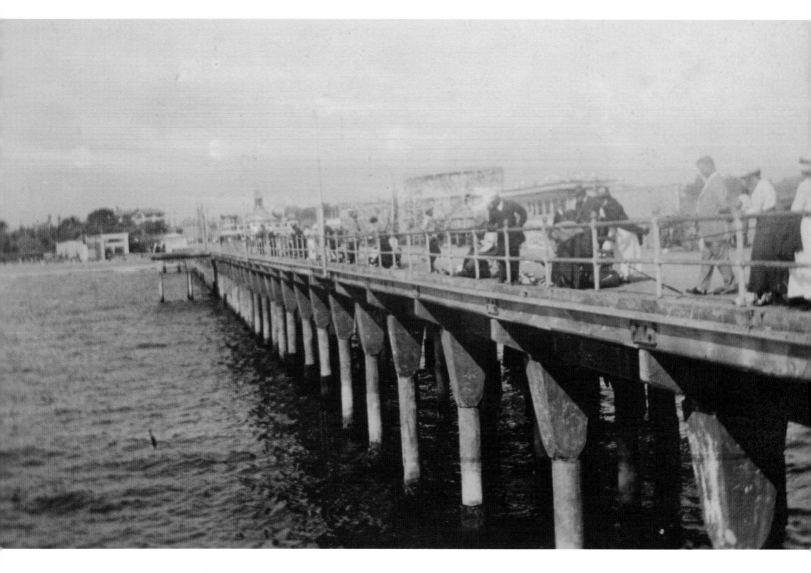

The Municipal Pier, c. 1910

This amateur snapshot was made at the outer end of the concrete pier. Though the image is flawed, it provides a good view of the concrete piles that eroded and were replaced by wooden piles in 1919.

THE MUNICIPAL PIER, C. 1921

This Adelbert Bartlett photograph shows the pier after the piles were replaced with wooden ones and the pier reopened in 1921.

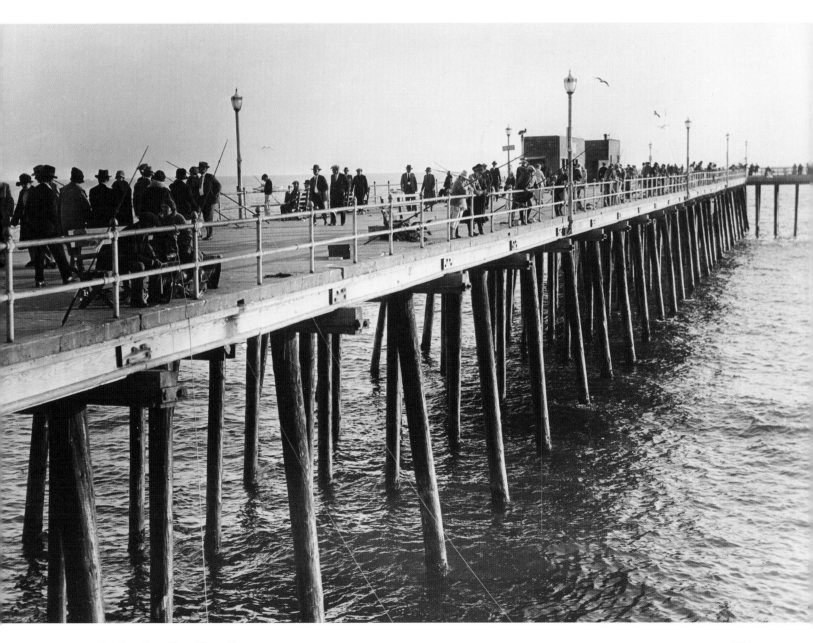

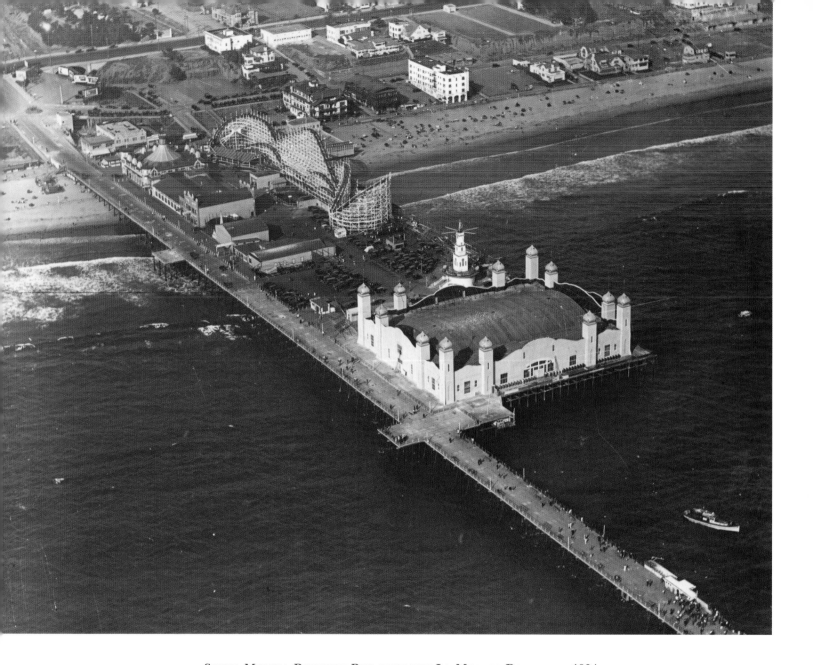

SANTA MONICA PLEASURE PIER WITH THE LA MONICA BALLROOM, 1924

An aerial view of the Santa Monica Pleasure Pier shows the size of the newly constructed La Monica Ballroom, the large building with spires. Adjacent is the long Municipal Pier.

SANTA MONICA LIFEGUARDS AT THE LA MONICA HEADQUARTERS, 1932

For a while, the headquarters for Santa Monica's lifeguards were located in the La Monica Ballroom. In 1933 the municipal lifeguard service became a separate division of the city's department of safety. Under this arrangement, Captain George Watkins (wearing the white hat), the head of the lifeguards, was ranked similarly to the police and fire chiefs.

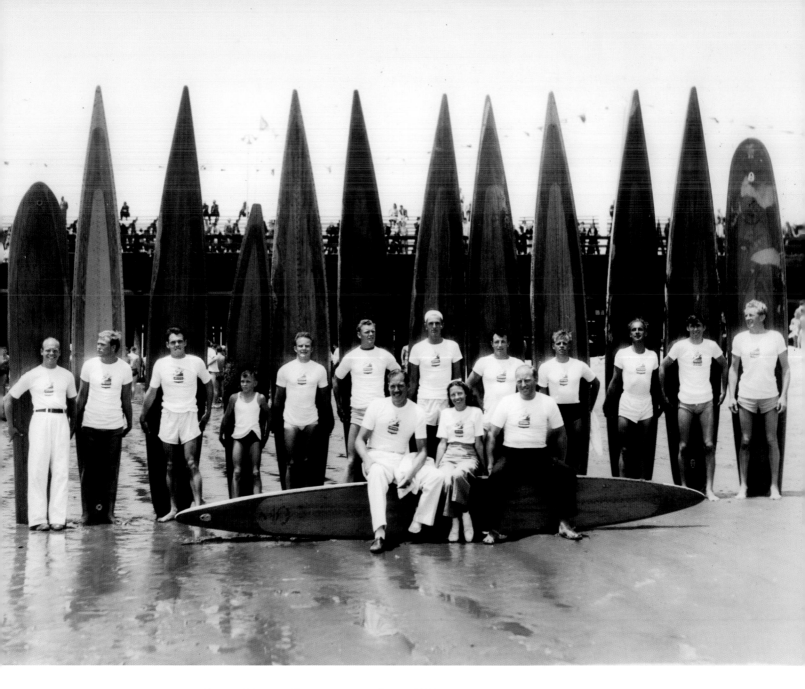

SANTA MONICA PADDLEBOARD CLUB, 1930S

Beautiful hollow, wooden paddleboards were used to ride the waves at Santa Monica Beach. This type of board was also used in races from Santa Monica to Catalina Island and back.

PADDLEBOARD RIDING, 1936

A familiar site on the beach in the 1930s was paddleboarder Dorothy Hawkins and Captain James, her pet duck.

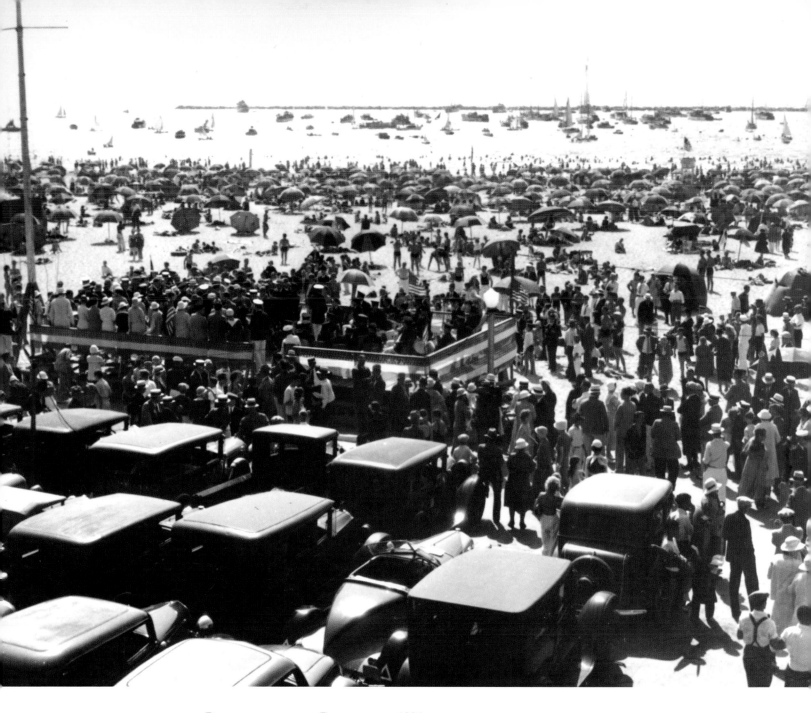

Dedication of the Breakwater, 1934

Snapped from Palisades Park, this picture shows the crowd that gathered to celebrate the completion of the breakwater and watch small boats in the new harbor.

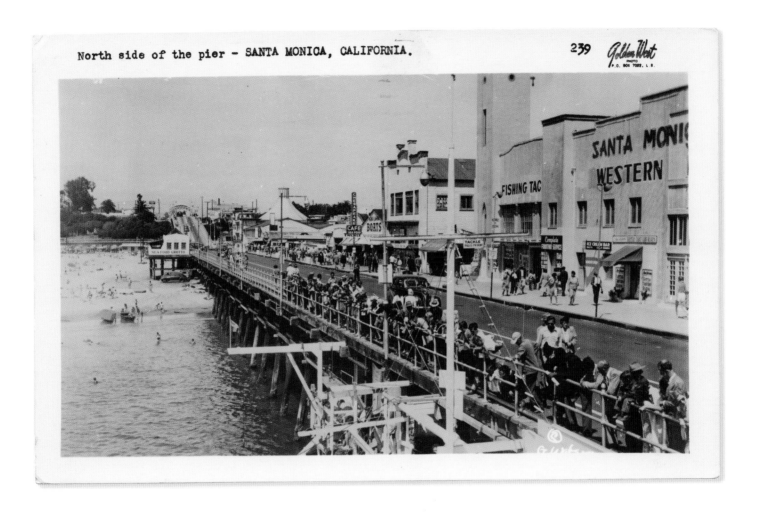

North side of the pier – SANTA MONICA, CALIFORNIA. 239

NORTH SIDE OF SANTA MONICA PIER, 1950s

Published by Golden West, this real-photo postcard shows the distinction between the Municipal Pier that was used mainly for fishing, and the amusement pier. By the time this was taken, the La Monica Ballroom has changed its name to become the Santa Monica Ballroom, home to Spade Cooley's Western Swing Band. Another new addition is the fishing tackle store.

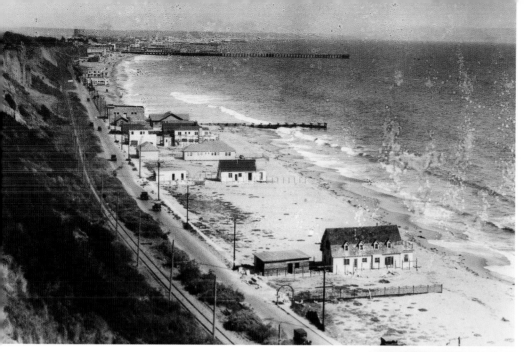

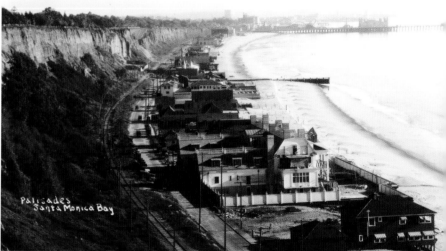

HOMES ALONG THE GOLD COAST, 1920s

These two views show the rapid growth of luxury homes along the beach beneath the palisades. The earlier image (top left) shows a few homes and the groin built at the foot of Montana Avenue. In the foreground of the picture is the land purchased by William Randolph Hearst to be the site of Ocean House, a mansion for Marion Davies. By 1926 many new buildings filled the area, including the large white structure, which is the Davies house under construction. On the street outside of the surrounding fence are twenty-one parked cars that belonged to the construction workers.

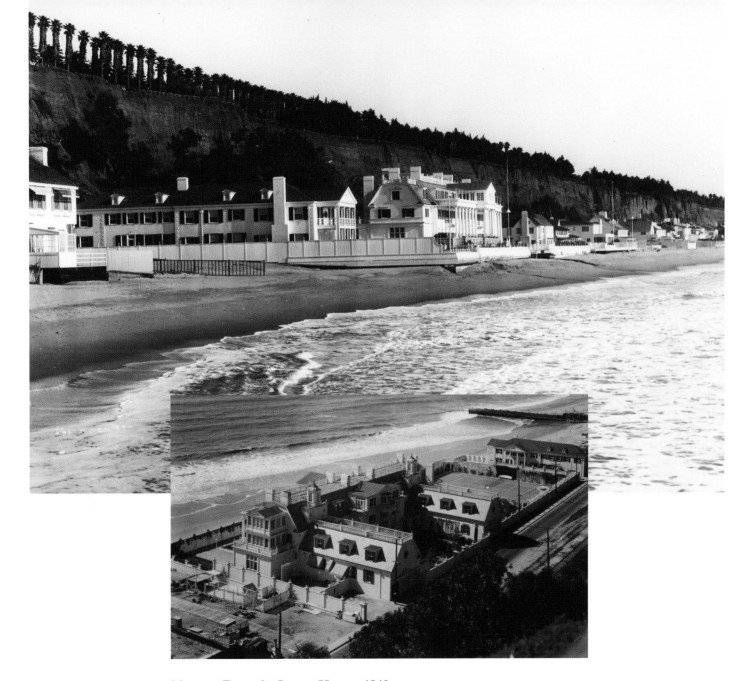

MARION DAVIES'S OCEAN HOUSE, 1940S

Built in 1926, Ocean House was the largest and most expensive home built on the beach. From the ocean side, the long wing with many windows housed the servants. The real-photo postcard (bottom) provides a birds-eye view of its original 118 rooms.

PALISADES BEACH ROAD, 1928

Adelbert Bartlett's view of the homes along the two-lane Palisades Beach Road (later known as the Pacific Coast Highway) shows a Pacific Electric Railway trolley on the old Southern Pacific Railroad tracks.

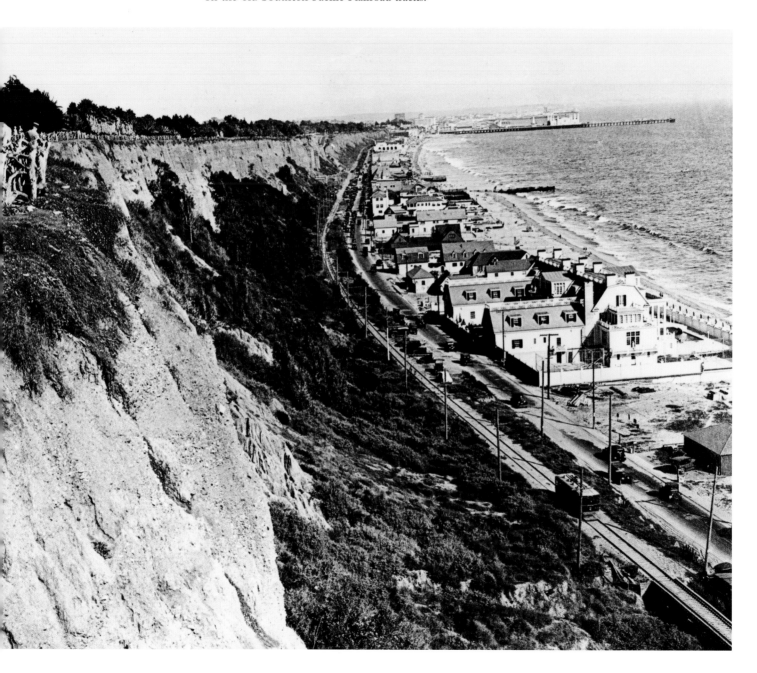

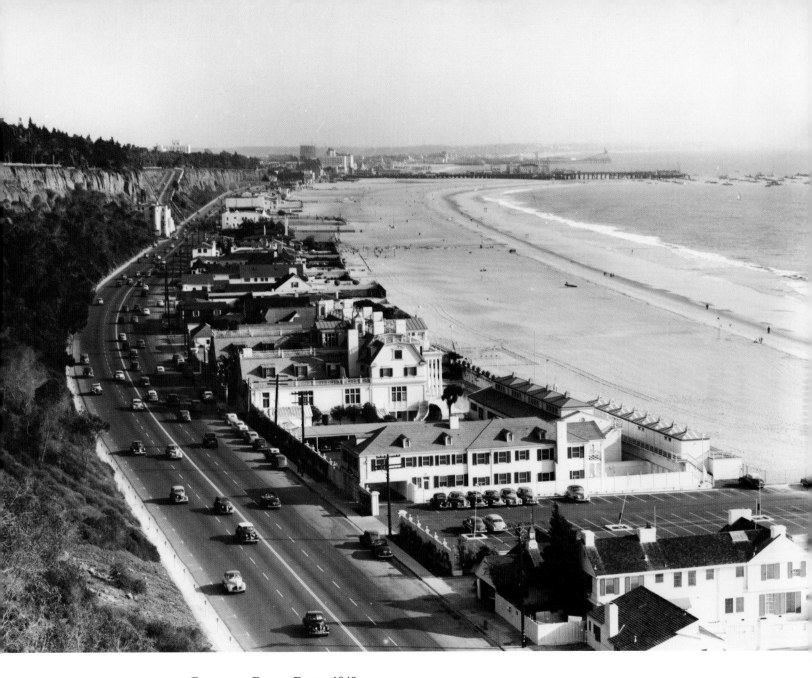

PALISADES BEACH ROAD, 1949

By the late 1940s, Palisades Beach Road was a six-lane highway, transformed by an expansion after the removal of the rail lines. The road passes directly in front of Ocean House. Notice how the sandy beach has increased due to the construction of the breakwater in 1934.

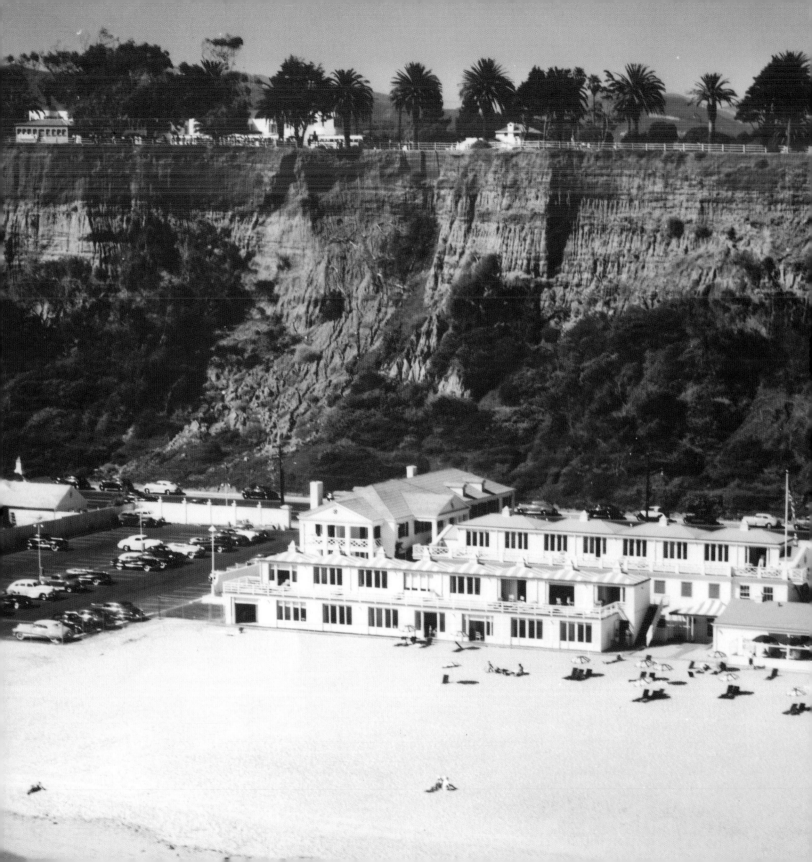

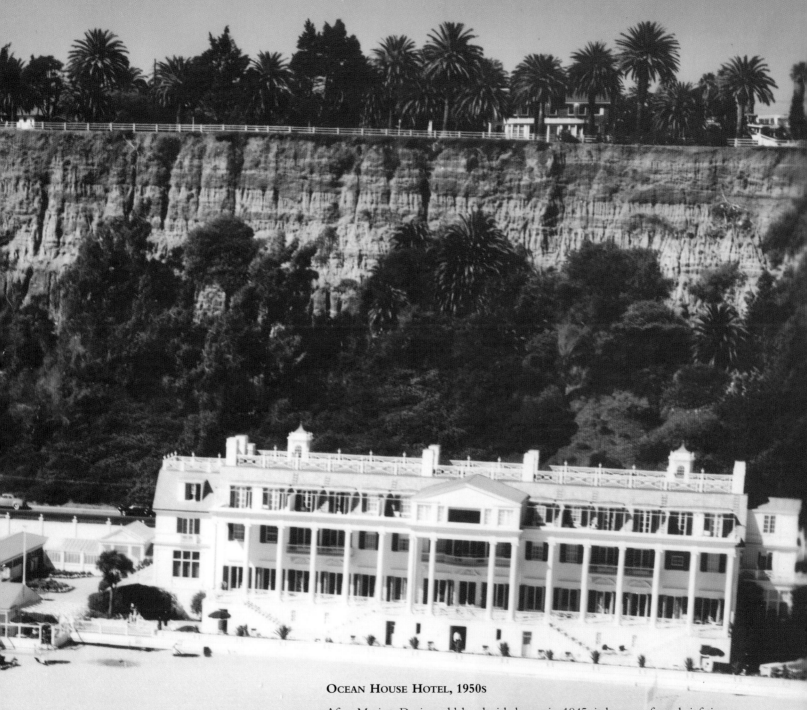

Ocean House Hotel, 1950s

After Marion Davies sold her lavish home in 1945, it became, for a brief time, a hotel owned by Joseph Drown, owner of the Beverly Hills Hotel. Unable to make a profit, he tore down the main house and sold some of the property to the state. All that remains today as a reminder of the once lavish compound is the "North House," which served as the servants' quarters when Davies owned the property.

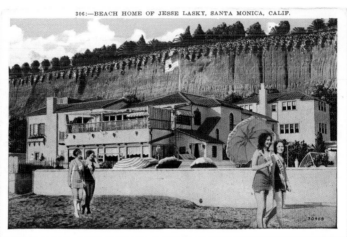

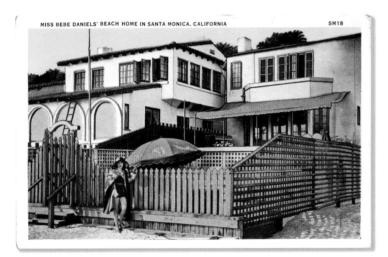

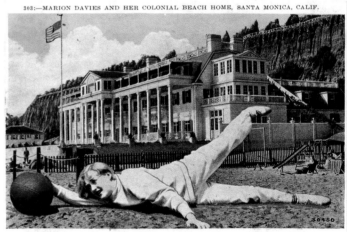

BEACH HOMES OF THE MOVIE STARS, 1930S

Postcards of movie-star homes were popular items for tourists to collect. These colorful pictures of lavish homes allowed visitors to take a piece of Gold Coast glamor home with them.

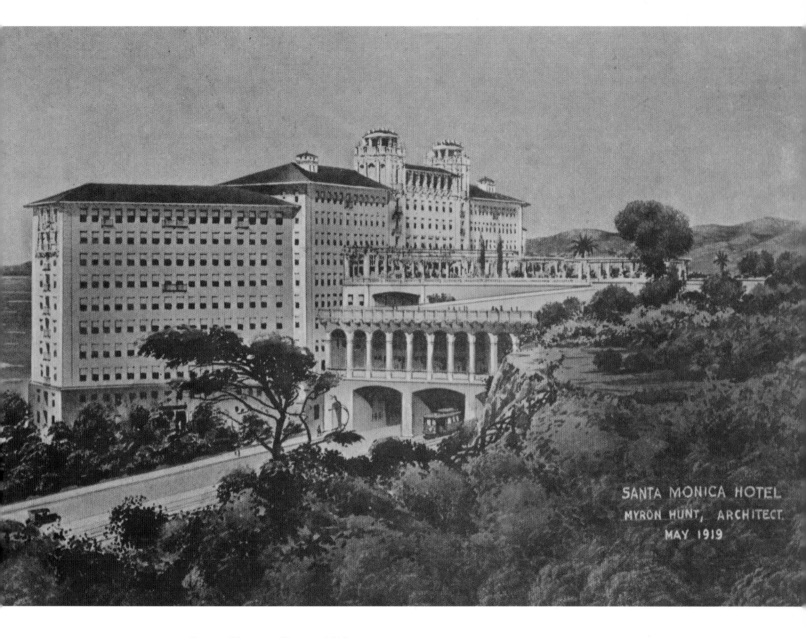

SANTA MONICA HOTEL
MYRON HUNT, ARCHITECT.
MAY 1919

SANTA MONICA HOTEL, 1919

Promoters who saw the potential for a world-class resort came up with fantastic ideas to develop Santa Monica Beach, but most never came to fruition. The most remarkable was the 368-room Santa Monica Hotel complex designed by legendary architect Myron Hunt, which was to be built on the beach at the foot of Wilshire Boulevard (once known as Nevada Avenue). It was never constructed.

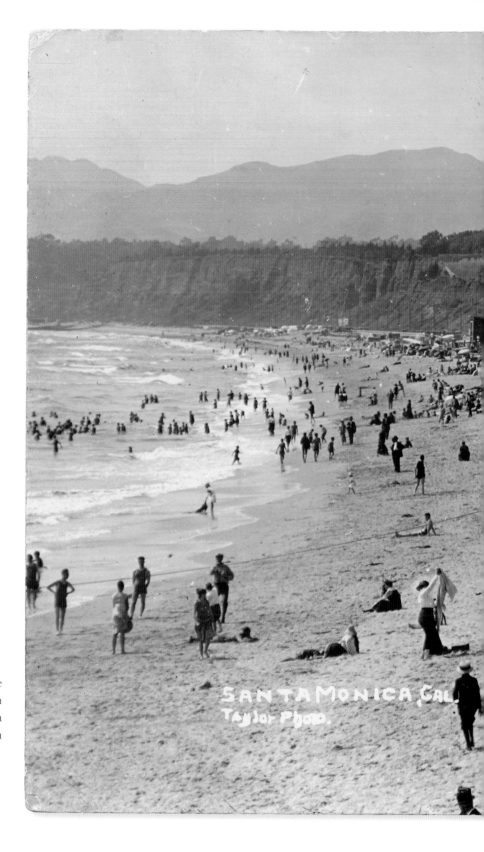

SITE OF SANTA MONICA ATHLETIC CLUB, 1919

A real–photo postcard by Taylor Photo shows a large building with the words "Bath House" painted on its side. This building became the Santa Monica Athletic Club in 1922, the first in a string of beach clubs along the shore.

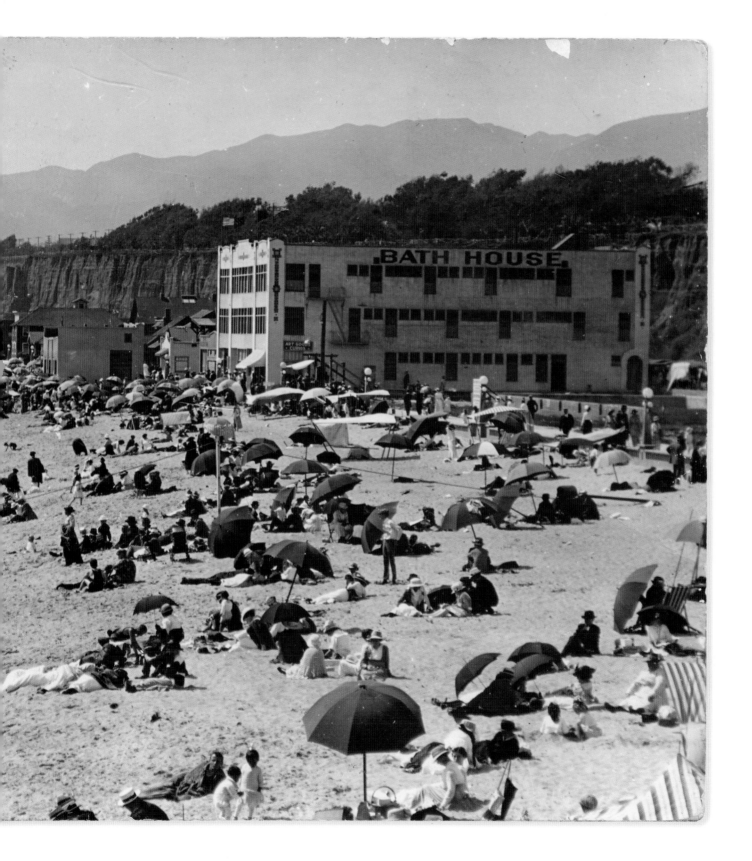

THE BEACH CLUB AND THE SANTA MONICA SWIMMING CLUB
1920s

The northernmost clubs on the beach were built in 1923. The Beach Club (left and top) is still in operation today and is one of the oldest private beach clubs in Santa Monica. The photographer's notation mistakenly identifies The Santa Monica Swimming Club (below).

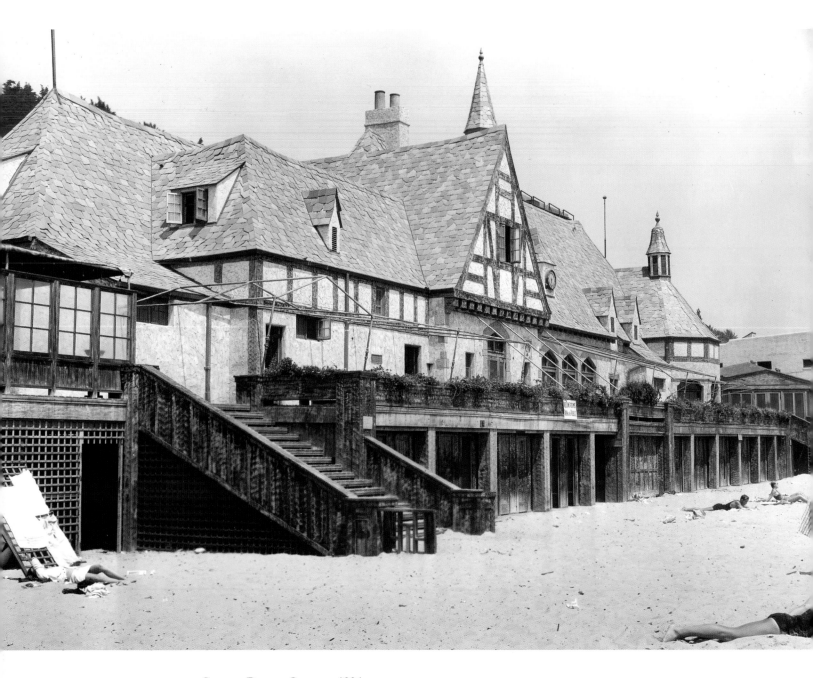

GABLES BEACH CLUB, C. 1926

Construction of the Gables Beach Club, a Tudor-style beach club, began in 1926 and the club was open for business later that year.

JACK DEMPSEY BOXING AT GABLES BEACH CLUB, 1927

Crowds gathered at the Gables Beach Club to watch Jack Dempsey fight in a charity event to benefit victims of the disastrous 1927 Mississippi River flood.

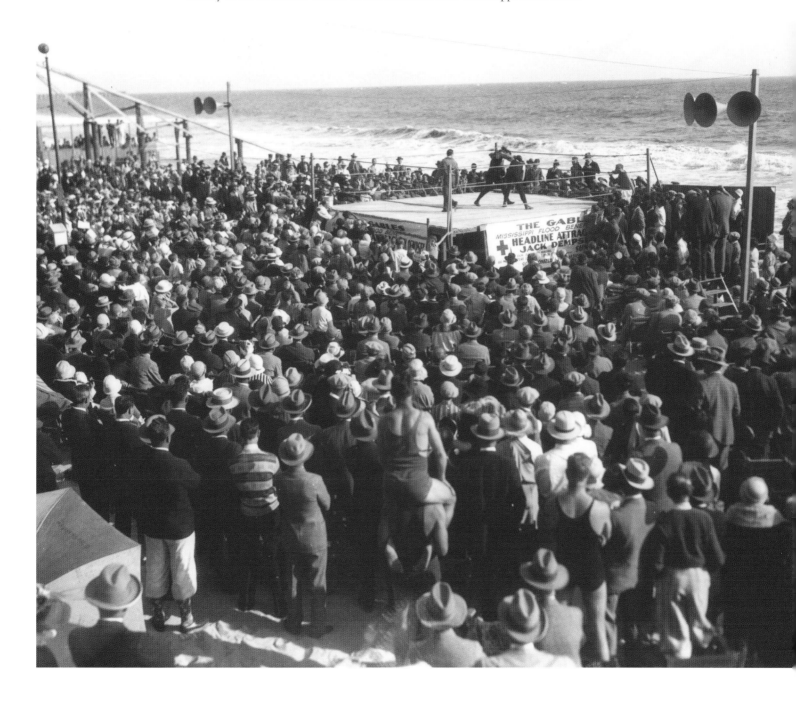

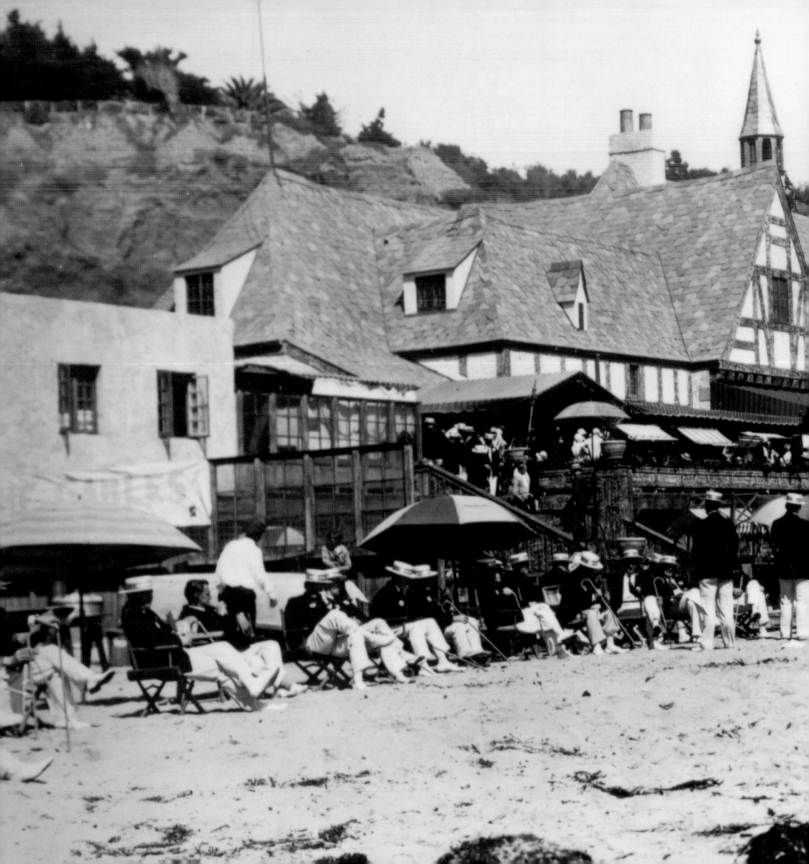

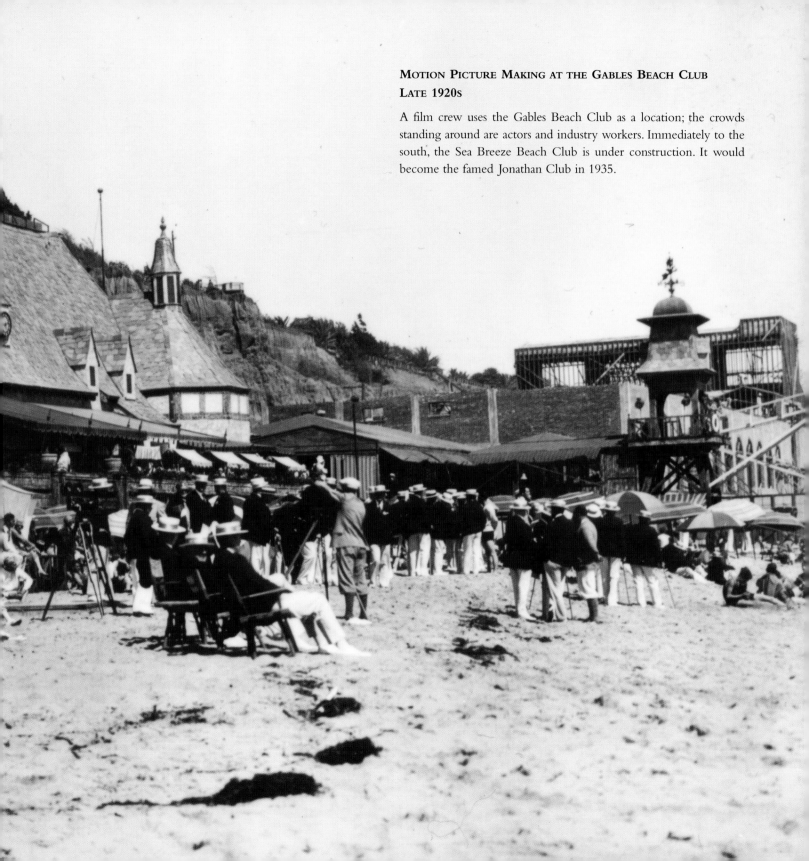

**MOTION PICTURE MAKING AT THE GABLES BEACH CLUB
LATE 1920S**

A film crew uses the Gables Beach Club as a location; the crowds standing around are actors and industry workers. Immediately to the south, the Sea Breeze Beach Club is under construction. It would become the famed Jonathan Club in 1935.

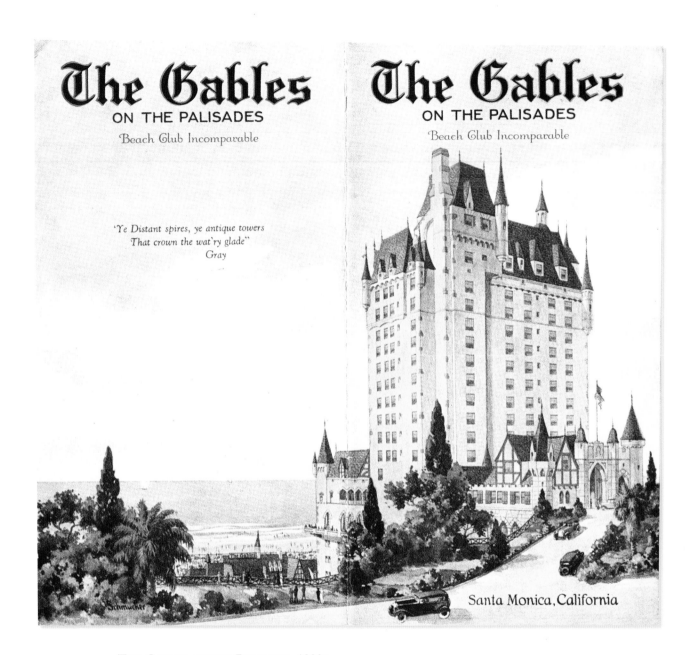

The Gables
ON THE PALISADES
Beach Club Incomparable

"Ye Distant spires, ye antique towers
That crown the wat'ry glade"
Gray

The Gables
ON THE PALISADES
Beach Club Incomparable

Santa Monica, California

THE GABLES ON THE PALISADES, 1920s

Promoters decided to create a fantastic club and hotel complex on the cliffs at the foot of Montana Avenue, something bigger and more luxurious than Santa Monica Beach had ever known. Designed to emulate the grandest castle-like structures of Europe, The Gables on the Palisades (The Gables, for short), as it was to be known, would be twenty-one stories high and would include the first new bridge to span the beach road.

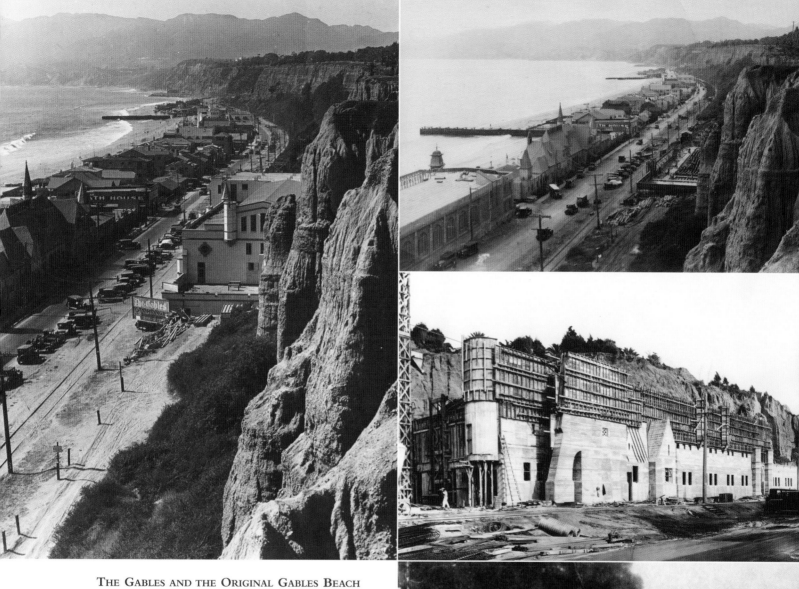

THE GABLES AND THE ORIGINAL GABLES BEACH CLUB, 1920S

Only three stories of the structure were completed by the time the Great Depression hit and the building was never finished (the shell of the structure remained until the 1960s and a part of it still serves as a retaining wall, preserving the bluffs). On August 30, 1930, a huge fire broke out in the original Gables Beach Club, destroying half of the building. The remainder was restored and later opened as the Sorrento Beach Club in 1932.

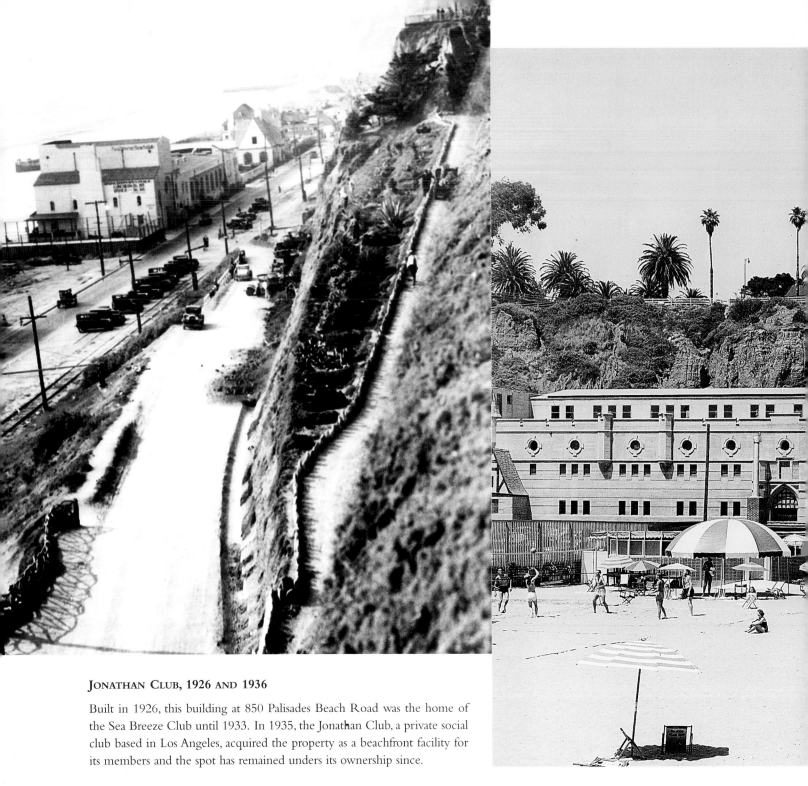

JONATHAN CLUB, 1926 AND 1936

Built in 1926, this building at 850 Palisades Beach Road was the home of the Sea Breeze Club until 1933. In 1935, the Jonathan Club, a private social club based in Los Angeles, acquired the property as a beachfront facility for its members and the spot has remained unders its ownership since.

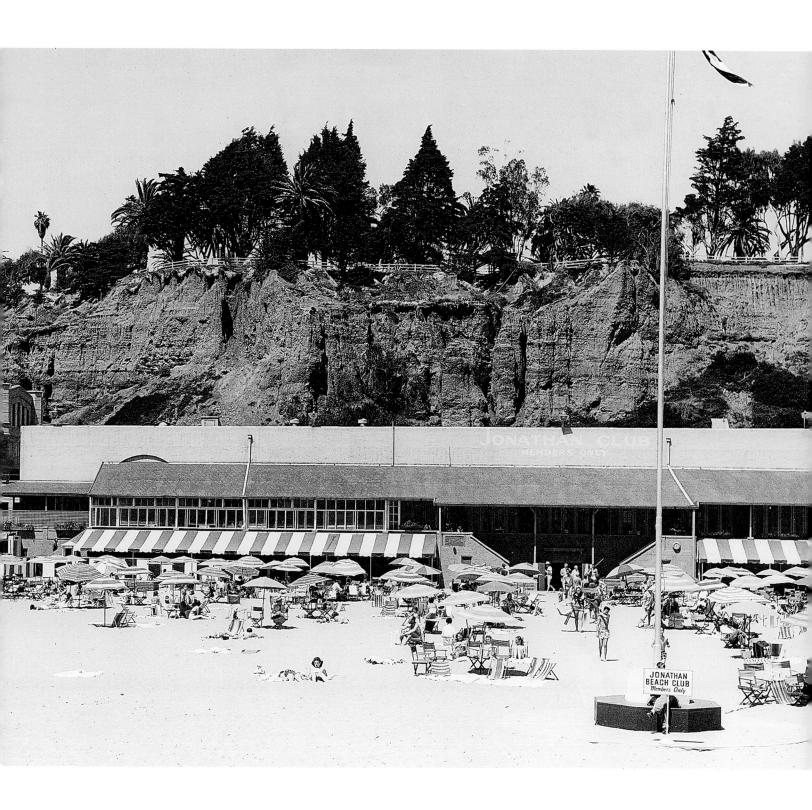

Beach Clubs at North Beach, c. 1930s

A summer crowd descends on the beach. This photograph offers a view of three major beach clubs (from left to right): the Wavecrest Club built in 1929, the Santa Monica Athletic Club established in 1922, and the Deauville Club built in 1927. Constructed on the former site of both the Santa Monica Bath House and the North Beach Bath House, the Deauville was built to resemble a French casino.

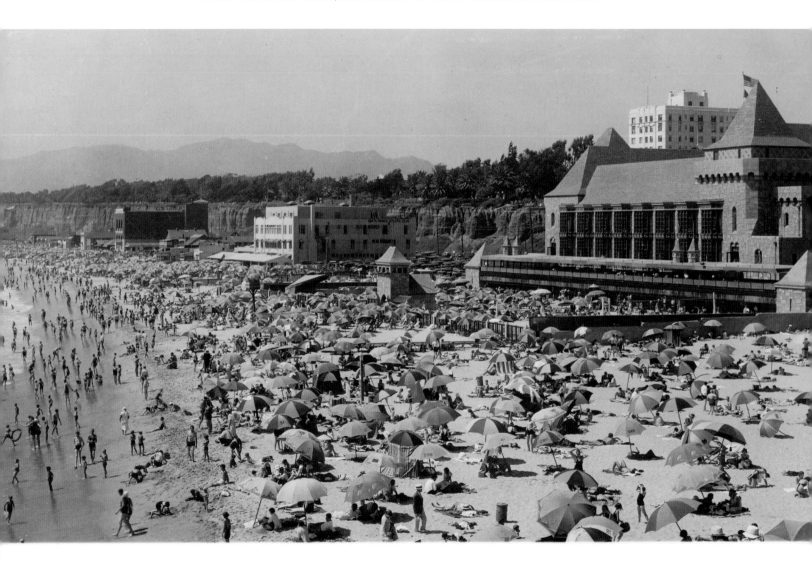

Beach Clubs along Coast Highway-Santa Monica, Calif.

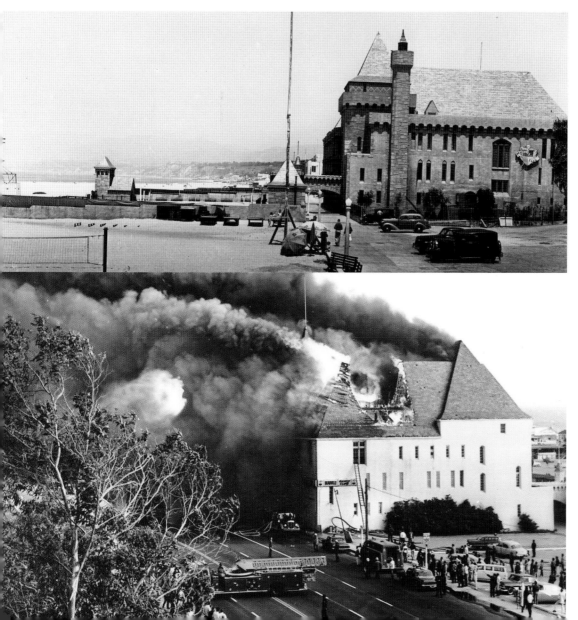

THE DEAUVILLE CLUB
C. 1940s

A real-photo postcard (top) shows the Deauville Club and the paved Palisades Beach Road. In 1930 the Deauville was purchased by the Los Angeles Athletic Club, but the name was not changed. The vintage photo (middle) shows cars parked at the club, in one of the beach's early parking lots. Originally architectural plans called for a bridge to span the highway so pedestrians could walk from Palisades Park to the Deauville; again a blue-sky plan that didn't happen. In 1964 (bottom), vandals destroyed the beautiful building that stood on the beach for thirty-seven years.

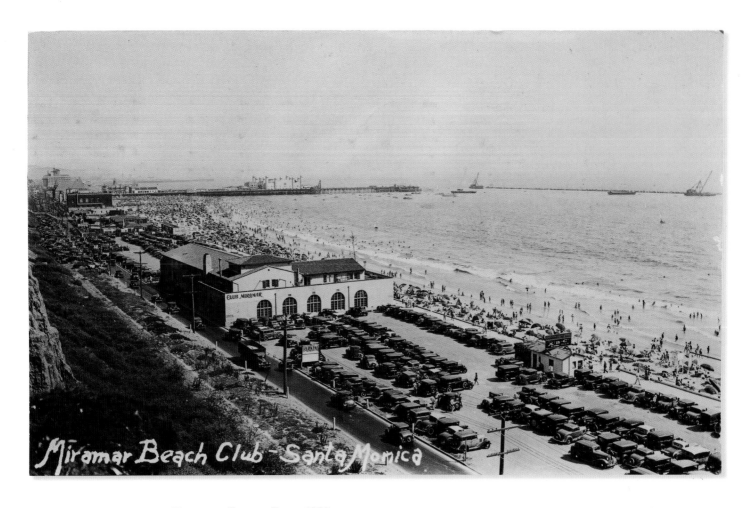

Miramar Beach Club – Santa Monica

MIRAMAR BEACH CLUB, 1930s

A real-photo postcard of the Miramar Beach Club shows the offshore breakwater under construction in the distance. Though this promotional postcard contains copy on the back from 1937, one can only assume the beach club was simply making use of an overstock of postcards made a few years earlier, since the breakwater was completed in July 1934. The owners of the Miramar Hotel originally planned that guests would access their beach club via an elevator built in the cliff that would connect to an underground tunnel to the beach. That was another plan that never happened. Advertising on the back of the postcard reads, "Enjoy the Beach, MIRAMAR BEACH CLUB 1937 MEMBERSHIP $10," and lists the club's many features, including a swimming pool, esplanade, cocktail lounge, dining room, gymnasium, card room, ping pong tables and volleyball courts. After World War II, the club changed ownership and became open to the public as the Variety Beach Club.

BEACH CLUBS ON PACIFIC COAST HIGHWAY, 1966

As the years passed, beach clubs became somewhat obsolete on the beach—only a few remain. In this image, the roof in the lower right corner is The Beach Club, the longest standing club on the beach. In the center of the photo, the building with the two stories of windows is the remaining stucture of Marion Davies's Ocean House, and south of that is a parking lot where the rest of her home stood. Where the California Incline meets the Pacific Coast Highway, the Jonathan Club still stands. In the far distance is the Santa Monica Pier, the demarcation between North Beach and South Beach. Note the wide expanse of sand and road that exists between the ocean and the cliffs, a dramatic difference from the image shown on pages 142 and 143.

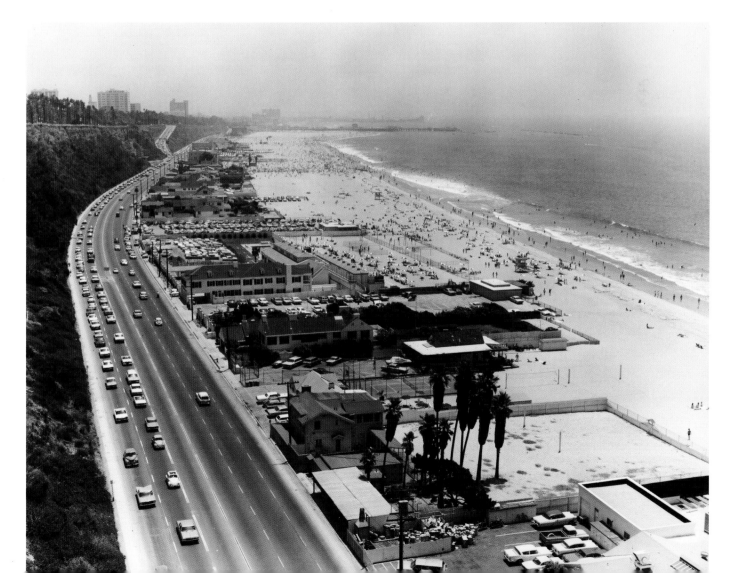

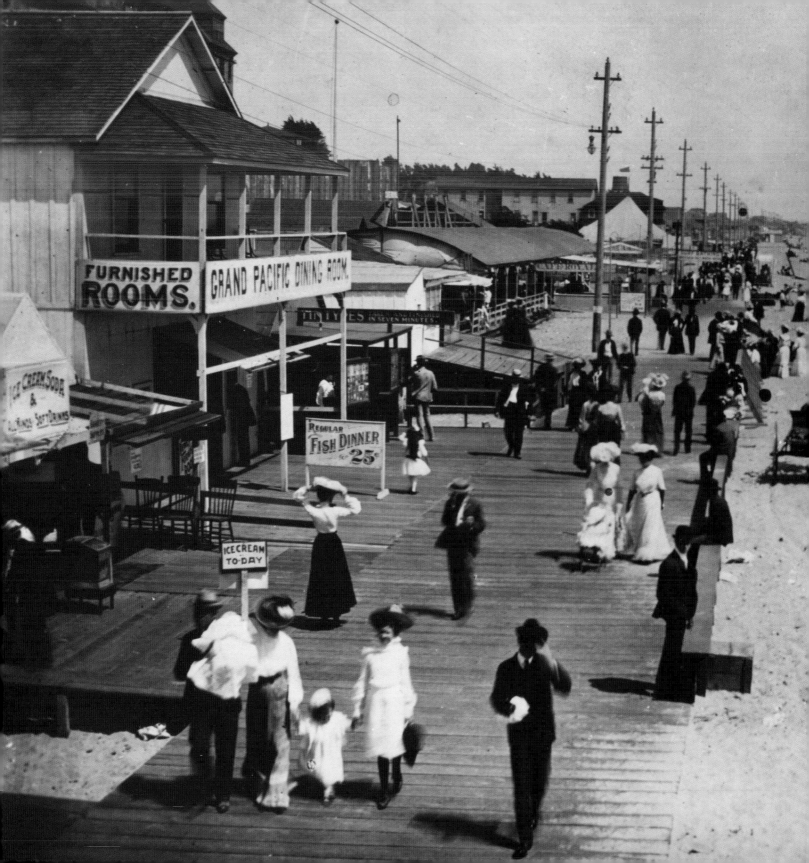

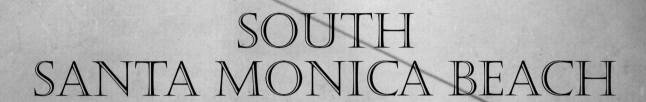

SOUTH
SANTA MONICA BEACH

SOUTH BEACH, 1890

South Beach is defined as the beach that stretches south of the Santa Monica Pier to Venice. Taken on the sand in front of the Arcadia Hotel, this photograph offers a view looking south toward Ocean Park. A wooden plankwalk, called a boardwalk today, made the trip easier. In the distance is the Crystal Plunge, located where Pico Boulevard now meets the sea.

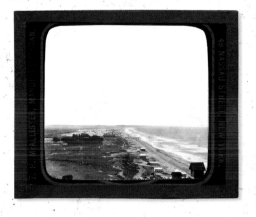

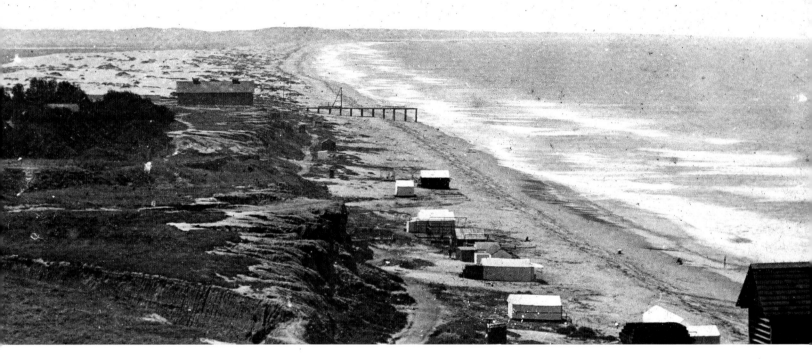

SOUTH SANTA MONICA, 1888

In this lantern slide by the T.H. McAllister Company, the view is south toward Ocean Park from the roof of the Arcadia Hotel. Directly below, the two cuts in the ground are called Pico Gulch. Below the trees is the foot of today's Pico Boulevard where Shutters on the Beach and Casa Del Mar Hotel now stand. The grove of trees can be seen in photographs made as late as the 1930s. The stub of a pier is all that remains of the Juan Bernard Pier, built in 1879. The white sandy area is a sand dunes that is today filled with houses. Further to the south are a pier and the wetlands of Playa Del Rey.

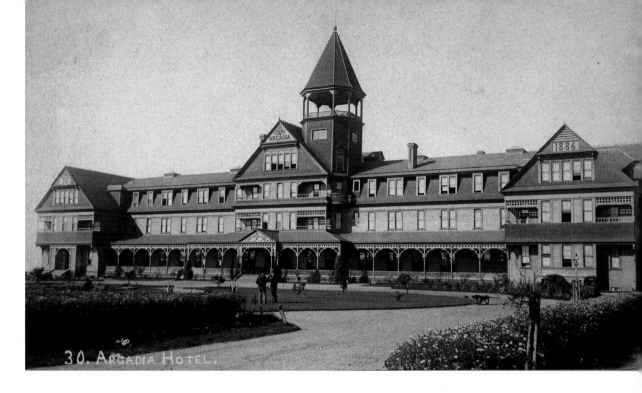

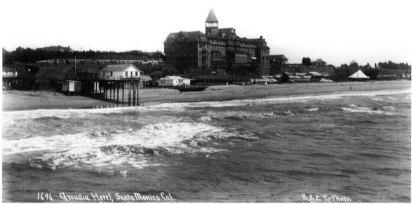

THE ARCADIA HOTEL, 1890s

Considered to be the finest seaside hotel in Southern California, the Arcadia was built next to a steep cliff. In a street view (top), the hotel appears to be a three-story building, but an oceanside view reveals all five stories. A photograph by the R & E Photo Company (bottom) shows a side-view of the opulent hotel. The hotel was named in honor of Arcadia Bandini, who was married to Colonel Robert Baker, one of the founders of the township of Santa Monica. The portion of a pier at left in the image is all that remains of the Los Angeles & Independence Railroad wharf.

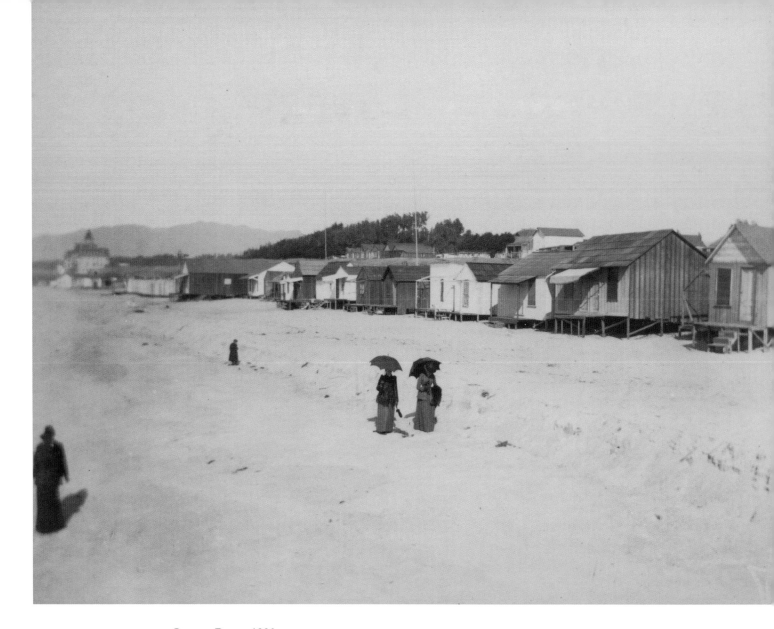

OCEAN PARK, 1890s

When the shanties were forced to leave North Beach at Santa Monica, they moved south to Ocean Park.

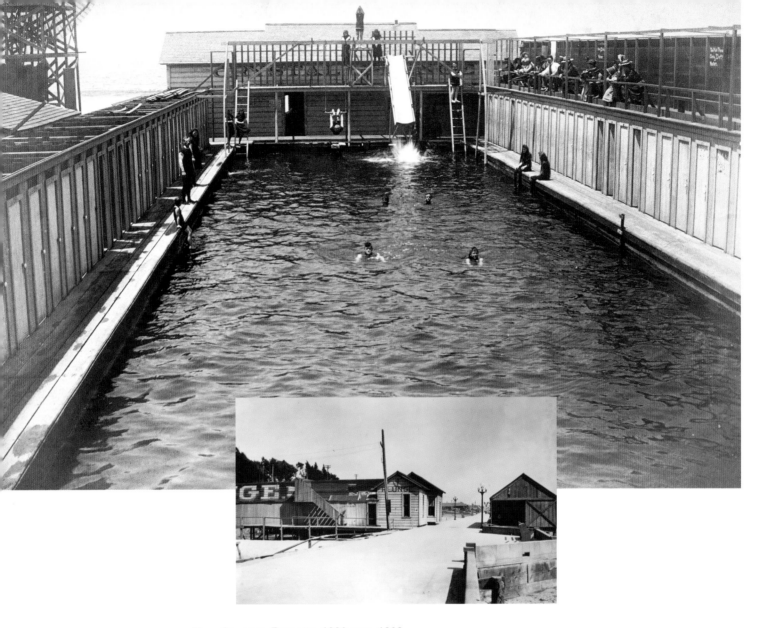

THE CRYSTAL PLUNGE, 1890 AND 1908

H.F. Rile took the top photograph of the Crystal Plunge, an open-air swimming pool located at the foot of Front Street (now Pico Boulevard). Sadly, the Crystal Plunge suffered irreparable damage from the storm of 1905, when the water undermined the foundation. By the time the later photo (bottom) was made, the Crystal Plunge was abandoned. The cement walkway was built in 1907. In 1924, the Casa Del Mar Beach Club was built on this spot, where a hotel named Casa Del Mar remains today. The storm drain in the foreground also remains.

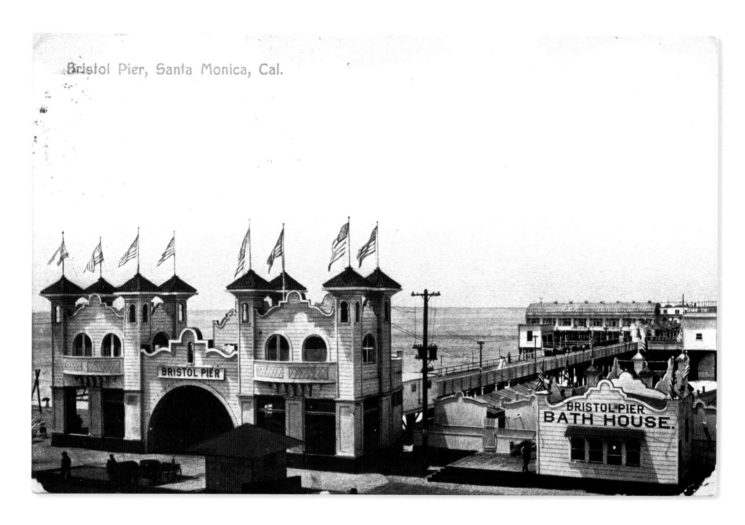

Bristol Pier, Santa Monica, Cal.

BRISTOL PIER, 1908

A postcard shows the Bristol Pier, which was built at the foot of Hollister Street in 1905 and originally named the White Star Pier. The card bears an inscription on the back that reads, "Dear Ella, I am coming home Monday A.M. Oh! I have had such a fine time here. There hasn't been a day but what we've been on the go somewhere. Well, I'll see you shortly—W.K." No doubt the enthusiastic sentiments of the card's author were shared by thousands of other tourists who visited Santa Monica Beach's many attractions.

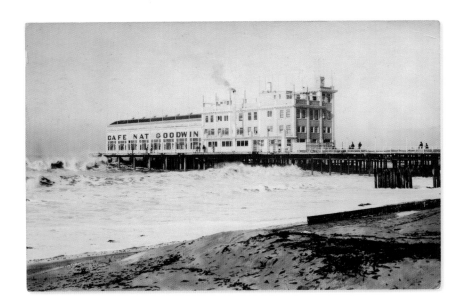

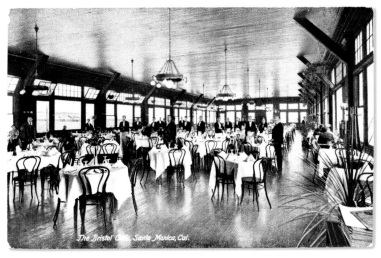

CAFÉ NAT GOODWIN, C. 1919

A real–photo postcard (top) shows the changes made to the Bristol Pier between 1908 and 1919. The portion of the pier parallel to the shore has been removed, and the Bristol Café moved and transformed into the huge Café Nat Goodwin. With these changes, the pier was renamed as the Crystal Pier in 1919. The color postcard (bottom) shows the magnificent interior of Nat Goodwin's café, which opened the same year. Text on the back of the card is sales copy: "Café Nat Goodwin, Café de Luxe of the West. High Class Cabaret. Never a dull moment. Entertainment from 12N. to Midnight. Service Unexcelled, Prices Moderate. Private Banquet Halls, Ballroom Roof Garden, Sun Parlor, etc. Automobile Parking for 350 Automobiles. Under the personal supervision of Mr. Goodwin."

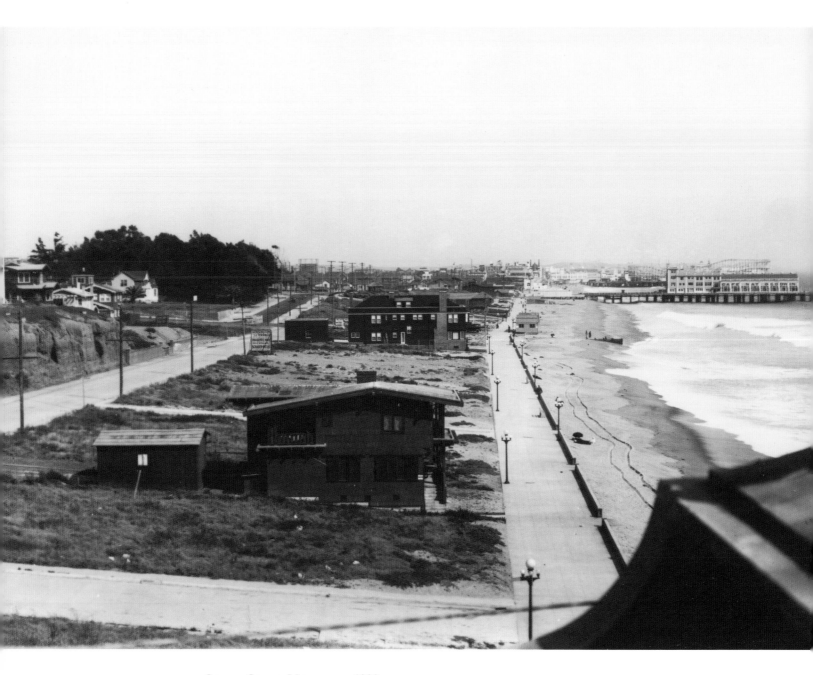

SOUTH SANTA MONICA, C. 1920

This photograph shows the area where the Breakers, Edgewater and Casa Del Mar clubs will later be built. The trees on the upper left are located on the south side of Front Street (now Pico Boulevard). Café Nat Goodwin is visible on the Crystal Pier.

CRYSTAL PIER, C. 1940

After Café Nat Goodwin closed, the structure was removed and a bathhouse and solarium occupied the pier. Later, the bathhouse building served as the headquarters for the Los Angeles County lifeguards. But in 1949, the Crystal Pier was demolished.

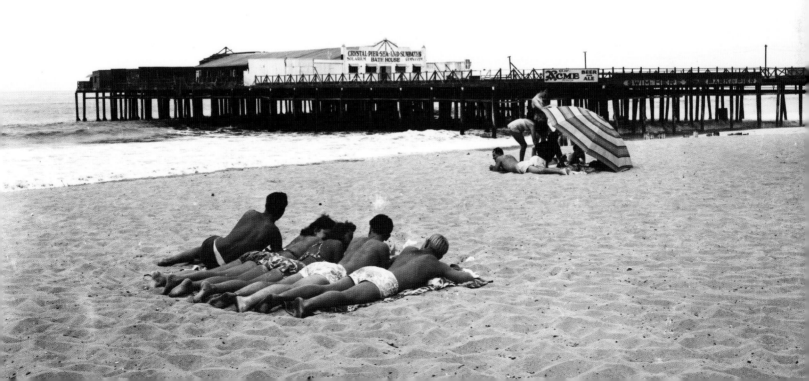

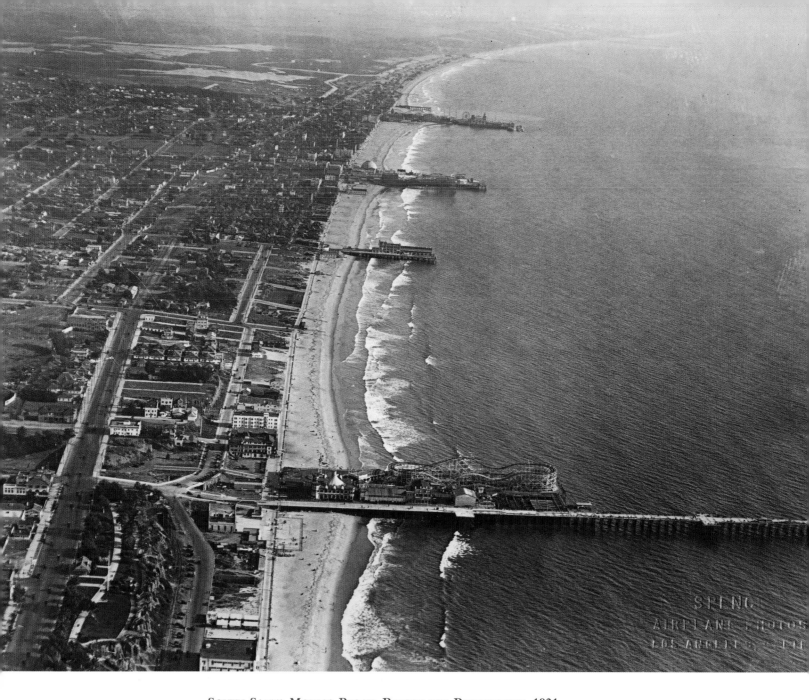

SOUTH SANTA MONICA BEACH, BEFORE THE BREAKWATER, 1921

This aerial photograph shows roughly the area of beach from the Santa Monica Pier to the Venice Pier. The two piers in between are the Crystal Pier and the Ocean Park Pier.

SOUTH SANTA MONICA BEACH, AFTER THE BREAKWATER, C. 1956

In this later image, the beach north of the Santa Monica Pier has grown at the expense of the southern beach because of the breakwater that was constructed in 1934.

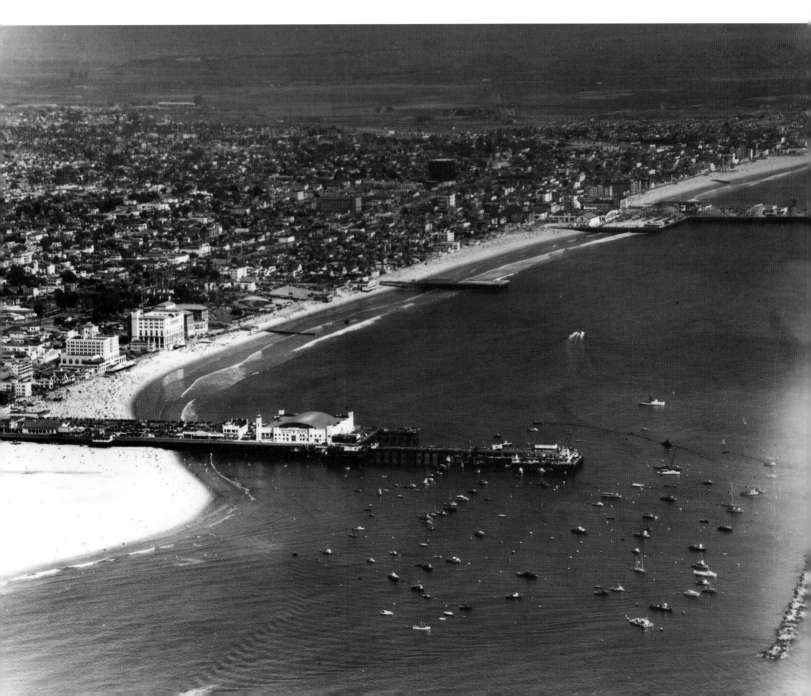

CONSTRUCTION OF THE CASA DEL MAR BEACH CLUB, 1924

The development of beach clubs and hotels on South Beach began in the 1924.
Built on the former site of the Crystal Plunge swimming pool, the Casa Del Mar
was the first to be built, and still remains today at the foot of Pico Boulevard as an
elegant hotel. The empty lot to the left of the worksite is the future home of the
Edgewater Beach Club and later, Shutters on the Beach.

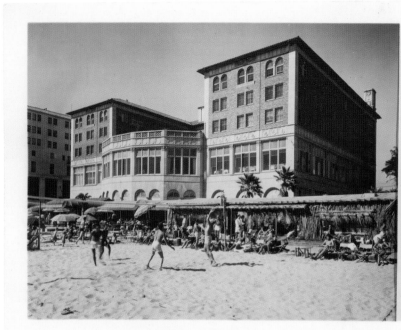

DEL MAR BEACH CLUB
SANTA MONICA, CALIF.

Limited Membership

Room and Suites
Available

INDOOR SWIMMING POOL
AND
PRIVATE BEACH

Dining Rooms and
Cocktail Lounges

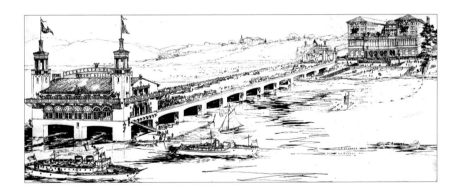

Casa Del Mar Beach Club, 1925

A real-photo postcard (top) advertised the Casa Del Mar Beach Club. In the photograph, spectators watch a volleyball game on the beach. An illustration shows an artist's conception of a proposed pier that would extend from the beach club to the ocean. While the city of Santa Monica did grant a franchise to the club for the pier's construction, the effects of the Depression scrapped the pier plans. The idea, however, was for the proposed pier to house a two-story yacht club building for the exclusive use of club members

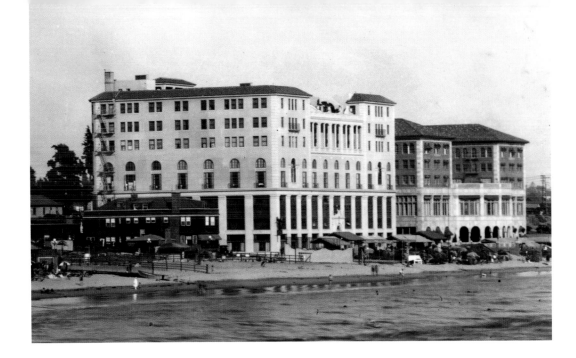

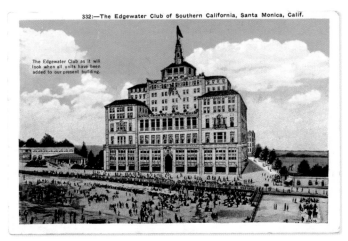

332:—The Edgewater Club of Southern California, Santa Monica, Calif.

The Edgewater Club as it will look when all units have been added to our present building.

EDGEWATER CLUB, 1925–1930

The Edgewater Club was built across the street from Casa Del Mar in 1925. Shortly thereafter, promoters issued color-picture postcards like the one below announcing plans for an expansion to the existing Edgewater Club. Unfortunately, the Depression but a stop to the plans, not only at the Edgewater, but also to plans for other beach clubs, as well. The area of green grass to the right of the proposed Edgewater expansion is the location of the Casa Del Mar Beach Club, perhaps part of the promoter's refusal to acknowledge the competition.

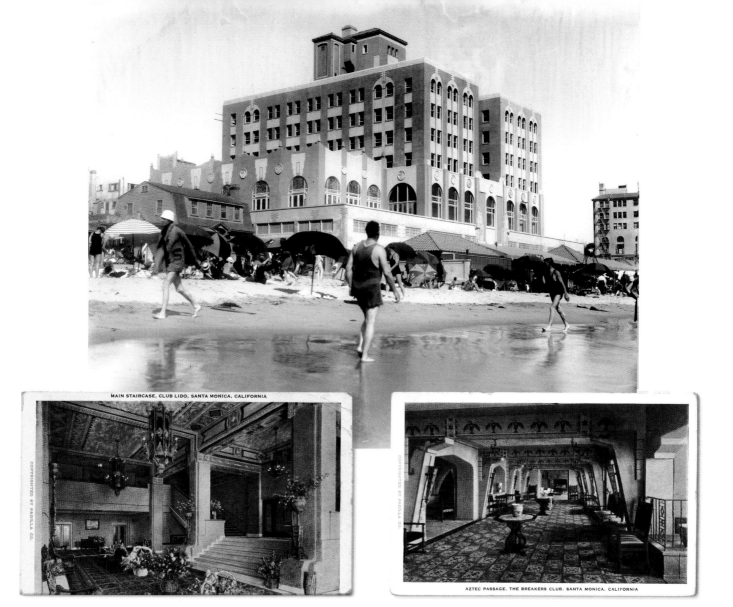

MAIN STAIRCASE, CLUB LIDO, SANTA MONICA, CALIFORNIA

COPYRIGHTED BY PADILLA CO.

COPYRIGHTED BY PADILLA CO.

AZTEC PASSAGE, THE BREAKERS CLUB, SANTA MONICA, CALIFORNIA

BREAKERS BEACH CLUB, 1926

After opening in 1926, the Breakers was a private beach club for only a few years. Color postcards from the Breakers show the club's interior. Themed rooms, including the Aztec Passage and the magnificent Club Lido, made the beachside retreat feel like an exotic resort. After the club closed down, the building reopened in 1934 as the Grand Hotel, and was later the Chase Hotel. During World War II, it housed military personnel and eventually became an apartment building in the 1960s called the Sea Castle Apartments.

Beach Clubs on South Santa Monica Beach, c. 1930

This photo shows the three beautiful beach clubs that stretched along the southern part of Santa Monica Beach, including (left to right) the Breakers, the Edgewater and Casa Del Mar. These establishments distinguished themselves from the clubs on North Beach because they doubled as hotels due to the large number of rooms available for members as well as tourists.

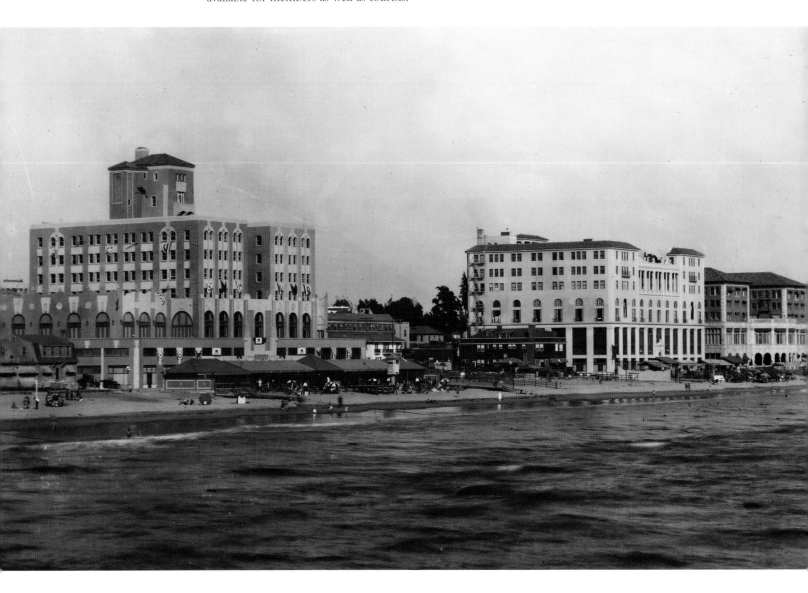

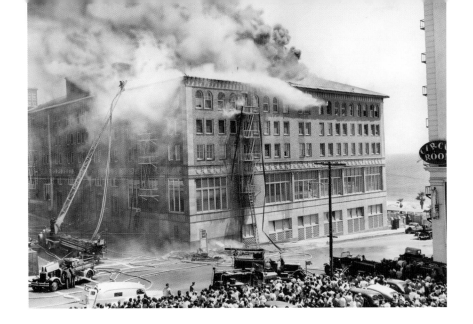

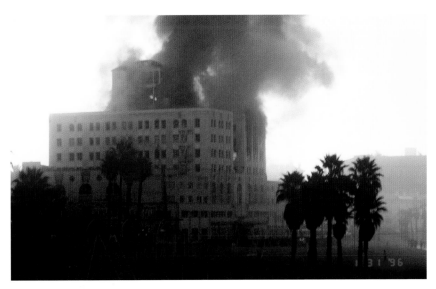

FIRES AT SOUTH SANTA MONICA BEACH, 1948 AND 1996

On July 12, 1948, fire broke out at Casa Del Mar Beach Club (top) and a huge crowd of spectators filled the street to watch the Santa Monica Fire Department, with the assistance of six firefighting units from Los Angeles, battle the blaze. On the far right of this photograph, the building that bears the Circus Room sign is a portion of the Edgewater Beach Club, which had by then become the Ambassador Club. The old Breakers Beach Club building was destroyed by fire January 31, 1996 (bottom). At the time it was known as the Sea Castle Apartments.

SOUTH SANTA MONICA BEACH ELECTRIC TRAM, LATE 1920s

Electric trams traveled from the Santa Monica Pier south past the Breakers, the Edgewater and the Casa Del Mar clubs and on to Venice. Fare for the ride was five cents.

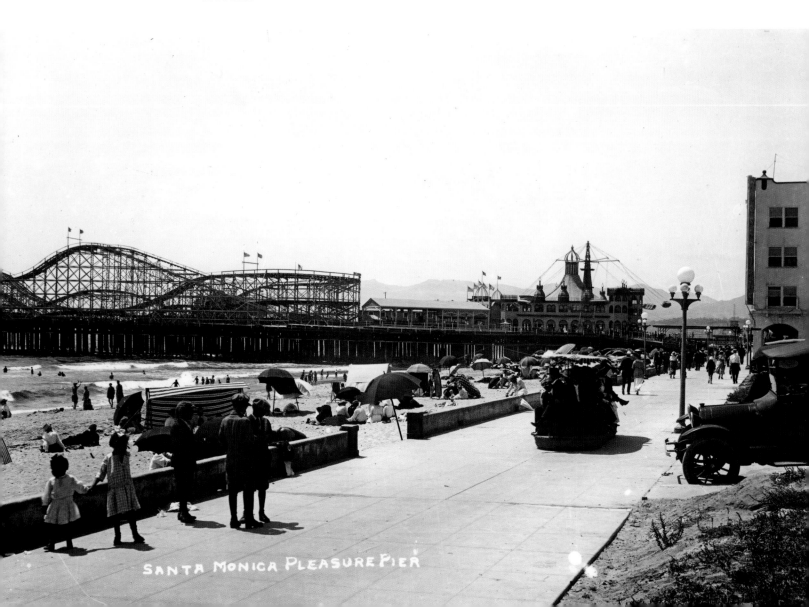

SANTA MONICA PLEASURE PIER

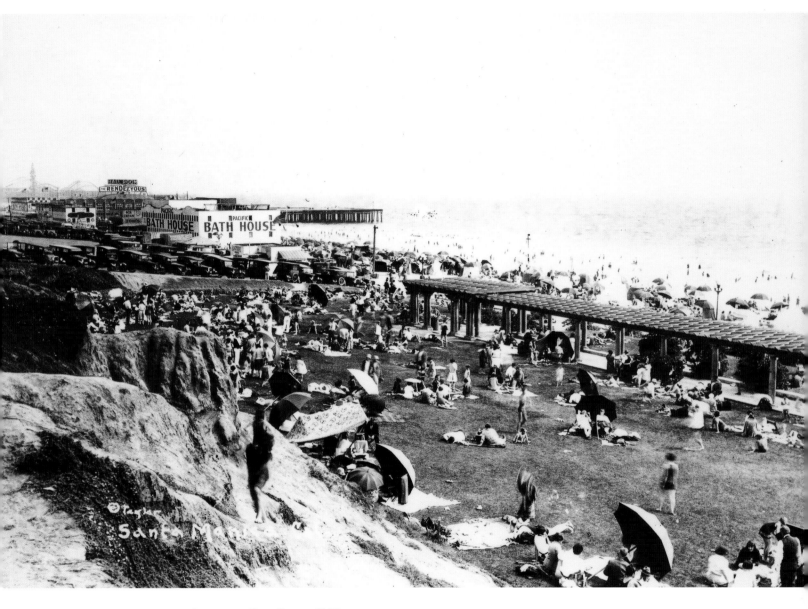

CRESCENT BAY PARK, 1937

The park in the photograph below is now called Crescent Bay Park and was donated to the city of Santa Monica by Carl Schader in 1910. Located across the street on the south side of the Casa Del Mar, the park was then known as Seaside Park, and has since been identified as Sunset Park, Southside Park and the Crystal Beach Park. A part of the Crystal Pier can be seen in the background of this image, and the Café Nat Goodwin Café is no longer on the pier.

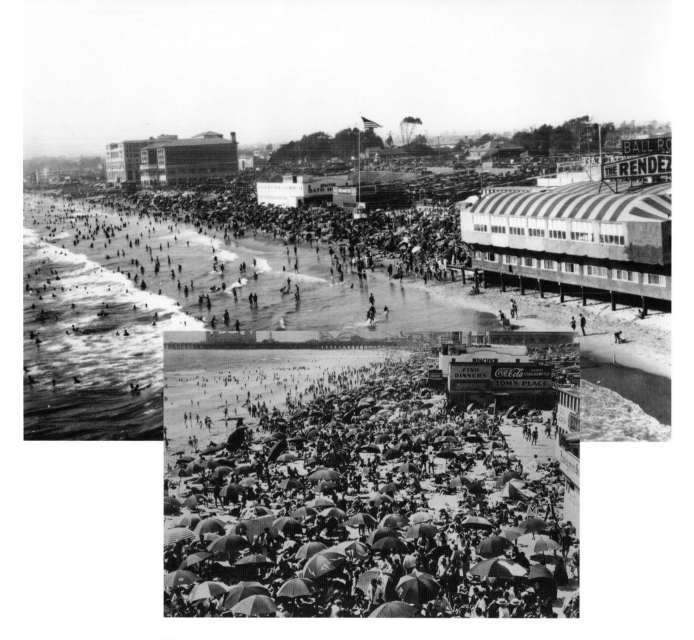

VIEW NORTH FROM SOUTH SANTA MONICA BEACH, 1930S

South Santa Monica Beach was immensely popular as it catered to the fun-loving crowds, rather than the ritzy set who belonged to the beach clubs on North Beach. These photographs, with the Santa Monica Pier in the distance, show how popular the beach area between the Bristol Pier and the Santa Monica Pier was in the 1930s. The large building with the striped roof was the Rendezvous Ballroom, owned by the Peterson family.

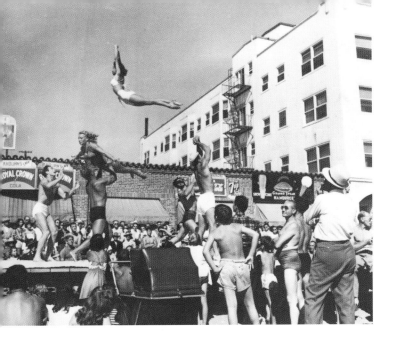

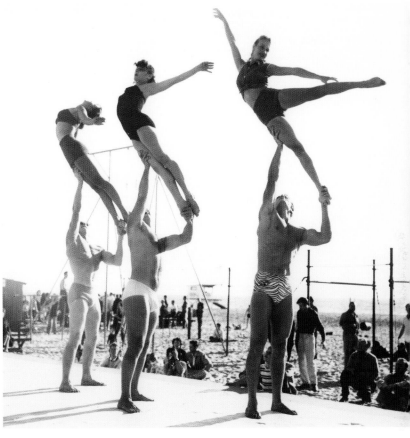

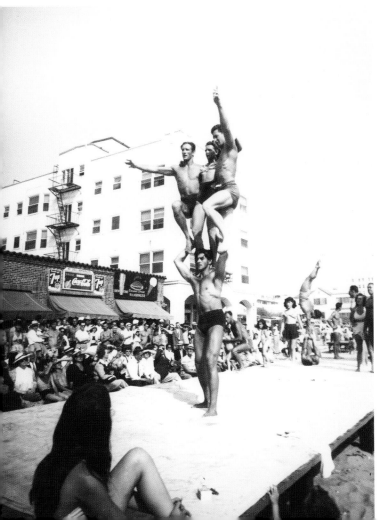

MUSCLE BEACH, EARLY 1940s

Enormous crowds gathered around the area known as Muscle Beach, just south of the Santa Monica Pier, to watch the amazing feats of the talented athletes. From beachside ballet, known as adagio, to serious heavy lifting and gymnastics, the activities at Muscle Beach proved just how fascinating strong bodies could be. The physical fitness boom began at Muscle Beach, and many famous bodybuilders got their start there, including Steve Reeves, Jack LaLanne, Joe Gold (of Gold's Gym fame) and Harold Zinkin, who was crowned the first Mr. California in 1941 in a ceremony held on Muscle Beach.

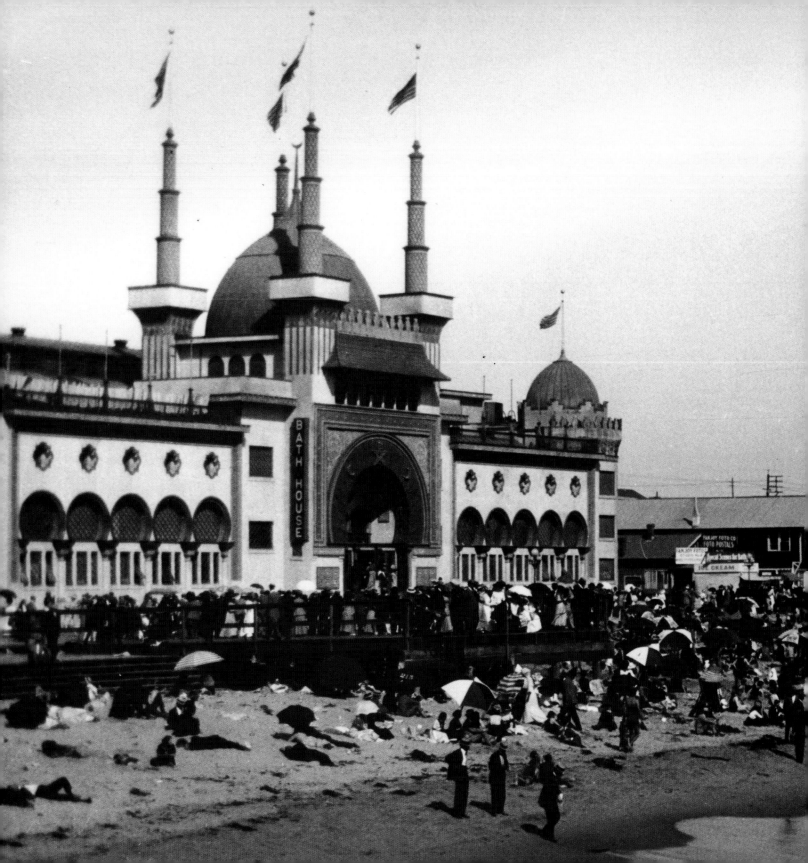

OCEAN PARK BATH HOUSE, EARLY 1900S

Built in 1905, the Ocean Park Bath House showed Arabian-influenced architecture. The entire building, including its minarets, was outlined with twinkling lights.

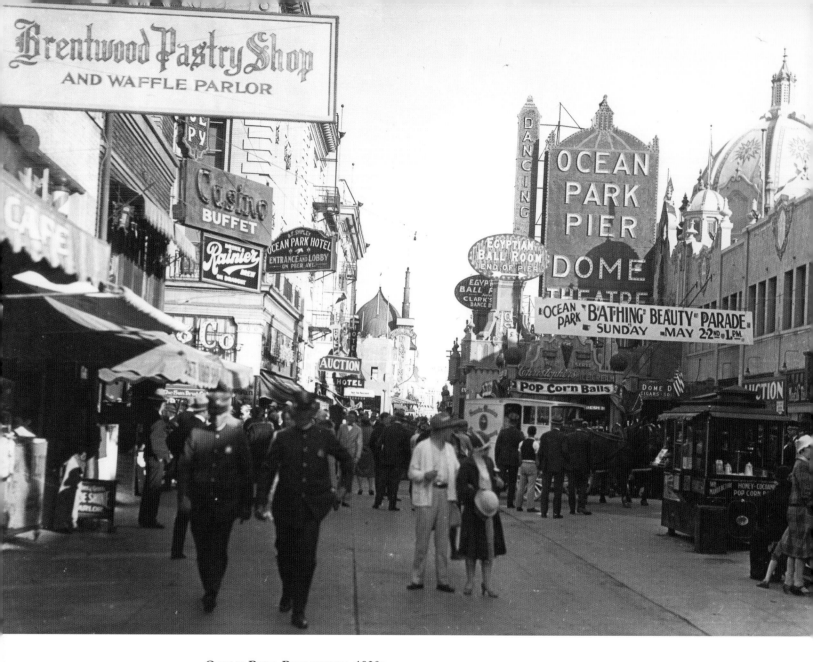

OCEAN PARK PROMENADE, 1920S

As this Adelbert Bartlett photo attests, Ocean Park was Santa Monica Beach's great amusement area. For many years these attractions—the bathhouse, pier and promenade—drew hundreds of thousands of visitors. Though the amusements are now gone, they remain in the memories of those of us who were fortunate enough to experience them firsthand.

OCEAN PARK FIRE, 1922

When the Ocean Park Pier caught fire, the fire destroyed the pier, most of the surrounding buildings and greatly damaged the Ocean Park Bath House. In 1956 the pier became the short-lived but long-remembered Pacific Ocean Park.

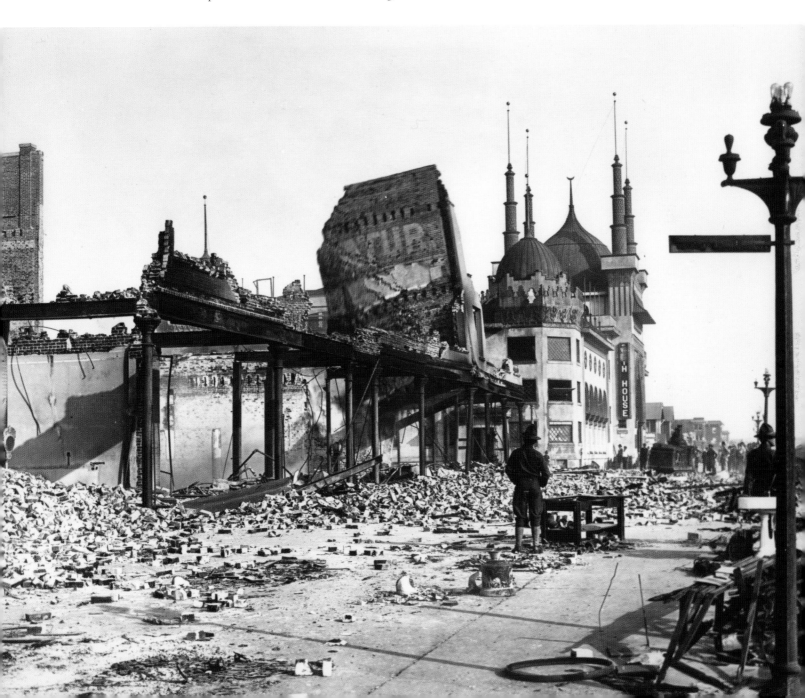

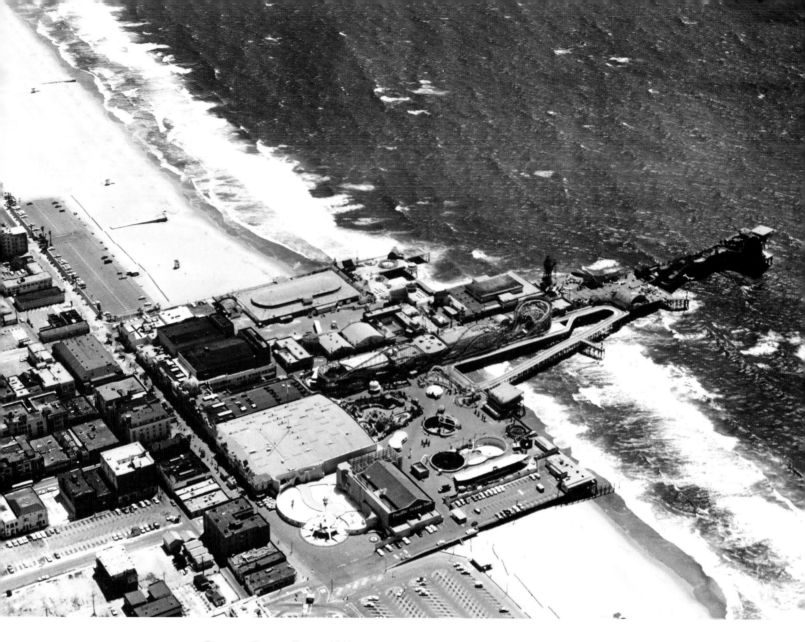

PACIFIC OCEAN PARK, 1963

In 1956 the Los Angeles Turf Club and CBS took over the old Ocean Park Pier and created a twenty-eight-acre amusement park called Pacific Ocean Park. A beloved tourist spot, it couldn't compete with the likes of Disneyland and was demolished during the winter of 1973 and 1974, thus ending the long and colorful era of amusement piers in Southern California. The only remaining amusement pier along the Southern California coast is the Santa Monica Pier.

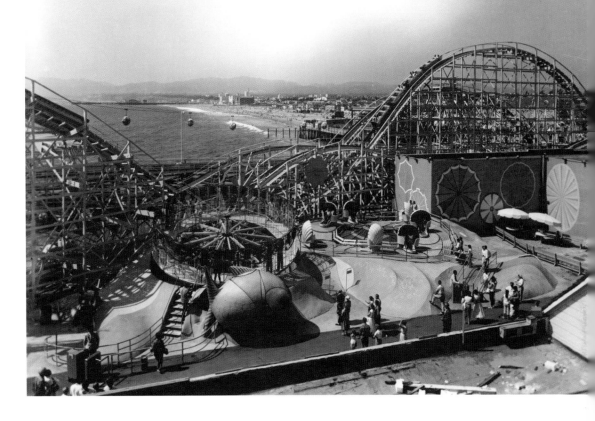

PACIFIC OCEAN PARK AMUSEMENTS, 1963

Color postcards display the various rides and attractions of Pacific Ocean Park, including the famous Seahorse entry, the rope bridge and the thrill-inducing suspended "bubble" cages that traveled the length of the park.

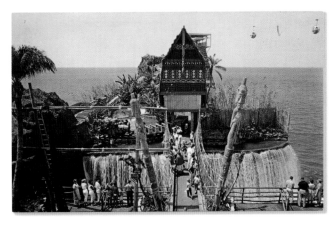

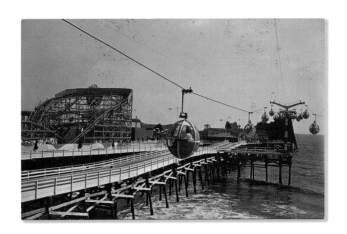

SANTA MONICA BEACH: PAST AND PRESENT

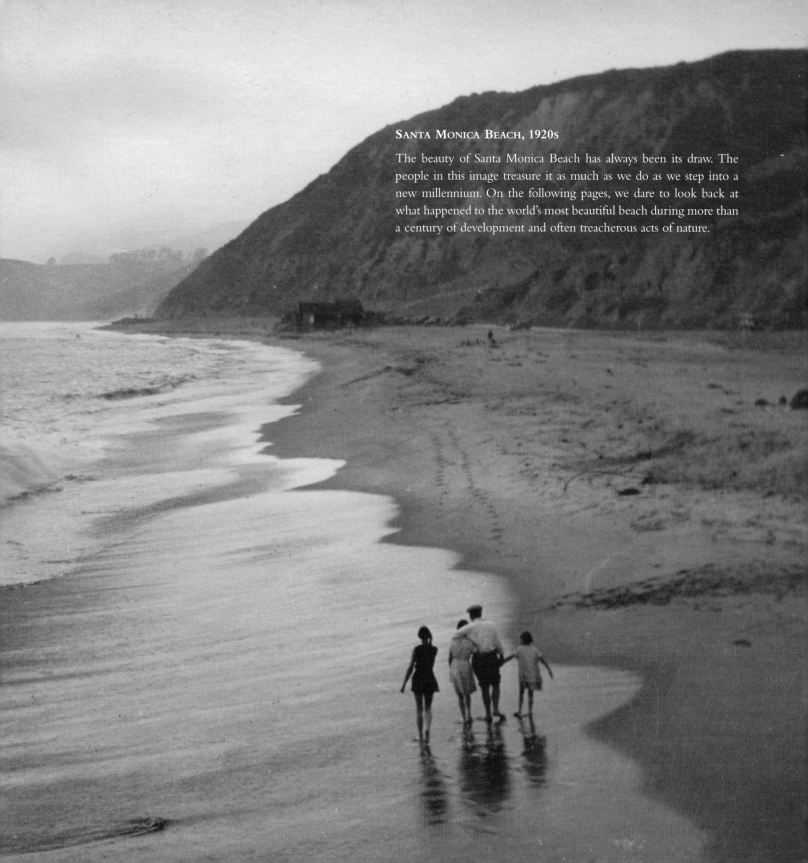

SANTA MONICA BEACH, 1920s

The beauty of Santa Monica Beach has always been its draw. The people in this image treasure it as much as we do as we step into a new millennium. On the following pages, we dare to look back at what happened to the world's most beautiful beach during more than a century of development and often treacherous acts of nature.

The 99 Steps, 2003

THE 99 STEPS

Built in 1875 at the foot of Arizona Avenue, the 99 Steps allowed access to the beach from the steep palisades. During the original structure's sixty-year life span, the wooden stairwell was altered several times, including during the 1890s when it was changed to accommodate the tracks of the Southern Pacific Railroad. The old wooden steps were removed in 1935 and replaced with a concrete structure that spans the Pacific Coast Highway.

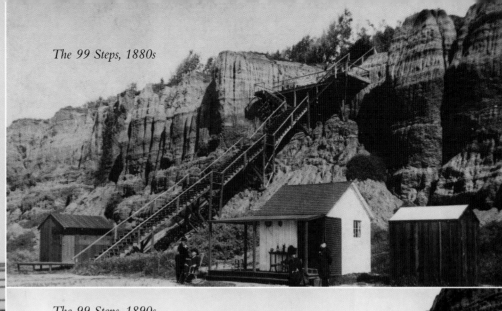

The 99 Steps, 1880s

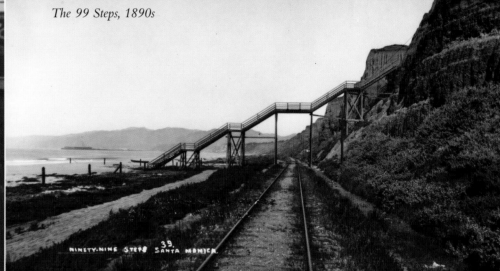

The 99 Steps, 1890s

NINETY-NINE STEPS 39. SANTA MONICA.

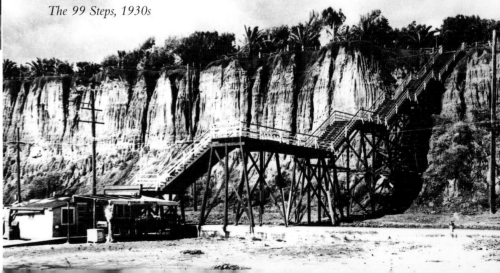

The 99 Steps, 1930s

P<small>AST AND</small> P<small>RESENT</small>

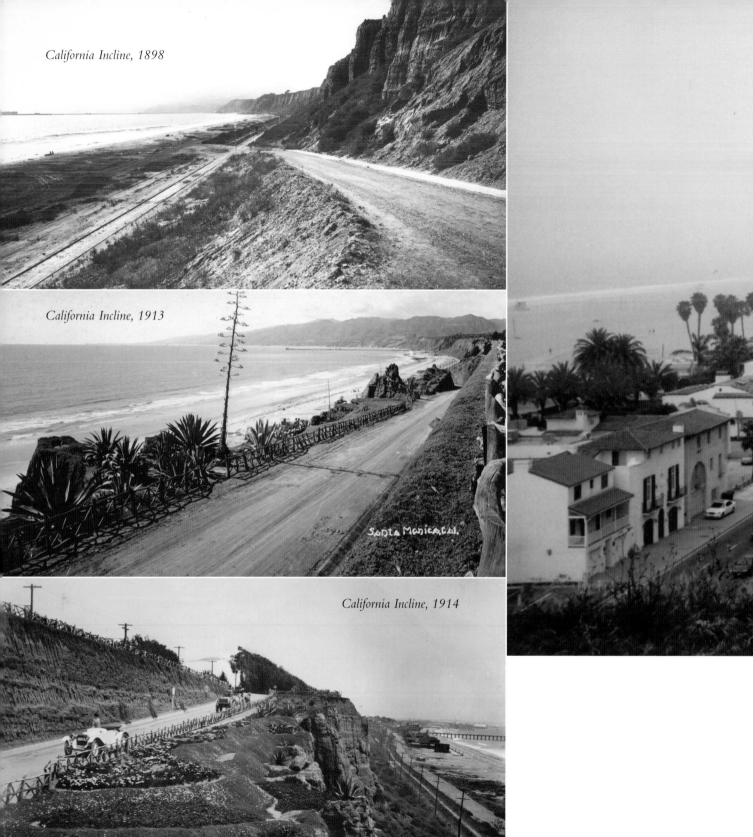

California Incline, 1898

California Incline, 1913

Santa Monica Cal.

California Incline, 1914

SANTA MONICA BEACH

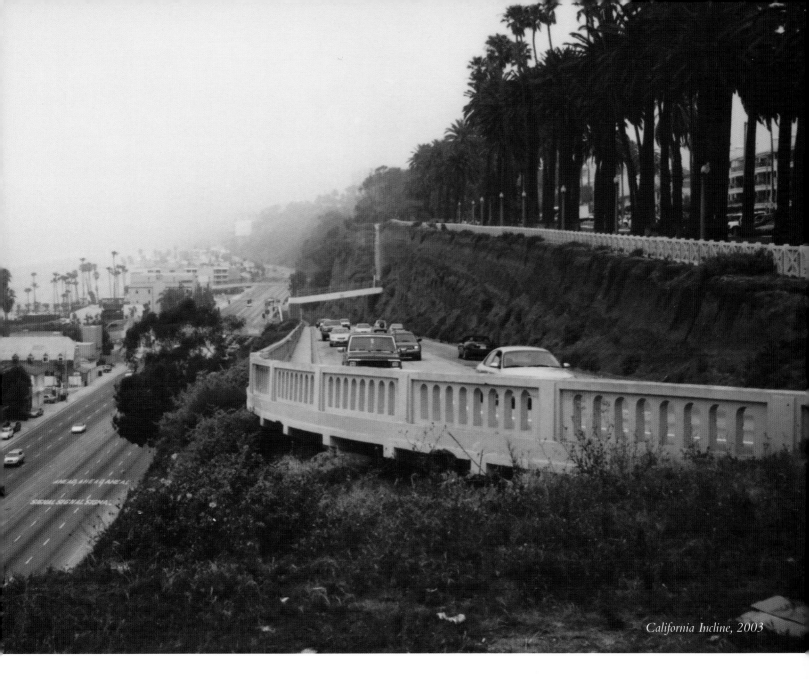

California Incline, 2003

THE CALIFORNIA INCLINE

Built in 1903 to allow vehicular access from the palisades directly to the beach, the California Incline began as a dirt road and steep grade. In 1980 the City of Santa Monica expressed fears that the Incline might pose a danger to motorists due to landslides. Though the city is still concerned with the problem, a solution has not yet been reached.

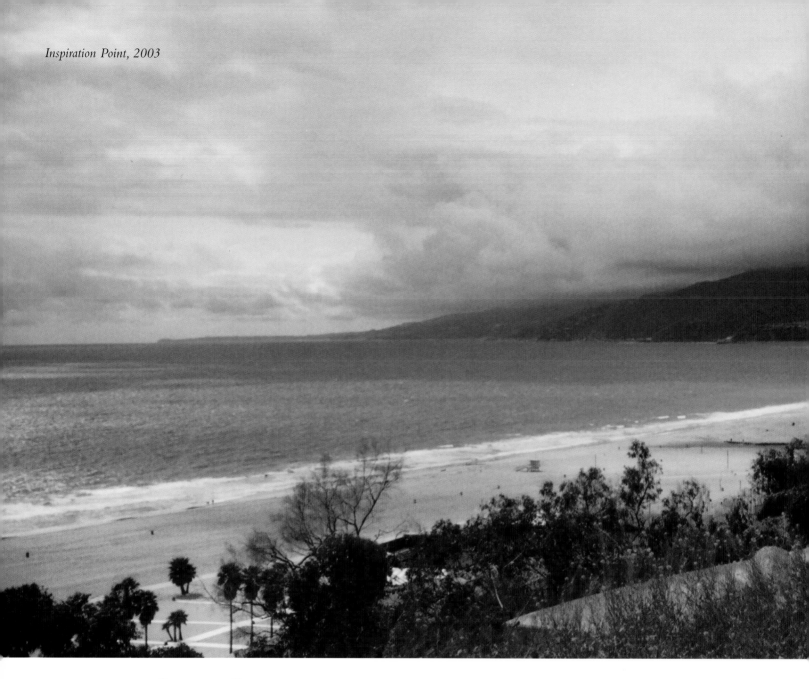

INSPIRATION POINT

Located at the edge of Palisades Park, Inspiration Point overlooks Santa Monica Canyon and the Pacific Ocean. Soldiers from the Portolá Expedition stood on the site in 1769 to look for a passage north along the coastline. Since 1964 the magnificent and awe-inspiring view from Inspiration Point has been obscured by the construction of a multi-storied condominium building.

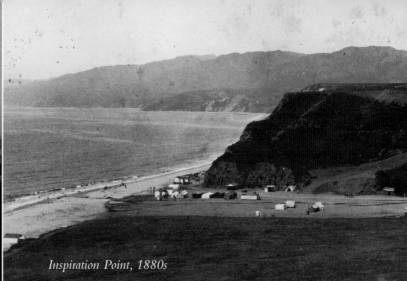

Inspiration Point, 1880s

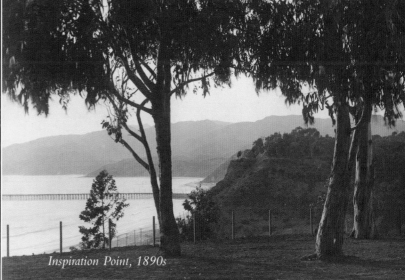

Inspiration Point, 1890s

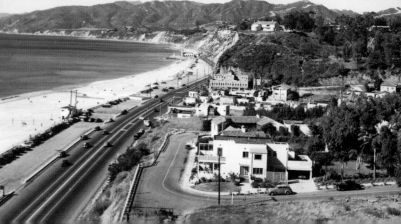

Inspiration Point, 1945

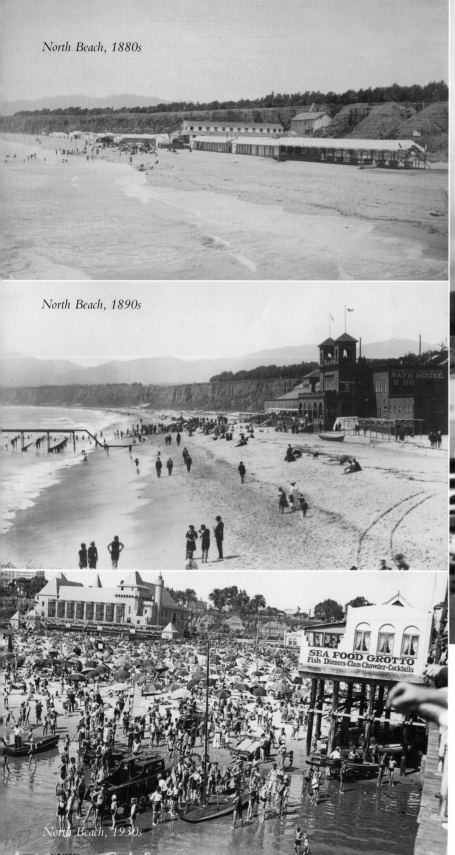

North Beach, 1880s

North Beach, 1890s

SEA FOOD GROTTO
Fish Dinners-Clam Chowder-Cocktails

North Beach, 1930s

SANTA MONICA BEACH

North Beach, 2003

NORTH BEACH

What used to be one of the most popular spots on the beach is now an asphalt parking lot and a maintenance yard for the city. On the flatland above the beach, high-rise buildings dominate the skyline. But at one time, bathhouses, including Duffy's Bath House, the Santa Monica Bath House and the North Beach Bath House complex drew constant crowds to this area.

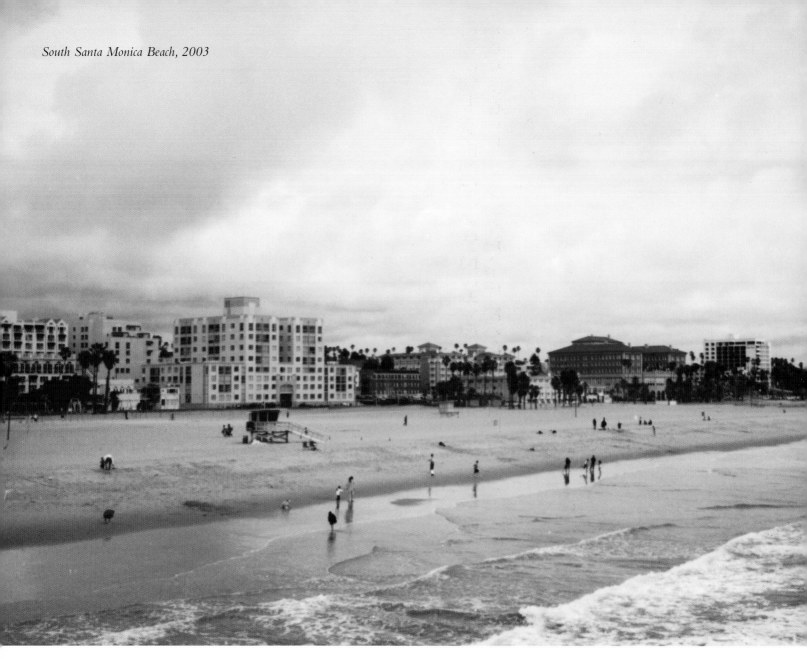

South Santa Monica Beach, 2003

SOUTH SANTA MONICA BEACH

The area located south of the Santa Monica Pier remains attractive to tourists, who treasure the beach. The early hotels, bathhouses and beach clubs that once populated the beach have given way to expensive hotels and condominiums overlooking the sea. The only original beach club building still standing is the Casa Del Mar, which is now a hotel.

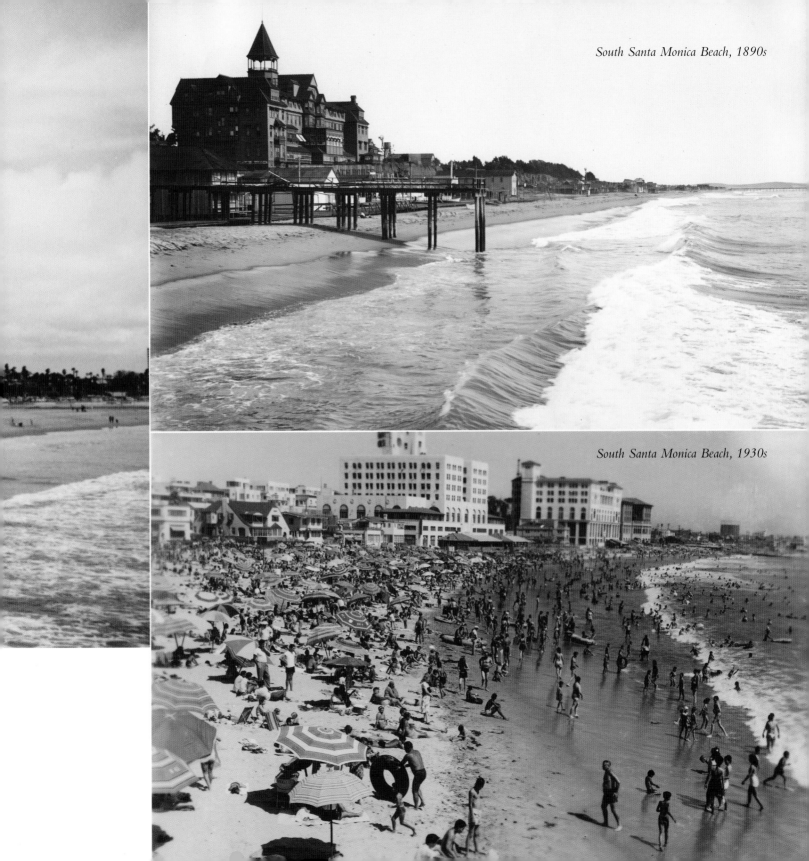

South Santa Monica Beach, 1890s

South Santa Monica Beach, 1930s

Breakwater, 2003

Breakwater/Yacht Harbor Looking North, 1930s

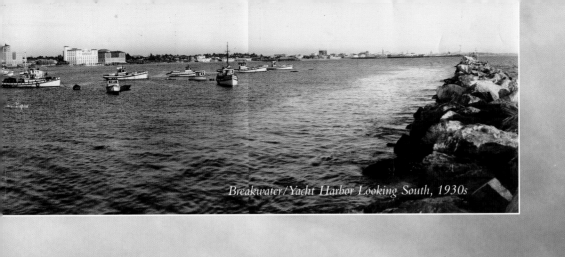

Breakwater/Yacht Harbor Looking South, 1930s

YACHT HARBOR AND BREAKWATER

Construction started in 1934 for a breakwater to create smooth, quiet water for a small-boat harbor just to the north of the Santa Monica Pier. The new yacht harbor became one of Santa Monica's most popular attractions the late 1930s and '40s. Over the years storms and waves knocked the rocks off the top of the breakwater, making it no longer effective. Today, there is no yacht harbor and the city is considering rebuilding a breakwater.

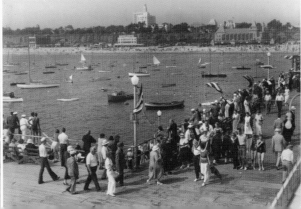

INDEX

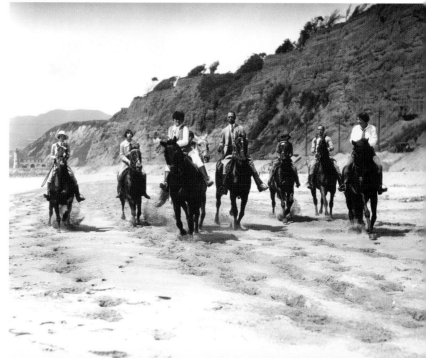

Santa Monica Riding Academy on
Santa Monica Beach, 1932

Celebrating the 4th of July at
Santa Monica Bath House, 1889

PHOTO CREDITS

The author gratefully acknowledges the photographic resources listed below for use of the images featured on the pages noted. All other images are from the Ernest Marquez Collection.

The Beach Club: pages 59, 150.

Bison Archives: pages 151 (bottom), 152, 161 (bottom), 179 (top), 181 (top).

The California State Library: pages 108, 112, 121.

The Huntington Library, San Marino, California: pages 95, 96, 97.

Jonathan Club: pages 158-159.

David Pann: page 181 (bottom).

Santa Monica Public Library: page 169 (top).

Jeffrey Stanton: pages 154–155.

The Young Collection: page 74.

BIBLIOGRAPHY

PUBLISHER'S NOTE:

While preparing to compile Ernest Marquez's bibliography covering the thirty years of research he has done for *Santa Monica Beach: A Collector's Pictorial History,* I was struck when he told me that his work is based on primary sources, family historical records, personal experiences and observations; he has "used" very few books as resources. Mr. Marquez notes that he has used and read Santa Monica Public Library's microfilm copies of the *Outlook* (also known as the *Santa Monica Evening Outlook, Evening Outlook, Santa Monica Daily Outlook, Santa Monica Bay Outlook* and *Santa Monica Outlook*) dating back to 1875. He has used and read the *Minutes of the Board of Trustees–About the Beach from January 3, 1887 to August 27, 1941* and the *Council Minutes on Piers and Wharfs from February 1, 1888 to February 21, 1940* as well as the "Engineer's Report on Santa Monica Pier Failure" published in *Architects & Engineers* v. 59:3 December 1919. And yes, he has used and read *Ingersoll's Century History, Santa Monica Bay Cities* by Luther Ingersoll (1908). Mr. Marquez recommends that readers interested in viewing Thomas Edison's 1898 film of a Southern Pacific train traversing the track on the Santa Monica Beach, visit the Library of Congress Web site at http://memory.loc.gov and search for the film's title "Going Through the Tunnel."

Mr. Marquez also explains that the history of the photographers and photographs included in this work were developed over a thirty-year period based on information collected from handwritten notes on the back of photographs, other historical photograph collectors, and from historians and archivists of major institutions.

PADDY CALISTRO
2004

Bathing beauties frolicking on Santa Monica Beach, 1932